Dark Energy

Dark Energy

Hitchcock's absolute camera and the
physics of cinematic spacetime

PHILIP J. SKERRY

BLOOMSBURY

NEW YORK • LONDON • NEW DELHI • SYDNEY

Bloomsbury Academic

An imprint of Bloomsbury Publishing Plc

1385 Broadway	50 Bedford Square
New York	London
NY 10018	WC1B 3DP
USA	UK

www.bloomsbury.com

First published 2013

© Philip J. Skerry, 2013

Library of Congress Cataloging-in-Publication Data
Skerry, Philip J.
Dark energy : Hitchcock's absolute camera and the physics of cinematic spacetime / by Philip J. Skerry.
pages cm
Includes bibliographical references and index.
ISBN 978-1-4411-8401-6 (hardcover : alk. paper)– ISBN 978-1-4411-8945-5 (pbk. : alk. paper)
1. Hitchcock, Alfred, 1899-1980–Criticism and interpretation. 2. Cinematography. I. Title.
PN1998.3.H58S56 2013
791.4302'33092–dc23
2013004492

ISBN: HB: 978-1-4411-8401-6
PB: 978-1-4411-8945-5
e-pdf: 978-1-6235-6421-6
e-pub: 978-1-6235-6869-6

Typeset by Fakenham Prepress Solutions, Fakenham, Norfolk NR21 8NN
Printed and bound in the United States of America

For my wife (with apologies to Alfred Hitchcock):
I beg permission to mention by name only four people who have given
me the most affection, appreciation, encouragement, and constant
collaboration. The first of the four is a brilliant psychotherapist; the
second is a loyal friend and companion; the third is the mother of my
children, Ethan and Jessica, and the grandmother of Louisa, Simon,
Amelia, Frankie, and Oliver; and the fourth is as fine a homemaker and
cook as ever performed miracles in a domestic kitchen. And their names
are Amy Simon Skerry.

Contents

Acknowledgments

In my book on the shower scene in *Psycho*, I listed my acknowledgments like film credits, with above- and below-the-line collaborators. I should like to continue that process in this space.

Special thanks go to my above-the-line interviewees, especially Sean Carroll, Martin Bojowald, Uri Hasson, and Charlie Rose. Without their contributions, I wouldn't have had a book. Thanks also to my very patient editor, Katie Gallof, who tolerated my requests for deadline extensions and gave me much needed encouragement. David Barker, the editor for my *Psycho* book, heard my pitch for the dark energy idea and helped me to formulate a proposal that passed muster with Continuum's editorial board. I got very valuable information on photography and cinematography from Bruce Cline and Ian Takahashi. My manuscript would not have been completed were it not for the fabulous typing skills of Dee Bassett and the last minute editing and typing talents of my sister-in-law, Alice Simon.

My below-the-line contributors are many. Jim Dailey and John Covolo, my colleagues at Lakeland Community College, gave valuable proofreading and editing help. I was especially encouraged by John, who told me early on that my approach was "bold." I owe a special debt of gratitude to my Hitchcock colleagues and friends who helped me along the way: Nandor Bokor, Uli Ruedel, Ken Mogg, John Baxter, and Kevin Brownlow. While I was doing research in Los Angeles, I consulted the prodigious Hitchcock collection at the Margaret Herrick Library. Thanks to Barbara Hall and her staff. My Los Angeles stay was made possible by the hospitality of my niece, Beth Hynes, and her husband, Kevin, both of whom listened to my dark energy idea with straight faces! Their children, Kevin and Killian, gave me special joy while I was visiting. A huge "thank you" to my family and to my patient wife Amy, who offered me encouragement and patience while I labored over this challenging project. For the photographs, I am indebted to Ron and Howard Mandelbaum and their staff at Photofest and to Gary Goodyear, who enhanced the Relativity Train photo.

There is no above- or below-the-line acknowledgment that could adequately express my gratitude to and admiration for the two great geniuses who were the guiding spirits of this book: Alfred Hitchcock and Albert Einstein.

My camera will tell you the truth, the absolute truth.

ALFRED HITCHCOCK, *HITCHCOCK* (2012), FOX SEARCHLIGHT PICTURES

For the rest of my life I will reflect on what light is.

ALBERT EINSTEIN (1917), SIDNEY PERKOWITZ, *EMPIRE OF LIGHT*

Prologue: On time, light, and Hitchcock

It was 1976, the year of Hitchcock's last film, *Family Plot.* He would live four more years, but his filmmaking career was effectively over. I, on the other hand, was teaching my first Art of the Film course. On this particular day, because of a scheduling conflict, my class had been relegated to a spare classroom with an ancient Bell and Howell 16mm projector and a white wall for a screen. The college's "official" film projectionist was unavailable, so I was operating the noisy machine and trying to talk over the cacophony. The film scheduled was *Shadow of a Doubt,* said to be Hitchcock's favorite film and made thirty-three years earlier, in 1943. We had come to the scene at the Newton dinner table, where the charming Uncle Charlie reveals his dark side. Hitchcock dollies in for a very tight close-up of Uncle Charlie as he turns toward the audience and delivers his hate-filled monologue about fat, greedy women. It's one of Hitchcock's most mesmerizing and powerful shots. Just as the shot reaches its culmination in a claustrophobic, extreme close-up, I noticed something peculiar. On the wide expanse of Uncle Charlie's patrician forehead, a small black hole had appeared. The hole got wider, and the film took on a strange glow. Smoke wafted across the projector lens as I smelled burning celluloid. I suddenly realized that the film had snagged in the projector gate and that the powerful beam of concentrated light was burning a hole in the immobilized frame of the film. Immobilized like the film, I stood there as my students looked at each other and then back at me and the projector, trying to figure out if this odd burning hole was a special effect of the movie. Finally, I uttered a loud "shit" and fumbled around on the side of the projector to find the off switch. By this time, the frame had burned out completely, mysteriously erasing Uncle Charlie and the Newton dining room from the screen.

I was being given a memorable lesson on the role of time and light in the cinema. In a matter of seconds, the powerful energy created by the beam of light had obliterated the world of the film right before our eyes. In effect, one kind of light, generated by the projector bulb, had destroyed another

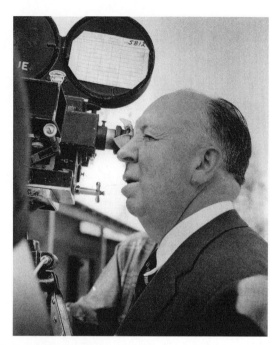

Hitchcock and his absolute camera

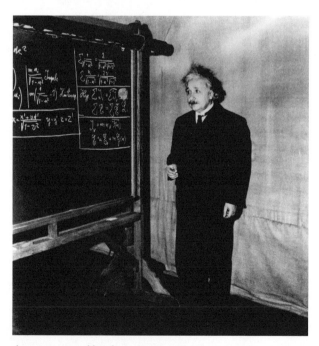

Einstein working on one of his famous equations

kind of light, captured in the shooting of the film and fixed in the chemistry of the film image. The motion picture camera captures light on film, and the motion picture projector produces light to rekindle the images on the screen. The film images move through the gate of the projector, and these individual frames meld together in the viewer's brain to create a spacetime continuum on the screen. The spacetime of 1943, captured by the images fixed on celluloid and projected in 1976, was obliterated by a light beam generated in 1976 that destroyed the light from 1943. I felt the presence of Einstein in the classroom.

Introduction: Searching for light in the darkness

There's an astonishing scene near the end of *North by Northwest* (1959) that shows the power and subtlety of Hitchcock's camera. The protagonist Roger O. Thornhill has been on the run from the police for a crime he did not commit, while at the same time he is pursuing the real perpetrators of the crime—the perfect formulation of Hitchcock's double-chase plot. Thornhill is finally apprehended by the police, who turn him over to the enigmatically named "The Professor," an innocuous looking intelligence officer, who tries to enlist Thornill's help in preserving the cover of the double agent Eve Kendall, Thornhill's duplicitous lover. Naturally, Thornhill feels betrayed by Eve—the name is significant—and wants no part in rescuing her. As Thornhill reluctantly walks with The Professor in the darkness of the tarmac at Chicago Midway Airport, he is provided by The Professor with a vital piece of information, knowledge that the audience already possesses. Thornhill listens to The Professor, whose words are drowned out by the airplane's motor; then an extraordinary thing happens: out of nowhere, a light floods Thornhill's face as the realization of Eve Kendall's plight—and of his unwitting role in it—washes over him. He finally sees his destiny.

A light from an unknown source floods the darkness and takes on symbolic importance. When I first saw this shot, I was reminded of the masterful painting, "Man With a Golden Helmet," and of the golden light illuminating the grizzled visage and setting it off from the darkness that surrounds it. The painting had long been attributed to Rembrandt but is now thought to be from a student of the Rembrandt school. I use Rembrandt as an example of artistic collaboration in my chapter on *Rear Window*. This is what Thomas McFarland says of this painting:

> Tragic meaning, therefore, underlies all our recognitions of the situation of man. That painting of Rembrandt's, [*sic*] where, against a dark

background, an old but infinitely noble man wears a mysterious golden helmet, is an epitome of all tragic realization. The helmet, gleaming, pointing upward, both symbolizes the mystery of the human mind and points toward the transcendent origin of all our light, while the bearded and hoary countenance beneath the helmet shadows forth our universal destiny of death. The sadness of the face links with the darkness against which it stands; the dignity of the face links with the mysterious artifice of the helmet.[1]

Dark and light: these are the essence of cinema, just as they are the basis of painting. The *camera obscura*, the forerunner of the modern camera widely used during the seventeenth century, while Rembrandt and his students were painting, consisted of a dark box with a tiny hole that allowed a beam of light to enter and create an inverted image on one wall. The *camera obscura*'s ability to capture light became the basis of the science and the technology that produced the motion picture camera. There's a poetic passage in the cinematographer Vittorio Storaro's book about the art of cinematography, with the provocative title *Writing With Light* (Italian title: *Scrivere con la Luce*). Speaking of his earliest experiences with light, Storaro says:

Energy vibrant with emotions, as visible energy is, appeared before me as soon as I opened my eyes for the first time; the impact was so strong that I think I actually cried out in pain; then I think I attempted, slowly, to emerge from the darkness whence I came to try and understand those still indistinct forms that were moving—although I no longer know whether these were in front of me or within.

When LIGHT came into contact with primeval darkness it set in motion a physical and chemical process that also impinged on my body; it was as if I could feel the Light itself, as well as the milk from my mother's breast, nourishing all those tiny particles that composed me. The virgin darkness having been penetrated, I had no choice but to try to understand the nature of such a violent act and what caused it: LIGHT. This meant beginning with the small portion of MATTER that was me, and crawling on all fours towards the primary source itself: ENERGY.

From the semidarkness of my little room I thus began, awkwardly, falling out of my cradle, to make my way toward the corridor with a light at the far end; I knew, or at least I thought I knew, that it would be a long journey, and I hoped that my diaper would hold out! But I seemed to have one thing clear in my little head: if I had started from "DARKNESS" I must at all costs finish up in "LIGHT."[2]

In the same vein, Hitchcock says to Truffaut, "At times, I have the feeling I'm an orchestra conductor...At other times, by using colors and lights in front of beautiful landscapes, I feel I am a painter."[3]

Frances Guerin, in *A Culture of Light*, isolates two "traditions" of light: the "scientific" and the "mythical."[4] The *camera obscura* is an example of the scientific. Just as important, in cultural history is, however, the mythical tradition, which employs light and dark to illuminate metaphysical as opposed to scientific truth. Here are the opening verses of Genesis:

> In the beginning God created the heavens and the earth. The earth was without form and void, and darkness was upon the face of the deep; and the Spirit of God was moving over the face of the waters!
>
> And God said, "Let there be light"; and there was light. And God saw that the light was good; and God separated the light from the darkness. God called the light Day, and the darkness he called Night. And there was evening and there was morning, one day. (*The New Oxford Annotated Bible*, Gen. 1.1–5)

In the Biblical version of creation, God employs light and dark to give form—and meaning—to the universe, with light connoting the good—("and God saw that the light was good") and darkness connoting the void: formlessness, chaos. In the scientific tradition, light, too, has the connotation of form and structure. In the *camera obscura* it is the beam of light that carves space out of the darkness to create an image. In *The First Three Minutes*, the cosmologist Steven Weinberg writes about the birth of our universe just seconds after "the Big Bang." He says that the infant universe contained only a few particles: electrons, positrons, and neutrinos. Then he makes this startling statement: "Finally the universe was filled with light."[5] Without light, there would be no cinema. It is surprising, therefore, that so few works have addressed the topic of light and the cinema. Guerin claims, "... an entire generation of film historians has, with one or two exceptions, paid little attention to this striking and, at the same time, conspicuous aspect of the cinema's aesthetic and history."[6]

My intention in the following study is to address this gap by paying close "attention" to how one of the great masters of the cinema uses light and its complement dark to create what he called "pure cinema": Alfred Hitchcock. Unlike the dearth of studies of light and the cinema, critical works on Hitchcock abound. In fact, Hitchcock—as his biographer Patrick McGilligan claims—is the most written-about director of all time.[7] So why another book on Hitchcock? The answer is both simple and complex—simple because I want to address the gap I mentioned above: there simply are no

studies of the science and myth of light and dark in the Hitchcock cannon; complex because such a study—along with my approach to Hitchcock's pure cinema—involves the development of science and technology in the late nineteenth and early twentieth century, including not only the development of cinema technology but also the evolution of modern physics and cosmology and their relevance to the art of film. In presenting the justification for this approach, I want to make it clear that I am *not* suggesting a direct cause and effect relationship between the early pioneers of cinema: Edison, the Lumière Brothers, Edwin S. Porter, George Melies; and the inventors of modern physics: Planck, Mach, Einstein, Bohr, Hubble; but rather a sharing of a particular scientific and cultural *zeitgeist*. Segeberg puts it well when he talks about cinema being embedded within cultural forces, but not being the direct effect of them—what Segeberg calls "a complex co-evolution rather than being merely contingent."[8]

The science and technology that produced the cinema had developed over a period of years in the nineteenth century, culminating in 1895, when the Lumière brothers held the first "official" film showing in Paris. Four years later, Alfred Hitchcock was born in London. The two "births," coming together at the close of the nineteenth century and the beginning of the twentieth century, are a perfect example of Segeberg's "complex co-evolution." Moreover, if one can say that Hitchcock's life and career paralleled the development of cinema, then one could also claim that they paralleled the development of modern physics, cosmology, and neuroscience. Einstein's special theory of relativity was proposed in 1905 when Hitchcock was 5-years-old and his father had him locked in a jail cell for five minutes for arriving home late; the discovery of gravitation lensing took place in 1919, one year before Hitchcock entered the film industry. In 1916, Einstein proposed his general theory of relativity, which further overturned the Newtonian universe and introduced the concept of curved spacetime and the bending of light rays. In effect, the universe was curved much like a film lens. Across the channel, Hitchcock was working for W. T. Henley's Telegraph works, a company that installed electrical cables. Although he had thought of a career in engineering, he realized that his true love was the cinema. Consequently, he spent his free time devouring the output of films from Europe and from America, including the seminal films of D. W. Griffith. McGilligan points out that, although Hitchcock had decided not to pursue engineering work, "No one ever had a better procedural grounding for film than Hitchcock did at Henley's. The job educated him technically, artistically and commercially."[9] In 1929, when Hitchcock directed his first sound film—*Blackmail*—Edwin Hubble presented the theory of the expanding universe, and in 1933, while Hitchcock was embarking on his great "thriller sextet" (1934–8), Fritz Zwicky proposed the theory of Dark Matter. In

1937, two years before Hitchcock would come to America—Professor Isidor Rabi observed nuclear magnetic resonance,[10] a quantum phenomenon that became the basis of Magnetic Resonance Imaging (MRI) technology, which lead ultimately to the development of neurocinematics in 2008.

This brief snapshot illustrates the kind of co-evolution that occurs when scientists, technologists, and artists all share in a *zeitgeist*, although they frequently are not aware of the cultural implications of this sharing. This lack of awareness was noted in 1959 by the British physicist and author C. P. Snow, who claimed in his famous lecture and later book that the sciences and the humanities—the two cultures—were growing further and further apart and in effect were not talking to each other. An analysis of how Hitchcock uses light and dark would enable me to address this cultural schism in three interrelated steps:

1 How Hitchcock and the cinema grew up together, with particular emphasis on the evolution of cinema technology and science and of Hitchcock's cinematic experiences and education.

2 How Hitchcock uses his camera to create cinema; most importantly, how light and dark work together to create "pure cinema"—hence the term "absolute camera" in the title.

3 How Hitchcock, the cinema, modern physics and cosmology are connected in both a literal and metaphorical sense. In essence, the pure cinema of a strip of film in a typical Hitchcock shot is the perfect embodiment of the physics and cosmology of modern science, especially the theory of dark energy.

Film is the greatest of the modern arts—and Hitchcock, in my opinion, is the greatest of filmmakers—because film is the perfect amalgam of the two traditions of light: the scientific and the mythical. As I was struggling to write this book and trying to figure out why I had chosen this particularly complex topic, I realized with a flash—yes, a flash of light—that what I was really writing about was light itself—the attempt to capture it, to understand it, or play with it, fix it on a surface—canvas, celluloid, paper—and then to share it with an audience or perhaps just to enjoy it privately. In a discussion with one of my interviewees—the eminent physicist and cosmologist Sean Carroll of Caltech—I asked him whether he knew of any books on the topic of light. He replied, "No, not that I can think of. Sounds like a good topic for a book. Why don't you write it?"

In a sense, I have written a book about light, but I've focused that broad topic—trained a beam of light, as it were—on the cinema, and more

specifically, on one of the great masters of the cinema, Alfred Hitchcock, who employed that great light tool, the motion picture camera, to create what he called "pure cinema." Because light encompasses science and art, I wanted to use both to try and understand how Hitchcock's "pure cinema" worked.

When I first pitched my idea to David Barker, my editor at Continuum Books, he seemed a bit skeptical. I reminded him that he had shepherded into print my earlier book on the shower scene in Psycho—*Psycho in the Shower: The History of Cinema's Most Famous Scene* (2009)—the only book ever written on a single scene from a film. However, as I was formulating my pitch, I had to admit that this new topic on Hitchcock and dark energy made the shower scene book look absolutely conservative in approach. David's reluctance reminded me of the skepticism that Scotty feels in Hitchcock's masterpiece *Vertigo*, when his old college chum Gavin Elster tries to convince him that Madeline is possessed by a dead ancestor. The skeptical Scotsman Scotty tries to use reason and rationalism in his dealings with Gavin and Madeline, but in the moral and visual multiverses of *Vertigo*, rationalism is doomed to failure. The ambiguity of *Vertigo* lies in its embodiment of Werner Heisenberg's uncertainty principle and Niels Bohr's probability theory of quantum mechanics. Perhaps Hitchcock was not aware of the abstruse and abstract principles of modern physics, but he instinctively knew that the cinema could dramatize these concepts as no other medium could.

I realized as I was trying to build my case for Hitchcock and dark energy that David was right to be skeptical. It turns out that I was engaging in what Malcolm Gladwell calls "rapid cognition" in his book *Blink*. Here is how Gladwell defines this term on his Website Gladwell.com:

It's a book about rapid cognition, about the kind of thinking that happens in the blink of an eye. When you meet someone for the first time, or walk into a house you are thinking of buying, or read the first few sentences of a book, your mind takes about two seconds to jump to a series of conclusions. Well, *Blink* is a book about those two seconds, because I think those instant conclusions that we reach are really powerful and really important and, occasionally, really good.[11]

My "Blink" moment came when I was in my local Barnes and Noble Bookstore checking on the number of my shower scene book in their film section. All of a sudden—in the blink of an eye—I recalled a statement that Janet Leigh had made to me when I was interviewing her for my book on *Psycho*. She talked about Hitchcock's "dictating camera," his "absolute camera." Then she paraphrased Hitchcock's instructions to her as he was directing her in *Psycho*: "... the only requirement I need is that you be where I need you to be for my

camera."[12] Janet Leigh's words had been playing around in the periphery of my consciousness, especially the phrase "absolute camera." Now in an instant, that term had become inextricably intertwined with a piece that I had read that morning in the Cleveland *Plain Dealer* newspaper about dark energy and dark matter entitled "Evidence Mounts for Mysterious Dark Energy." I had written in my notebook this excerpt from the article: "In addition to offering a new line of sight on this mysterious phenomenon, the research supports the interpretation of dark energy as a 'cosmological constant,' a force that permeates empty space and, bizarrely, has the opposite effect of gravity."[13] In effect, those two terms—"dark energy" and "absolute camera"—fused in my mind, and Blink, the topic that I have now been working on for over three years came to me.

Einstein, himself, spoke of the importance of intuition and sudden cognition: "A new idea comes suddenly and in a rather intuitive way. But intuitive is nothing but the outcome of earlier intellectual experience."[14] In his recent book on the role of the unconscious mind, *Subliminal*, Leonard Mlodinow claims, "Our subliminal brain is invisible to us, yet it influences our conscious experience of the world in the most fundamental of ways: how we view ourselves and others, the meanings we attach to the everyday events of our lives, our ability to make the quick judgment calls and decisions...and the actions we engage in as a result of all these instinctual experiences."[15] Mlodinow quotes Charles Sanders Pierce, the philosopher and scientist, on the definition of subliminal: "...that inward light...a light without which the human race would long ago have been extirpated for its utter incapacity in the struggles for existence."[16] This "inward light" certainly characterized Einstein's thought processes as demonstrated by the following remark he made about "discovering" his special theory of relativity. Einstein was visiting a close friend, to whom he confided about his relativity theory: "I'm going to give it up!" However, after a brief stroll with his friend, he recalls, "I suddenly understood the key to the problem."[17] Hitchcock, too, relied on intuition and sudden cognition in creating his films, although the pervasive mythology of Hitchcock's working methods insists that he was so prepared for a film that making it was like building a house from a blueprint. In his essay "Direction," Hitchcock says that he likes "... to have a film complete in my mind before I go on the floor." But then he admits, "Sometimes the first idea one has of a film is of a vague pattern, a sort of haze with a certain shape... You see this hazy pattern, and then you have to find a narrative idea to suit it."[18] This sounds very much like Einstein's comments on his thought process: "What, precisely, is 'thinking'? When at the reception of sense impressions, memory-pictures emerge, this is not, yet 'thinking.' And when such pictures form series, each member of which calls forth another, this too is not yet 'thinking.' When,

however, a certain picture turns up in many such series, then—precisely through such return—it becomes an ordering element for such series, in that it connects series which in themselves are unconnected. Such an element becomes an instrument, a conception."[19]

In coming up with the topic of this book, I found an affinity with both Einstein and Hitchcock—if I may align myself with these two geniuses—in the way they generated their ideas. In attempting to synthesize these materials, I came to realize how little we really know about cinema. The eminent film scholar David Bordwell, a founding member of The Society for Cognitive Studies of the Moving Image (SCSMI), claims, "Moving image media are an unusual technology. We designed and created and improved them across a hundred years and more, yet we scarcely understand the mysterious power they wield. This is a puzzle that should make any academic researcher curious."[20] According to its Website, SCSMI was founded to examine "... [how] the theories and findings of empirical science can shed light on the art and craft of film." The society sponsors a journal, *Projections: The Journal for Movies and Mind*, which contained this editorial response to Bordwell's statement that "we scarcely understand the power [media] wield": "This is the puzzle that binds together the various disciplines and writers that appear in our journal. We ask our readers to join us as we ponder and seek to respond to the 'mysterious power' of the cinema."[21]

While I was writing my book on the shower scene in *Psycho* and attempting to do a shot-by-shot analysis of that seminal scene, I encountered this mysterious power. No matter how I tried to account for all the elements of mise-en-scène and montage, there was something that eluded my grasp. That is why I seized upon the theory of dark energy when I first encountered it. In trying to understand the physics of dark energy, I didn't realize that I would be embarking on an intellectual journey that would take me from quantum mechanics, the study of the smallest things, to cosmology, the investigation of the largest things. Throughout this journey, I kept as a kind of credo a note card with a quotation from Thai film director Apichatpong Weerasethakul when he won the top prize at the 2010 Cannes Festival for his film *Uncle Boonmee Who Can Recall His Past Lives:* "I would like to thank my mother and my father, who 30 years ago took me to a little cinema in our little town, and I was so young and didn't know what it was on the screen. I didn't know the concept of cinema. With this award, I think I know a little more what cinema is, but it still remains a mystery. I think this mystery keeps us coming back here and to share our world."[22]

1

In search of light and enlightenment

Inching along the 110 Freeway outside of Los Angeles, I squint from the early morning sunshine. I'm on my way to Caltech in Pasadena to interview Professor Sean Carroll, a noted theoretical physicist and cosmologist, whose Great Courses Program on dark matter and dark energy had introduced me to modern physics earlier in the year. The brilliant sunlight of Southern California causes the cars, the freeway, and the skyline of Los Angeles to glow, despite the ubiquitous smog. As I brake yet again and sit in the ridiculous and infamous freeway traffic, I remember the first time I came to Los Angeles in 1985 for a film conference at the University of Southern California (USC).

I recall how dazzled I was to be riding down Sunset Boulevard on a bus that had picked me up at my hotel and taken me to Universal Studios—the final studio home of Alfred Hitchcock—for a tour. Two days earlier, when my flight from gray and frigid Cleveland had arrived at LAX, I got my first glimpse of Southern California sunshine. The next morning, as I was making my way to USC, I was astonished to see mountains on the horizon where there had been none yesterday. I asked someone at the conference what had happened, and he explained that during last evening the Santa Ana winds had blown away the smog and had allowed the mountains miraculously to appear. I reminded myself that I was in Hollywood and that special effects were routine here. I also recall reading about an art movement from the 1960s and 1970s that took as its subject the special light of Southern California. Called the Art of Light and Space, this loosely related group of artists was fascinated by the special luminosity of Southern California, even when that light was filtered through layers of smog![1]

In the last half-hour, I have moved perhaps one hundred yards, and I remember my niece's admonishment that morning when I left her house in Manhattan Beach at 7:00 a.m. for a 10:00 a.m. appointment: "Leave plenty

of time to make your appointment!" At that time, I thought the warning unnecessarily cautious since Pasadena is about thirty miles from Manhattan Beach and I had allowed three hours to make my journey. But it is now close to 9:00 a.m., and I fear I will be late. When I started out at 7:00 a.m., time seemed to move along at a sluggish pace as I sped along the 405 Freeway at 75 mph—for about four miles. I then saw the Sunset Boulevard exit and remembered my first trip here over twenty-five years ago, but then the traffic came to a sudden halt as miles of brake lights flashed ahead of me. Inexplicably, time seemed to speed up as the traffic and I slowed down.

I then remembered that what seems inexplicable in ordinary experience is clearly explained by modern physics. Over a century ago, in 1905, Einstein had proposed his special theory of relativity, in which he challenged the fixed time and space categories of Newton. While I am trapped in the time and space of my rental car, I take the opportunity to review my note cards for my upcoming interview with Professor Carroll. Earlier I had circled in red pen this quotation from *Discover* magazine about the Newtonian universe: "Newton imagined that the universe was spanned by absolute space, which served as a rigid invisible backdrop or grid against which the position of all stars and planets...could be definitely located. Remove all objects from the universe and Newton's grid would remain while time ticked along at a steady universal rate, as if marked by God's wristwatch."[2] Einstein, however, claimed that time and space were not separate and immutable but rather fluid and intertwined—spacetime, rather than space and time. Einstein had arrived at this startling and revolutionary theory partly through a series of thought experiments, during which he pictured someone riding alongside a light beam on a railroad track.

Still sitting in my motionless car but fantasizing about riding alongside this light beam, I find my notecards on Einstein, on one of which is this quotation: "From the very beginning it appeared to me intuitively clear that, judged from the standpoint of such an observer, everything would have to happen according to the same laws as for an observer who, relative to the earth, was at rest. For how should the first observer know or be able to determine that he is in a state of fast uniform motion?"[3] Next to the quotation, I find this note from Walter Isaacson's biography of Einstein, "... his visual imagination allowed him to make conceptual leaps that eluded more traditional thinkers."[4] It occurs to me that Einstein's thought experiments were cinematic and that he worked an idea out visually in his head the same way that Hitchcock did as he was planning a film.

Hitchcock's creative process has been the subject of much debate. Claiming that he had essentially made the film mentally before principal photography commenced, Hitchcock often said that he wished he didn't have

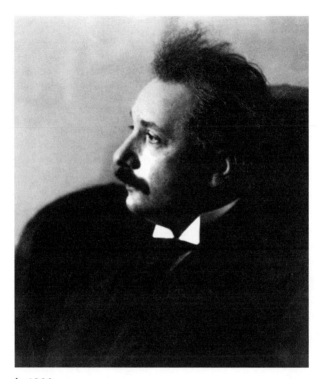

Einstein, early 1900s

to make the picture. Of course, as my students and I had observed when we visited movie sets, much of the content of film is determined by the exigencies of the actual production phase. Bill Krohn in his excellent work on Hitchcock's production methods, *Hitchcock at Work*, effectively challenged this "myth" of Hitchcock's creative process, pointing out that Hitchcock indeed did the same as other great filmmakers: making script changes as the film was being shot, shooting multiple takes of a single scene to give the editor flexibility, and yes, looking through the camera eyepiece to check the lighting and composition.[5] However, even though I agree with Bill Krohn, I still prefer to see Einstein and Hitchcock sharing this characteristic of a strong visual imagination. The *sina qua non* of this visual imagination is light.

Light is the key to unlocking the close relationship between physics and cinema—and between Einstein and Hitchcock. Clearly, without light there would be no cinema. Leo Enticknap says that the invention of photography in the early part of the nineteenth century was "... the creation of a permanent record of the existence of light in a given place and at a given moment in time."[6] Since I'm sitting in a stationary car in a given spacetime, I again

consult my notes on Einstein and find that his special theory of relativity was grounded on a postulate about light, which he defines this way, "Light always propagated in empty space with a definite velocity V that is independent of the state of motion of the emitting body."[7] This velocity is always a constant 186,000 miles per second. Einstein felt frustrated with this constant of light because it seemed in conflict with common sense. As Isaacson explains, "[Einstein] puzzled over the apparent dilemma that an observer racing up a track toward a light would see the beam coming at him with the same velocity as when he was racing away from the light—and with the same velocity as someone standing still on the embankment would observe the same beam."[8] This conundrum frustrated Einstein until he had his "Blink" moment, during which he realized that it is impossible for two events to be simultaneous in the absolute sense and that therefore "there is no absolute time." Einstein arrived at this revolutionary idea through a thought experiment involving moving trains, lightning strikes, and two observers who are passengers and one observer on the ground. Two events, such as two lightning strikes, perceived to be simultaneous by one observer, are not perceived to be simultaneous by another observer who is in motion relative to the first. The semi that slowly passed me earlier is now parallel with me, and I can't tell if he is moving or if I am—an everyday experience of relativity of motion that confirms Einstein's thought experiment. I then imagine that my semi fellow traveler and I are in trains moving relative to each other—and then I again think of Hitchcock.

As any student of Hitchcock knows, he loved to use trains as film settings, not only because they restrict movement and thus build suspense but also because they move, sometimes relative to one another. I think of The Lady Vanishes, the penultimate film that Hitchcock made in England, one year before he came to Hollywood. Most of the film takes place on a moving train. In scene after scene, Hitchcock constructs his mise-en-scène to emphasize the relativity of motion: the camera is placed in the fourth wall, and we see the characters moving in a "normal" speed interacting with one another, while through the train window in the background, the outside world speeds by at a dizzying pace, sometimes a blur as the train moves by buildings that are close to the tracks, but at other times, more leisurely, as the vista spreads out over farmlands. Within the train, there is also a kind of relativity taking place, but this time it is a thematic relativity—of truth and of perception. The heroine, Iris, has met a charming old lady, Miss Froy, on the train. Then, mysteriously, Miss Froy disappears, and no one but Iris claims to have seen her. In an earlier scene, when Iris meets Miss Froy for the first time, the noise of the train obscures their greetings, so Miss Froy writes her name with her finger on the steam-coated window. This name appears intermittently, sometimes

visible to Iris and sometimes only to the audience. The key to the mystery of Miss Froy, of course, is light, which either reveals or obscures the "reality" of Miss Froy and her mysterious signature. In most of Hitchcock's films, this kind of suspense is created by parceling out knowledge to the characters and to the audience. Sometimes, characters possess information that the audience doesn't know; frequently the reverse is true—as in *The Lady Vanishes*, when Miss Froy's name suddenly appears to the audience but not to Iris.

I am struck again by the similarities between Einstein's thought experiments and theories, and Hitchcock's cinematic practices. A fascinating similarity is their interest in trains. I remember reading about the young Hitchcock's experiences riding the trams about London in McGilligan's biography: "Hitchcock soon became addicted to the city trams and rode them everywhere; he later boasted of riding to the end of every route by age eight, memorizing the stops and favorite places."[9] Hitchcock was also a "timetable buff," and he created imaginary journeys on the Trans-Siberian railway. At just about the same time, Einstein was laboring away in obscurity in the patent office in Berne, Switzerland. His friend had secured him a job as a lowly, third-class patent clerk. However, the work he was involved in—evaluating the quality of patent applications—would have a profound impact on the theories he would propose in 1905 in a series of papers that would revolutionize modern physics and science. Just as the young Hitchcock was fascinated by railroad timetables, the unknown Einstein was reviewing patents that attempted to solve a frustrating problem with those timetables: the lack of synchronized clocks. Many of the patents that Einstein analyzed dealt with solutions to this problem. Peter Galison of Harvard states about Einstein's work: "It was a ringside seat to all of the great inventions of the time. The patents showed new and exciting ways to synchronize clocks with the exchange of telegraph signals, clocks that were synchronized by radio waves—all made the synchronization of time and what time was and how it was measured something immediately important and exciting for Einstein."[10] As he thought about the intractable problem of time synchronization, Einstein came to realize that the patents he was evaluating revealed a profound flaw in our understanding of time itself. Physicist Brian Greene explains Einstein's realization of this flaw in our notion of time: Greene imagines that he is traveling due north in a vehicle at 60 mph. His route is diverted, however, to a road that runs north by northwest. This is what Greene says: "I'm still going 60 mph, but I'm not making as much progress towards the north, and that's because some of my northward motion has been diverted—or shared with—my westward motion. Einstein realized that time and space are linked in much the same way as north and west are. And with this surprising insight, Einstein would overthrow the common sense idea that time ticks the same for everyone."[11]

Perhaps Alfred Hitchcock realized this idea instinctively when he directed the consummate comic thriller, appropriately titled, *North by Northwest* (1959), in which his Madison Avenue protagonist, Roger O. Thornhill, has his life diverted from one direction—the bored and humdrum routine of getting and spending—to another, radically different direction—the terrifying but exhilarating life of a man on the run, a survivor of assassination attempts and bitter betrayals by his family and his government. What Brian Greene says of Einstein's discovery—"There's a profound link between motion in space and the passage of time. Roughly speaking, the more you have of one, the less you have of the other"[12]—could be applied to the experiences of Roger O. Thornhill: The less time he had as his pursuers closed in on him, the more space he seemed to have. I'm thinking of the extraordinary attack on Thornhill by a crop duster in the broad expanse of an Indiana cornfield, or the last-minute escape from the confines of an art auction room to the vast expanse of Mount Rushmore.

Hitchcock seems to have known instinctively that the world of the film—the diegesis—is very much an Einsteinian construct. I find another quotation about Einstein's theory on my note cards from Isaacson's biography: "...[the theory of relativity] means that measurement of time, including duration and simultaneity, can be relative, depending on the motion of the observer. So can the measurements of space, such as distance and length. But there is a union of the two, which we call spacetime, and that remains invariant in all inertial frames."[13] In my mind's eye, I see this quotation altered a bit as I mentally substitute "camera" for "observer": "... measurement of time, including duration and simultaneity, can be relative, depending on the motion of the *camera* [italics mine]. So can the measurements of space such as distance and length." As all filmmakers eventually realize, a shot in film is a perfect embodiment of spacetime, with the relativity of each depending on the movement and position of the camera, which melds space and time into one through the capturing of light rays.

In addition to space and time, Einstein was also fascinated by light and its properties. In a theory that is probably more revolutionary than special relativity, Einstein proposed that light was not only an electromagnetic wave but also a particle—a photon. This theory is contained in a paper also written in 1905—generally known as Einstein's "miracle year,"—entitled "On a Heuristic Point of View Concerning the Production and Transformation of Light."[14] When Einstein wrote this paper, he was 26; the film industry was about ten years old, and Hitchcock was about six. One could say that the modern world was born at the same time as Hitchcock. And this modern world—its *zeitgeist*—was mainly founded on light, not only in Einstein's startling theory about its composition, but also in its propagation through artificial sources via electrical

currents. In another 1905 paper, Einstein proposed his most famous equation: $E = mc^2$. One could also construct a film equation that might look like this: $C = LM$ (cinema equals light × motion). In the development of cinema at the end of the nineteenth century, the melding of photography with motion was as explosive as Einstein's theory of the equivalency of mass and energy. The energy potential of mass in the equation $E = mc^2$ at the beginning of the twentieth century ushered in the nuclear age; the combination of motion and photography—light—in my equation $C = LM$, ushered in the cinematic age.

The light glints from the rear window of the car in front of me and temporarily blinds me, and I feel for a moment like the person from Einstein's thought experiment riding on a beam of light. About a decade after the special theory of relativity, Einstein proposed his general theory of relativity, this time proclaiming that not only were time and space intertwined but that they could be bent—and perhaps twisted—in the same way that light could be bent, or refracted. The curving and bending of light again brings me back to the cinema—and to the camera, the lens of which curves and bends light in order to create an image. With this in mind, I decide to review an earlier interview on my digital voice recorder with the cinematographer Charlie Rose, who had invited me to his cinematography class on lighting at the UCLA extension program. During lunch break I had sat down with Charlie to discuss cinematography. I press the play button on the digital recorder and hear myself ask Charlie, "What is light to a cinematographer?" Charlie answers:

> Light is this incredible force. I live in Southern California, so when I wake up in the morning it's sunny outside. That energy, those photons, excite me. They get me interested in what I want to do. I see that light, and I get energized by that. I have a brother who lives in Cleveland, where it's overcast a lot, and he's depressed nine months of the year. Here in Los Angeles, though, we have this beautiful thing, this radiance of light and quality of light that I find just amazing. I am affected by the photons in movement because they actually excite me and give me an energy that I try to visualize when I am working on a set or when I am at home just sitting in my study and watching the different shapes of the palm trees outside. As I look from one to another, I notice the difference in focus and sharpness, so the closer an object is to where the shadow forms, the harder the shadow; the farther away, the softer the shadow. This mix and blend of hard and medium, soft and sharp shadows—I find it all fascinating.

I think about Charlie's words as I look out my car window at the radiance and quality of the light. I try to imagine seeing this light through Charlie Rose's eyes—or through Hitchcock's. Like Charlie's brother, I am from Cleveland,

where during parts of the year, I don't see the sun for weeks on end. Then I again think of Hitchcock. Charlie's words sound very much like Hitchcock's statement to his cinematographer about the lighting of his 1966 film *Torn Curtain*: "It came to the point where one asked: 'what *is* light?' That's when I brought Jack Warren in and I said, 'Look at the way we're sitting here. What is the light like in this room? Are there black shadows anywhere? We're living in a reflected light. In the office, as we sit here, there's not one bit of direct light on us, even from the window because the curtains have softened it. The colors are not shouting at us. Everything is soft and there is no artificial element of light in this room. Why can't we put the same effect on the screen in *Torn Curtain*?'"[15]

In 1939, after having directed over twenty films in England and in the process becoming the most famous director in the UK, Hitchcock came to Hollywood. He had made this momentous decision for several reasons, one of which was his frustration with the limitations of the British film industry, which was hamstrung by lack of funds for first-class productions and by a critical establishment that considered filmmaking on a par with music hall entertainments. In addition, Hitchcock felt that he had been a victim of ubiquitous class snobbery most of his life: after all, he had been born Catholic in a country with a state religion—Anglicanism—and a history of religious warfare and intolerance. Three of Hitchcock's grandparents had been Irish, and British suppression of and antagonism towards that green island also added to Hitchcock's angst. Having been born into a Cockney family—his father was a greengrocer and thus a "shopkeeper"—further complicated and hindered Hitchcock's "artistic" aspirations, for in England, the "arts" were definitely the province of the ruling class and the Oxbridge intellectual elite. Hitchcock's education had definitely been that of a lower-middle class young man: a few years at a Jesuit school—St. Ignatius—and some desultory courses in science, technology, and art. At 18, Hitchcock had already entered the working world and would probably have been absorbed into that world were it not for the development of a new kind of entertainment and art: the cinema. Another reason that drew Hitchcock to Hollywood was the brilliant sunshine. In his splendid biography of Hitchcock, which I've brought to my interview, Patrick McGilligan says this about Hitchcock's decision: "Hitchcock often said that London's gloomy weather was his signal motivation." McGilligan then quotes Hitchcock speaking about the weather in England: "The sky was always gray, the rain was gray, the mud was gray, and I was gray."[16] In an interview for *The New York Times* in 1937, two years before he left for the states, Hitchcock had this to say about making films in the UK: "... the greatest difficulty we have in making films in England is to combat the climate."[17]

As I squint from the sun, even with my wrap-around Raybans, I see very little gray. I try to imagine Hitchcock arriving by the Super Chief train in Southern California in 1939 and de-training into the sunshine. I then recall the wonderful documentary on Hitchcock, *Dial H for Hitchcock*, by Ted Haimes. In it, the filmmaker shows clips from the 8mm home movies that Hitchcock made as Alma, Hitch, and their daughter Pat drove around Hollywood.[18] The luminous sunshine is captured vividly in these clips. I smile to myself as I realize that the air in 1939 was most likely pristine—no layers of smog—and the Santa Ana Mountains would be visible all day!

As I finally see my Pasadena exit, I have my own "Blink" moment, but this time—appropriately—it involves a montage of interrelated images—Hitchcock and his family arriving by train in 1939 and Iris pulling the emergency stop in *The Lady Vanishes* when she realizes that there is indeed a Miss Froy, and Einstein arriving in America in 1933, having escaped when Hitler took power, leaving behind a different kind of darkness. These three images are related to

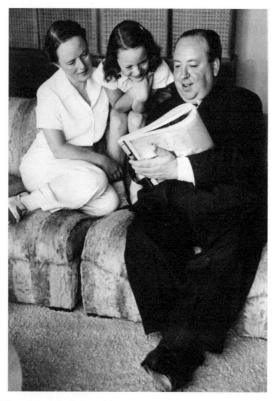

Hitchcock and family in the United States

a snippet I recall from Hollywood history: in 1913, the film industry "officially" moved from the East Coast to the West Coast, trekking by train across country, just the way Hitchcock did. The Jesse L. Lasky Feature Play Company set up its first studio at the corner of Selma and Vine and began filming *The Squaw Man*, the first Hollywood-produced feature-length western. In 1916, Lasky merged with Famous Players to form Famous Players-Lasky, the same studio that gave Hitchcock his first job in the film industry in 1920.

As I search for Caltech, I realize that the mind, indeed, is cinematic. The mental images it can conjure fascinated the 26-year old Einstein as well as the 21-year old Hitchcock when he got a job designing title cards for Famous Players-Lasky. The word "serendipitous" pops into my mind as the mental images of my montage coalesce even more dramatically: it is April of 2011, and I have finally reached my destination with fifteen minutes to spare: in April of 1939, Alfred Hitchcock and family detrained in this same city of Pasadena seventy-two years ago. Ten years earlier, in 1929, the eminent astronomer Edwin Hubble, working in the Mount Wilson Observatory near this same city of Pasadena, discovered the expanding universe,[19] which led to the theory of dark energy. Time is indeed fluid and relative. As I find a parking space, I open my door and enter the sun-filled world of Pasadena and walk—like the Hitchcocks—to my destination.

2

Hitchcock's "absolute camera"

Joe Stefano, screenwriter of *Psycho*, says in the documentary *Dial H for Hitchcock*: "It seemed like there was never a time when he [Hitchcock] wasn't making movies...there seemed like a time set aside for him. I almost have the feeling that he was supposed to be making movies during this period of this particular century. What if he had been born thirty or forty years earlier? Think of what we would have lost?"[1] The same might be said of Albert Einstein. Walter Isaacson, author of *Einstein: His Life and Universe*, says, "Looking back at a century that will be remembered for its willingness to break classical bonds, and looking ahead to an era that seeks to nurture the creativity needed for scientific innovation, one person stands out as a paramount icon of our age...."[2]

Stefano's words ring true when one looks carefully at Hitchcock's birth date—1899—and sees it in the context of the development and history of cinema and by extension of modern culture. Four years before Hitchcock's birth, the film industry was officially born with the first film showing by the Lumière Brothers in 1895 in Paris. In order to qualify as the first "official" film showing, the Lumière Brothers' presentation had to satisfy several criteria, the most important of which were the following:

1 The films had to be presented in a projection format, not in peepshow presentation, as in Edison's Kinetoscope. In other words, the showing had to be public rather than private. In effect, the ability of filmmakers to present a single film to a large number of viewers at the same time became a key to the growth of the exhibition side of the cinema equation. In addition, the technology of projection had to be advanced enough to support such a presentation.

2 The audience had to be paying spectators, not witnesses to demonstrations of new technology, such as the demonstration at Edison's lab of the kinetoscope. In conjunction with the first criterion, this requirement—that audience members pay for their entertainment—became the foundation of the idea of cinema as industry.

3 The projected images must be photographic; in other words, no shadow shows or magic lantern slides. The essence of the cinema is the science of photography.

4 The photographs must move; they had to be *motion* pictures. This criterion required a technology advanced enough to film movement and then to project movement, as well as a science of optomechanics modern enough to trick the mind into seeing individual photographs *as* movement.

Each of these criteria had its own etiology and development; the Lumière Brothers in 1895 (and Thomas Edison in 1896) were in a position to weave these developmental threads into a cinema "garment." And Hitchcock was born in 1899 and was in the right place and time—as Joe Stefano intimates— to don this garment. As my colleague Professor John Covolo has claimed about great innovators in the arts, "The man and the moment came together."

The various threads had been developing during the latter part of the nineteenth century, when the Industrial Revolution had reached its apex and modern science was being born. Some of the threads, though, had been in existence much earlier, in particular the *camera obscura* and the magic lantern. The key to the development of cinema, though, is the technology of the late nineteenth and early twentieth century and the science behind that technology. The term "technology" refers to the practical application of scientific discoveries, theories, and experiments. In his indispensable history of cinema technology, Leo Enticknap says, "Images don't move on their own. They have to be made to move—or appear to move—by technology invented and developed by human beings with the purpose of tricking the human brain into thinking that it was a continuous moving two-dimensional (or in some cases, three-dimensional) picture. No technology = no movement."[3] In her article for the *Schirmer Encyclopedia of Film*, Kristen Anderson Wagner summarizes the development of a key aspect of this technology: the movie camera:

Several technological advances were necessary before it was possible for cameras to record moving images. The glass plates used in early

photography needed to be replaced by flexible film stock, and a mechanism was required to pull the film through the camera. An inter-mittent device was needed to stop each frame briefly in front of the lens, and a shutter was added to block light between frames. Finally, the lengthy exposure times necessary for early photography—from several minutes to more than an hour—needed to be reduced significantly for moving pictures, which require a minimum rate of twelve frames exposed per second to successfully create the illusion of motion. Developments made throughout the nineteenth century by countless inventors around the world culminated in the introduction of the movie camera in the 1890s, and with it the birth of motion pictures.[4]

In essence, then, *the* essential thread in this technological tapestry is the motion picture camera.

In making the argument for Alfred Hitchcock as a seminal figure in the history of cinema and of the modern *zeitgeist*, I am using a strategy similar to the one I employed in my book on the shower scene *Psycho in the Shower: The History of Cinema's Most Famous Scene*,[5] the credo of which is that the shower scene is the most significant scene in film history. The film scholar Paul Monaco claims that this scene "... marked the arrival of what was to become the dominant motion-picture aesthetic of the late twentieth century."[6] In the same way, the birth of Alfred Hitchcock in 1899 would, if I may edit Monaco's statement, mark the arrival of a figure destined to become the greatest and most influential film director of all time, mainly for his mastery of the technology of the cinema, particularly the motion picture camera.

In my book on the shower scene, I supported my thesis that the scene is pivotal in film history with two books, neither of which was about film: John Feinstein's *The Punch: One Night, Two Lives, and the Fight that Changed Basketball Forever*[7]; and Malcolm Gladwell's *The Tipping Point: How Little Things Can Make a Big Difference*.[8] Feinstein's point is that the punch that Kermit Washington threw at Rudy Tomjanovich in a professional basketball game in 1997 became a "watershed" moment in sports, marking a shift to a much more violent sports climate. In a parallel fashion, Gladwell contends that ideas, social changes, and trends reach a threshold and then spread dramati-cally. I used these two books to argue that the shower scene was indeed a watershed moment and thus a tipping point in cinema history. I should like to employ the same strategy in this chapter by adding two additional books, ironically again not about film, to support my claim of Hitchcock's watershed and tipping point birth. The first is Stephen Greenblatt's *The Swerve: How the World Became Modern*.[9] Greenblatt argues that the rediscovery of Lucretius'

two-thousand-year-old poem *On the Nature of Things* (*De rerum natura*) by an avid hunter of ancient manuscripts, Pogio Bracciolini, in 1417 became a "swerve," bending the trajectory of culture away from the Medieval world and toward the Renaissance, with its pursuit of beauty and pleasure and with its openness to the scientific exploration of nature. For the title of his book, Greenblatt translates Lucretius' Latin word *clinamen* into the English "swerve...an unexpected, unpredictable movement of matter."[10] In short, the reintroduction of Lucretius' poem in the fifteenth century caused the Western world to swerve "...in a new direction."[11] Concomitantly, I should like to claim that in the ten-year period from 1895 to 1905, the world experienced another swerve, this time away from the Victorian worldview and towards the modern period, with its enshrinement of science and technology as *the* dominant culture forces. Like Lucretius' poem, Hitchcock was in a unique position to embody these forces. His birth in 1899 positioned him in the middle point of this swerve, four years after the founding of the film industry, and six years before Einstein's special theory of relativity.

The second book presents a paradigm for my attempt to analyze Hitchcock's cinema in light of modern physics. Arthur I. Miller's, *Einstein, Picasso: Space, Time, and the Beauty That Causes Havoc*[12] engages in what the author calls "parallel biographies ... to explore the intellectual climate at the beginning of the twentieth century, an era of genius unmatched since the Renaissance. The best works produced in that era will be forever among those that define the high road of civilization."[13] Miller attempts to compare and contrast Einstein's special theory of relativity to Picasso's seminal modernist painting, *Les Demoiselles d'Avignon*. As justification for this comparison, Miller says, "By widening our viewpoint of the origins of Picasso's *Demoiselles* to include science, mathematics and technology, we gain deeper insight into Picasso's monumental struggles."

As I was reading Greenblatt's *Swerve*, and Miller's *Einstein, Picasso*, I came across a brilliant piece by John McPhee in "The Writing Life" section of *The New Yorker*, in which he describes his process of writing profile pieces. Speaking of the evolution of his book *Encounters with the Archdruid*, McPhee states, "To a bulletin board I had long since pinned a sheet of paper on which I had written, in large block letters, 'ABC/D.' The letters represented the structure of a piece of writing, and when I put them on the wall I had no idea what the theme would be or who might be A or B or C, let alone the denominator D."[14] Although McPhee claims that this abstract structure was "...no way to start a writing project....," it worked for him, so I should like to borrow and adapt it for this chapter. Let A be the introduction of the movie camera in the 1890s; let B represent the birth of cinema in 1895; let C be Einstein's 1905 paper on the photon theory of light; and let D be the birth of Alfred Hitchcock in 1899.

ABC/D

I have discussed above the letters A, B, and D. Now I should like to extrapolate on C since many of the theories I'll discuss in the next chapter hinge on Einstein's theories. In the introduction to the anthology, *The Dreams That Stuff is Made Of: The Most Astounding Papers on Quantum Physics and How They Shook the Scientific World,* Stephen Hawking writes, "The question of the nature of light has been a central issue for much of the history of physics."[15] Newton's theory that light is particle-like was challenged in the 1860s by James Clerk Maxwell's theory that light is an electromagnetic wave. Max Planck's 1901 paper, "On the Law of Distribution of Energy in the Normal Spectrum," and Einstein's 1905 paper, "Concerning a Heuristic Point of View Concerning the Production and Transformation of Light," solved the dilemma of the nature of light—wave or particle?—by theorizing that light was both a wave *and* a particle, consisting "... of a finite number of 'energy quanta' that could not be divided...the particle of light is now called the *photon.*"[16]

If we accept the letter C, the photon theory of light, then A in the above equation becomes a technological application of the science of light. Actually, the development of the movie camera can be seen as a veritable experiment in physics, in which photons of light are gathered by the camera lens and then captured in the chemistry of the emulsion layered onto the flexible celluloid base. The motion picture camera that was invented in the 1890s provides continuity to the history and development of the cinema up until the first decade of the twenty-first century, when the movie camera, film, and projection have been revolutionized by digital technology. Leo Enticknap claims,

> The key reason film has survived so long lies in the interface between the software and hardware used to create and reproduce film-based moving images. The essential functions of a camera, printer and projector remain unchanged from those of the 1890s. The optical precision of photographic lenses available has been developed and improved, as has the accuracy of film transport mechanisms and the mechanical stress exerted on the film in motion. The designs of shutters have improved to maximise the amount of light exposure during photography and projection, as has the quality and versatility of the film duplication process. But the essential mechanical properties and functions of film-based equipment have not; leaving aside the issues of nitrate inflammability and chemical decomposition, unexposed film stock produced by the Lumières could be used in a modern 35mm studio camera and

a finished Lumière film could easily be shown using the projector in a modern multiplex with only minor modifications.[17]

The denominator D in my equation now comes into play with Hitchcock's birth in 1899. As Joe Stefano intimates in the quotation that begins this chapter, Hitchcock was born at a propitious time. While cinema developed from the static photographed tableaus and single-shot documentaries of Lumière and Edison to the pioneering and innovative montage and mise-en-scène of Edwin S. Porter and D. W. Griffith, Hitchcock was giving himself the perfect education and background for a career in the burgeoning film industry. His education gave him scientific and technical knowledge. Hitchcock's biographer Patrick McGilligan states, "Hitchcock attended lectures in physics and chemistry, took all manners of shop classes, calculated nautical and electrical measurements, and studied the principles of magnetism, force, and motion."[18] In his leisure time, Hitchcock took advantage of the rich theatrical melieu of London, while at the same time attended showings of the newest technological marvel, the cinema. McGilligan claims that Hitchcock absorbed these experiences like a sponge and "... began to develop his own ideas about how to tell a story visually."[19] At the same time, he sought employment and was hired in 1914 by W. T. Henley Telegraph Works, where he learned to calculate the sizes and voltages of telegraph cables. Hitchcock says of this work experience, "It was in a sales department, but I had to have technical knowledge of electricity... But at the same time, you see, I... had great enthusiasm for the theatre and for films. I would go to the theatre first nights...alone."[20]. In addition, while at Henley's, Hitchcock took art classes at Goldsmith College, where, according to McGilligan, he learned "... principles of art: composition, depth of field, and uses of color, shadow and light."[21] His art classes, combined with the monotony of his work at Henley's, convinced Hitchcock that he did not want to pursue a career in engineering. At the beginning of this chapter, I quoted Joe Stefano in reference to the serendipity of Hitchcock's birth: "Think of what we would have lost" if Hitchcock had been born earlier. The same might be said of his choice of profession: "Think of what we would have lost" if Hitchcock had disappeared into the commercial world of Henley's or if he had chosen an engineering profession.

In 1962, Hitchcock agreed to a series of interviews with the film critic and director, Francois Truffaut. These interviews were collected and edited into the indispensable book, *Hitchcock*, published in 1967. In the first chapter, Hitchcock speaks extensively—and revealingly—about his early years and his crucial career choice to enter the film industry. Speaking of the years 1915–16, Truffaut asks Hitchcock: "Wasn't it your ambition, at the time, to become an

engineer?" to which Hitchcock replies: "Well, little boys are always asked what they want to be when they grow up... When I said I'd like to become an engineer, my parents took me seriously and they sent me to a specialized school, the School of Engineering and Navigation, where I studied mechanics, electricity, acoustics, and navigation." Truffaut then interjects, "Then you had scientific leanings?" And Hitchcock replies, "Perhaps. I did acquire some practical knowledge of engineering, the theory of the laws of force and motion, electricity—theoretical and applied."[22]

At the same time that Hitchcock was educating himself in science and engineering, he was also indulging in his passion for the cinema. As he says to Truffaut, "From the age of sixteen on I read film journals. Not fan or fun magazines, but always professional and trade papers."[23] It was an advertisement in one of these trade papers that led Hitchcock to a decision that not only changed his life but changed the course of cinema history: he applied for a job in the newly opened Famous Players-Lasky, an American studio that had opened a British branch in order to capitalize on that country's cinema talent. Here's what Hitchcock told Truffaut:

F. T. How did you happen to go from Henley's to a film company?

A. H. I read in a trade paper that an American company, Paramount's Famous Players-Lasky, was opening a branch in Islington, London. They were going to build studios there, and they announced a production schedule. Among others, a picture taken from such and such a book. I don't remember the title. While still working at Henley's, I read that book through and then made several drawings that might eventually serve to illustrate the titles.

F. T. By "titles" you mean the captions that covered the dialogue in silent pictures?

A. H. That's right. At the time, those titles were illustrated. On each card you had the narrative title, the dialogue, and a small drawing. The most famous of these narrative titles was "Came the dawn." You also had "The next morning..." For instance, if the line read: "George was leading a very fast life by this time," I would draw a candle, with a flame at each end, just below the sentence. Very naïve.

F. T. So you took this initiative and then submitted your work to Famous Players?

A. H. Exactly. I showed them my drawings and they put me on at once. Later on I became head of the title department. I went to work for the editorial department of the studio. The head of the department had two American writers under him, and when a picture was

finished, the head of the editorial department would write the titles or would rewrite those of the original script.[24]

These facts about Hitchcock's career decisions are well-known. I restate them here because I wish to argue that the concatenation of events and experiences served to place Hitchcock in a unique position in cinematic history. In my equation ABC/D, I make Hitchcock's birth the denominator because the cinema that the Lumière brothers and Edison bequeathed to the modern world was beginning to take on the shape that would make it the dominant force in popular culture—the studio system. Hitchcock entered this system in 1920 when he was hired by Famous Players-Lasky (later to be called Paramount) to write title cards. For my purpose in this chapter, the salient point about this system is that it is a silent one. Truffaut, in the introduction to his book on Hitchcock, claims, "If the cinema, by some twist of fate, were to be deprived overnight of the sound track and to become once again the art of silent cinematography that it was between 1895 and 1930, I truly believe most of the directors in the field would be compelled to take up some new line of work..."—except for three directors: John Ford, Howard Hawks, and Alfred Hitchcock.[25] In answer to Truffaut's question, "Are you in favor of the teaching of cinema in universities?" Hitchcock replies, "Only on condition that they teach cinema since the era of Melies and that the students learn how to make silent films, because there's no better training. Talking pictures often served merely to introduce the theater into the studios."[26] Hitchcock also says to Truffaut about working in the silent cinema, "... the work in Britain served to develop my natural instinct, and later it enabled me to apply new, offbeat ideas. But the technical know-how, in my opinion, dates back to my work on *The Lodger* [1926]. As a matter of fact, the techniques and camera precepts that I learned then have continued to serve me ever since."[27]

Becoming an employee of Famous Players-Lasky opened up for Hitchcock the world of silent cinema in a very powerful way. A major characteristic of this world was the American orientation of Famous Players. Throughout his career, Hitchcock spoke of his film "education" at Famous Players by insisting that he was "American-trained." I became curious about what Hitchcock meant by this term, so I asked several of my fellow film scholars to give me their opinions. I also remembered Hitchcock telling Truffaut that it was the key element of mise-en-scène—lighting—that was his American "inheritance," so to speak: "... I especially admired the approach to lighting used by the Americans in 1920 because it overcame the two-dimensional nature of the image by separating the actor from the background through the use of back lights—they call them liners—to detach him from his setting."[28] The eminent British film historian Kevin Brownlow claimed in an email to me: "Hitchcock

used to buy the American trade papers in the 1920s, which was unusual for a British film technician. But then he was working at Famous Players-Lasky studios in Islington which was full of Americans. Didn't he say he regarded himself as an American filmmaker from the start?"[29] I find it significant that Brownlow refers to Hitchcock as a "film technician." Hitchcock, himself, in several interviews talks about his technical orientation. In an interview with *American Cinematographer* magazine, Hitchcock so states, "Well, of course, I'm a technician as well as a director."[30] The influential film critic and scholar Andrew Sarris calls Hitchcock "... the supreme technician of the American cinema."[31] My film scholar colleague and friend John Baxter emails, "I'm not sure what Hitch meant about being 'American-trained'...he could have meant...an allegiance to the studio system."[32] Perhaps the most cogent comment came from Ken Mogg, author of the *The Alfred Hitchcock Story* (London, 1999) and founder and editor of the indispensable Website, *The MacGuffin:*

> Hitchcock, for his part, traveled in Germany and was impressed by the films and techniques he saw and learned there; *and* like Eisenstein, he admired the American films and their makers; *and*, thanks to Ivor Montagu in particular, he was in the vanguard studying the films and theories of the Russians. You couldn't ask for a better all-around training as a filmmaker than young Hitch was exposed to! But "American-trained" because of his time spent with Famous Players-Lasky? Eisenstein puts emphasis on the Americans' attention to, and command, of "tempo." So that's possibly part of what "American-trained" might refer to.[33]

Ken Mogg's statement is rich in detail and provides, along with my ABC/D equation, a template for the last part of this chapter. The invention of the motion picture camera and the founding of the film industry provided a technological, cultural, and commercial environment that "selected," in a Darwinian sense, the young Hitchcock for success. His technical training, artistic talent, and cultural interests were traits that would almost guarantee success in the newly developed studio system that was beginning to dominate cinema, which is unique among the arts in its synthesis of technology, commerce, and art. In 1920, with his portfolio in hand, Hitchcock applied for a position at Famous Players-Lasky. He brought with him his experience in the world of commerce, his technical and scientific training, his artistic talent and education, and—perhaps most importantly—his love of cinema. During the 1920s he experienced the benefits of the studio system, which provided him a total film education. An example of this education is Hitchcock's memory of an early experience:

I can remember I was on one picture in 1927 when the cameraman went sick and we didn't have a replacement, so I had to do it myself. I was doing both the directing, and the lighting, and it was rather amusing because I would say to the assistant director, "We're ready to go" and he would say, "Well, you haven't *lit* it yet." I'd actually forgotten to light it, and I thought, "Oh dear, now I've got to light it. I forgot that." And on another occasion, I would light the scene and say, "Let's go." And they would say "But you haven't *rehearsed* it yet." So the ability to do the two jobs was rather difficult. I was able to do lighting, but I did take the precaution of grinding off a few feet of every scene and sending it across to the lab, which was on the lot, to have them hand test it. I mean, I wasn't all that confident of my ability as a lighting man. But even so, it worked out quite well. That was in the days of lighting from the floor with the Kliegs, and the back spot from the top creating the halo around the head, what they call the "liner" today. What was always at the back of the lighting man's mind was the separation of the image from the background. Then, also he used to go in for a great deal of modeling. In other words, there was this yearning to get a stereoscopic effect. But one wondered, was it worth it, really? Was it worth creating an artificial effect in lighting simply to achieve this separation of the figure from the background? Because, there are other ways of doing it—by focus for example. You can focus on your primary subject and let your background fall out. You have to do it in close-ups anyway.[34]

Being employed at the Islington studio also presented to Hitchcock an invaluable trip to Germany in 1924 for an Anglo–German co-production at UFA studios. Hitchcock's experiences in Germany were part of a multi-layered set of influences that would have a profound effect on him as a director. I've already mentioned Hitchcock's film viewing while a young man in London, what Gottlieb calls, "... his deep immersion of the ongoing history and development of filmmaking."[35] Then there is his "American training" at Famous Players, which I've detailed above. An important component of this training was in the area of photography. In their interview, Truffaut asks Hitchcock about this early training in photography:

Truffaut: I imagine you were then becoming increasingly interested in the technical aspect of filmmaking...

Hitchcock: I was very much aware of the superiority of the photography in American movies to that of the British films. At eighteen I was studying photography, just as a hobby. I had noticed, for instance, that the Americans always tried to separate the

image from the background with backlights, whereas in the British films the image melted into the background. There was no separation, no relief.[36]

When Hitchcock went to Germany in 1924, he was exposed to the powerful visual style of German Expressionism, about which McGilligan says: "The Germans loved shadows and glare, bizarre angles, extreme close-ups and mobile camera work; the 'floating camera' that became a Hitchcock trademark was first Murnau's." While watching Murnau's film *The Last Laugh*, Hitchcock overheard the German director say to his cameraman: "What you see on the set does not matter. All that matters is what you see on the screen."[37] Another major cinematic influence on Hitchcock was his membership in the Film Society of London, which exposed him to the avant-garde films and theories of the Soviet Socialist Realism School of Eisenstein, Vertov, Kuleshov, and Pudovkin. In contrast to the mise-en-scène emphasis of German Expressionism, the Soviets focused on montage as a powerful means of cinematic expression. As the filmmaker and theorist Pudovkin claims, "Film art begins from the moment when the director begins to combine and join the various pieces of film."[38]

In 1925, Hitchcock directed his first film, *The Pleasure Garden*, and began a process that would transform cinema and make him the greatest director of all time. The components of this process developed over the thirty years that had elapsed since the Lumière Bros. had founded the film industry in 1895. The evolution of the industry from vaudeville/music hall/arcade entertainment to the studio system would provide Hitchcock in 1920 with a complex blend of art, technology, and commerce that would allow his talents to blossom. Hitchcock called his approach to films, "pure cinema," a combination of mise-en-scène and montage, at the basis of which was the motion picture camera. Hitchcock says about his camera, "The only thing that matters is whether the installation of the camera at a given angle is going to give the scene its maximum impact. The beauty of image and movement, the rhythm and the effects—everything must be subordinated to the purpose."[39] This is the essence of Hitchcock's "absolute camera."

3

Rear Window: The apotheosis of the absolute camera

In a piece he wrote for the *Hollywood Reporter*, Hitchcock states, "To the student of motion picture making, Hollywood is a vast laboratory. A scientist may make important discoveries in a shed with a leaky roof—Mme. Curie did—but the efficiency worker is improved by better chemicals and more accurate instruments of measurement. This is what we get in Hollywood—the best cinema equipment in the world."[1] If the camera, the key piece of cinema equipment, has one major function—to create a record of light at a particular time and place—then the infrastructure to accomplish this task is of paramount importance. The pun is intentional, for the studio is in many ways the laboratory Hitchcock mentions, where "experiments" with light are the foundation of the entertainment industry.

However, the film studio is not just a laboratory; it is also a place of commerce, where art blends with science and technology to create works of cinema. At least, this is what the studio was like during most of Hitchcock's career. Today, it is a different kind of institution. In Hitchcock's time, the studio's unique blend of art, commerce, and technology precluded it from being a place of pure science, but it could certainly be a place of "pure cinema," especially if Hitchcock was at the helm, as he was in his glory days at Paramount.

Before we discuss the importance of this studio to Hitchcock's career, it would perhaps be helpful to reiterate one of the goals of my study: to discuss Hitchcock's cinema in the context of modern physics and cosmology. To that end, I have drawn comparisons between Hitchcock and Einstein, and I should like to continue this comparison as it relates to the overlap of science and art in their education. One fascinating link between them is two seminal, paternal childhood experiences that would become part of their mental landscape for the rest of their lives. Einstein's first experience took place at about age five.

He remembers: "A wonder...I experienced as a child of four or five years, when my father showed me a compass. That this needle behaved in such a determined way did not at all fit into the nature of events, which could find a place in the unconscious world of concepts (effect connected with direct 'touch'). I can still remember—or at least believe I can remember—that this experience made a deep and lasting impression upon me. Something deeply hidden had to be behind things."[2] At about the same age, Hitchcock was provided a different kind of compass by his father. In their series of interviews, Truffaut asks Hitchcock, "The only thing I know about your childhood is the incident at the police station. Is that a true story?" Hitchcock answers, "Yes, it is. I must have been about four or five years old. My father sent me to the police station with a note. The chief of police read it and locked me in a cell for five or ten minutes, saying 'This is what we do to naughty boys'...I truly cannot imagine what it was I did."[3] This naughtiness would become, if I may indulge in a bit of Freudian analysis, a leitmotif in Hitchcock's life and career; for this "naughty boy" would come to believe in the essential naughtiness of human behavior.

In another parallel, Einstein relates an experience from his early adolescence: "At the age of twelve I experienced a second wonder of a totally different nature: in a little book dealing with Euclidian plane geometry, which came into my hands at the beginning of a school year. Here were assertions, as for example the intersection of the three altitudes of a triangle in one point, which—though by no means evident—could nevertheless be proved with such certainty that any doubt appeared to be out of the question."[4] At about the same age, Hitchcock was attending St. Ignatius, a Jesuit school with very strict discipline. Hitchcock says to Truffaut of his experiences with the Jesuits: "It was probably during this period...that a strong sense of fear developed—moral fear—the fear of being involved in anything evil."[5] That Einstein's childhood experiences led to a career in science and Hitchcock's to one in art is no surprise. Certainly the compass and Euclidean geometry gave Einstein a sense of "something deeply hidden" behind the appearance of things: immutable laws of science; just as Hitchcock's jail cell and Catholic education gave him this same sense, but with a twist: rigid laws of moral behavior.

One important similarity between Einstein, the scientist, and Hitchcock, the artist, is their reliance on imagination as the prime creative force. Einstein says "Imagination is more important than knowledge," a statement that Hitchcock would agree with. As I've pointed out, Hitchcock's "pure cinema" begins with the same kind of thought experiments that Einstein relied on. Hitchcock often asserted that he had made the film in his head before production started. He says to Truffaut, "Let's take *North by Northwest*, which isn't based on a novel.

When I start on the idea of a film like that, I see the whole film, not merely a particular place or scene, but its direction from beginning to end."[6] What Walter Isaacson says about Einstein's thought processes and methods—" ... his visual imagination allowed him to make conceptual leaps that eluded more traditional thinkers"—sounds very much like Hitchcock's often repeated claim about not wanting to shoot the film since he had already made the film in his head. Finally, and perhaps most importantly, is their sharing of traits in their respective creative process: Einstein's assistant in the 1930s, Nathan Rosen, says, "In building a theory his approach had something in common with that of an artist. He would aim for simplicity and beauty, and beauty for him was, after all, essentially simplicity."[8] Hitchcock says something similar to Truffaut about directing *The Birds* (1960): "Something happened that was altogether new in my experience. I began to study the scenario as we went along, and I saw that there were weaknesses in it. This emotional siege I went through served to bring out an additional creative sense in me."[9]

A major contrast between Einstein and Hitchcock, though, is the process that follows the visual thinking; that is where the studio/laboratory comes in. Being a theoretical physicist, Einstein didn't conduct his own experiments. He relied on others for that empirical task, such as when in 1919 British astronomers proved that Einstein's general theory of relativity was true: that objects warp the space around them and thus that space is not flat.[10] With Hitchcock, however, the creative process was not purely theoretical; pure cinema had to be captured on film, via a camera and by a studio. In the case of *Rear Window*, that studio was Paramount Pictures.

In 1954, Alfred Hitchcock signed a contract with Paramount for a nine picture deal, with Hitchcock directing and producing five films, and the studio producing the remaining four. The deal was engineered by Hitchcock's agent and friend Lew Wasserman, later to become studio head at Universal, Hitchcock's final home studio. The first picture that Hitchcock directed under this contract was *Rear Window* (1954), destined to become one of Hitchcock's greatest films and a landmark in American cinema.

Much has been written about *Rear Window*, including three book-length analyses of the film. The French critics, including Truffaut, have written extensively on the film, seeing it as Hitchcock's "testament" film, one that contains the essence of Hitchcock's cinema: the audience sees a character looking at something off-screen: the audience then sees what the character is looking at; and then the audience is shown the character's reaction. This three-shot montage technique, Peter Bogdanovich explains, is the foundation of Hitchcock's film style.[11] In Truffaut's interview with Hitchcock, Truffaut says about *Rear Window:* "I imagine that the story appealed to you primarily because it represented a technical challenge: a whole film from the

viewpoint of one man, and embodied in a single large set." Hitchcock replies, "Absolutely. It was a possibility of doing a purely cinematic film. You have an immobilized man looking out. That's one part of the film. The second part shows what he sees and the third part shows how he reacts. This is actually the purest expression of a cinematic idea."[12]

I should like to augment the above description of the pure cinema of *Rear Window* by making three additional claims. Truffaut says that "... it is a film about cinema;"[13] I hold that yes, it is a "testament" film, but more so a demonstration of the artistry of Hitchcock's "absolute camera"; second, it is an artistic and technical investigation of an important scientific concept; and third, it stands as a veiled tribute to the silent cinema and to the Hollywood studio system.

By 1954, Hitchcock was at the height of his creative powers. After *Rear Window*, he would make *To Catch a Thief* (1955), *The Trouble With Harry* (1955), *The Man Who Knew Too Much* (1956), *The Wrong Man* (1956), *Vertigo* (1955), *North by Northwest* (1959), *Psycho* (1960), *The Birds* (1963), and *Marnie* (1964). This incredible string of nine films is unequaled in the history of cinema. According to Robin Wood in *Hitchcock's Films Revisited*, Hitchcock can be likened to both Shakespeare and Mozart as "... a universal artist who can address a popular and sophisticated audience."[14] It is no exaggeration to draw parallels to Shakespeare's great plays written between 1600–8—*Hamlet, The Merry Wives of Windsor, Troilus and Cressida, All's Well that Ends Well, Measure for Measure, Othello, King Lear, Macbeth, Anthony and Cleopatra, Coriolanus,* and *Timon of Athens*—and to Mozart's incredible opera output from 1780 to 1791—*Idomeneo, King of Crete; The Abduction From the Seraglio, The Marriage of Figaro, Don Giovanni, Cosi Fan Tutte, La Clemenza di Tito,* and *The Magic Flute.* In Chapter 2 I posited that the denominator of Hitchcock's birth—D—is a key to understanding his greatness as a director. Coming into the industry when he did—in 1920—introduced him to the power of the silent cinema, which was essentially a visual medium. His experiences with German Expressionism only reinforced this power. He was able to make the transition to sound in 1929 with the first British talkie, *Blackmail.* During the next ten years, Hitchcock mastered the cinema of sound while at the same time learning how to navigate the complexity of the British studio system. During the 1930s, Hitchcock became the greatest director in England, making a series of six films—"the thriller sextet"—that would become the classic formulation of the "thriller" genre. When he came to the United States in 1939, under contract to David O. Selznick, he would work during the Golden Age of the American studio system, making films for all of the major studios in Hollywood and with most of its great stars. Hitchcock took advantage of the technical, artistic,

and commercial resources of the studio system, experimenting with color and long takes (*Rope*), wide screen cinematography (the Vista-Vision films for Paramount), black comedy (*The Trouble With Harry*), documentary-like realism (*The Wrong Man*), and 3-D (*Dial M for Murder*). At the same time, Hitchcock learned to survive within a studio system that was in the process of collapsing in on itself. In 1955 he became a television star, with the launching of *Alfred Hitchcock Presents*, one of the most successful TV series of all time. And in 1960 Hitchcock "reinvented himself" as the producer and director of a low-budget horror/slasher film, *Psycho*, that would signal the death knell of the restrictive Production Code and forever-after yoke violence with sexuality as a surefire formula for movie success. Alfred Hitchcock made his last film, *Family Plot*, in 1976, capping an incredible career that spanned fifty years and fifty-seven films.

Rear Window, made approximately two-thirds into Hitchcock's career, was a Paramount film. Thirty-four years earlier, Hitchcock had entered the industry through this very studio, then called Famous Players-Lasky. By 1954, the studio system was in a state of flux. Six years earlier, this same studio—Paramount—had been the target of an anti-trust suit brought against the studios by independent theater owners. The Paramount Decree (1948) divested the studios of their movie theater chains, thus shutting off the spigot of profits that financed film production. The studios, including Paramount, would never be the same.

The relationship between the film director and the studio is a complex one. In terms of film scholarship and criticism, the relationship presents a conundrum. If we speak, for example, of a "Hitchcock film," do we mean the same thing as "a Rembrandt painting," or "a Hemingway novel"? Because film is a collaborative medium, can a film director be considered an "auteur"? In answering these questions, critics have placed themselves on a continuum, ranging from the auteurism of the French critics and their American champion Andrew Sarris to the studio system emphasis of Thomas Schatz, whose description of the studio system in *The Genius of the System* is the best that I know of. Speaking of the filmic output of the studios, Schatz says: "The quality and artistry of all these films were the product not simply of individual human expression, but of a melding of institutional forces. In each case, the 'style' of a writer, director, star—or even a cinematographer, art director or costume designer—fused with the studio's production opera-tions and management structure, its resources and talent pool, its narrative traditions and marketing strategy. And ultimately any individual's style was no more than an inflection of an established studio style."[15] I've pointed out earlier that Hitchcock lobbied hard for the role of the director as creative auteur, essentially arguing that he had made the film in his head before it

was put onto celluloid. This lobbying grew out of the frustration of an artist/ technician working in a medium that is utterly dependent on technology and commerce, as was (is) the cinema, even in its early beginnings with the Lumière Brothers. In taking an auteurist position early in his career—well before the term "auteur" was applied to film directors—Hitchcock was drawing on his experiences in Germany in 1924, where he saw firsthand the creative power of the director. As Garncarz states, "In the German film industry the director's freedom was traditionally much greater than the British industry. German directors had an influence on the script and much freedom in its filmic realization, calculated the film's budget, and were responsible for its editing."[16] Hitchcock found allies in his lobbying quest for the pre-eminence of the director, the most important of whom were Francois Truffaut and his colleagues at *Cahiers du cinéma*, where the *politiques des auteurs* theory was first launched. Truffaut's introduction to his book on Hitchcock presents a very convincing argument for Hitchcock as the ultimate film auteur. In comparing Hitchcock to other important Hollywood directors, Truffaut claims:

> If Hitchcock, to my way of thinking, outranks the rest, it is because he is the most complete filmmaker of all. He is not merely an expert at some specific aspect of cinema, but an all-around specialist, who excels at every image, each shot, and every scene. He masterminds the construction of the screenplay as well as the photography, the cutting, and the sound track, has creative ideas on everything and can handle anything and is even, as we already know, expert at publicity!
>
> Because he exercises such complete control over all the elements of his films and imprints his personal concepts at each step of the way, Hitchcock has a distinctive style of his own. He is undoubtedly one of the few filmmakers on the horizon today whose screen signature can be identified as soon as the picture begins.[17]

In direct contrast to Truffaut's thesis is the position taken by the anthology *Casting A Shadow: Creating the Alfred Hitchcock Film*, edited by Will Schmenner and Corrine Granof, and published in association with an exhibition presented by the Mary and Leigh Block Museum of Art at Northwestern University. In the Preface, David Alan Robertson calls the auteur Hitch a myth:

> … Hitchcock, like the great masters before him, obviously stood at the head of a large and creative workshop of artists, artisans, and technicians. Actual documents, cited in this publication and included in the accompanying exhibition, tell a different story than Hitchcock's carefully crafted public

persona allowed. They reveal an even more intriguing and remarkable story of collaboration and delicate creative processes that involved many people making decisions in a layered, multistep process. Indeed, Hitchcock's working methods were flexible—allowing other people to come up with ideas critical to the picture and making room for changes to the movie while he was on the set. In doing this, he engaged the best talents in the field, Robert Boyle and Henry Bumstead for production design, Academy Award-winning costume designer Edith Head, and even artist Salvadore Dali to inspire an important dream sequence in the film *Spellbound* (1945), to name but a few. From this perspective, Hitchcock emerges as a man orchestrating, indeed directing—rather than as a medium channeling—his vision through his workshop. It is an image that is at once more believable and more impressive than the myth.[18]

If we accept the argument that Hitchcock's pure cinema is the result of a collaboration among artists in his "workshop," then we can see another intriguing parallel between Einstein and the director. Because Einstein was a theoretical physicist and cosmologist, the validity of his theories depended upon the experiments of his scientific colleagues. It is what Thomas Kuhn in his groundbreaking book, *The Structure of Scientific Revolutions*, calls "normal science." Kuhn says of this kind of science, "A third class of experiments and observations exhausts, I think, the fact gathering activities of normal science. It consists of empirical work undertaken to articulate the paradigm theory, resolving some of its residual ambiguities and permitting the solution of problems to which it had previously only drawn attention."[19]

In the following discussion of *Rear Window*, I am proposing a compromise to the auteur vs. collaboration debate by using the name Hitchcock as a synecdoche, a part—and of course, a very large part—that stands for the whole. My approach reflects current scholarly approaches in areas such as art history and cultural studies. Previously, I queried whether a "Hitchcock film" could be considered the same as a "Rembrandt painting." Even with the great Dutch master, however, there is now evidence that many Rembrandt paintings, such as "The Man With the Golden Helmet," were actually produced by apprentices and students in the Rembrandt workshop. Recently I visited the Cleveland Museum of Art's "Rembrandt in America" exhibit, which presents very convincing evidence that many of the Dutch master's works in American collections were collaborative efforts. Einstein realized the collaborative nature of scientific discoveries. In *Einstein: A Hundred Years of Relativity*, Andrew Robinson observes, "Yet despite the strangeness of its predictions, relativity was built on the mechanics of Galileo and Newton modified by the electrodynamics of Maxwell, as Einstein is at pains to

emphasize. Most modern physicists regard relativity theory as revolutionary but Einstein himself did not...."[20]

In the case of *Rear Window*, and for almost all the films through *Marnie* (1964), Hitchcock's workshop was probably the greatest collection of artistic, technical, and commercial talent in the history of cinema. At the top of the workshop list is Hitchcock's "right-hand man," cinematographer Robert Burks, who shot all but one (*Psycho*) of Hitchcock's films from 1951–64. The film's editor is George Tomasini, who began his collaboration with Hitchcock on this film and stayed with him until his untimely death after *Marnie*. John Michael Hayes, the screenwriter, would do three other films with Hitchcock: *To Catch A Thief*, *The Trouble With Harry*, and *The Man Who Knew Too Much*. Hal Pereira does the art direction; Sam Comer and Ray Morer provide set decorations; John Fulton does special photographic effects. Edith Head, multiple Academy Award Winner, designs the costumes; Wally Westmore does make-up; Franz Waxman provides the score. A bit later in the decade, Hitchcock would add the film composer Bernard Herrmann, who would do the scores for all the films from *The Trouble With Harry* through *Marnie*. Other names appear again and again in the production credits of Hitchcock's films during this amazing period: Robert Boyle and Henry Bumstead, art directors: Saul Bass, title design; Herbert Whitlock, pictorial design; Hilton Green, assistant director. One problem for Hitchcock scholars in assessing the contributions of the Hitchcock workshop is that the conventions and practices of attributing credits were to list only "major" collaborators on front credits, unlike contemporary practices of splitting the credit scroll into front and back credits, with everyone who plays a part in the production getting a mention, even the person who drives the catering truck. In fact, only thirty-two names appear in the credits of *Rear* Window, and thirteen of those are the actors and actresses!

To me, Hitchcock's workshop collaborators are the consummate cinematic "dream team." So when I say, for example, that Hitchcock does so and so, what I mean is that Hitchcock and his "dream team" accomplish that particular cinematic feat. Indeed, as David Allen Robertson points out, Hitchcock is "orchestrating his vision through...his workshop."[21]

An important collaborator in Hitchcock's film career deserves several paragraphs all to himself—Herbert (Herbie) Coleman, who was with Hitchcock for twenty-five years, longer than anyone else, except perhaps for Hitchcock's personal assistant Peggy Robertson. Coleman began his association with Hitchcock on *Rear* Window. Coleman's memoir, *The Hollywood I Knew: A Memoir: 1916–1988*, provides ammunition for those critics who take the "genius of the system" position. In Chapter 37, Coleman presents convincing evidence of Hitchcock's collaborative methods:

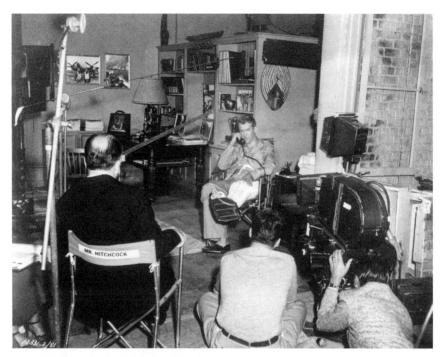

Alfred Hitchcock directing Jimmy Stewart in Rear Window

1 After hiring Coleman as assistant director, Hitchcock says to him, "The only staff I'll be bringing with me are Bob Burks, my cameraman; his camera operator, Bill Shurr; and his camera assistant, Lenny South. I'm leaving the selection of the rest of my staff in your hands."

2 Of the film's editing, Coleman says, "Before we'd reached the halfway mark on *Rear Window*, Hitchcock was giving George [Tomasini] complete freedom on the first cut. Their relationship quickly turned into a friendship that lasted until George's untimely death on a fishing trip to the High Sierras, after he'd completed editing *Marnie*, his tenth consecutive picture with Hitch."

3 After the major actors of the film had been chosen by Hitchcock, he tells Coleman, "It is your responsibility...to select the actors for the remaining parts. When you're satisfied you have the right girl for Miss Torso, keep her away from the dance department. Give her a record of our music and let her create her own dance."

4 Referring to the studio workmen's cacophony in building the set,

Hitchcock asks Coleman, "'What have you done about all that noise...? You wouldn't expect me to shout my directions to my actors?' Of course not, Mr. Hitchcock. I pointed to a microphone hanging on a corner of the set. Below the mike were buttons and the actors' names. 'All you'll have to do, Mr. Hitchcock, is pick up that mike, push the button for the actor you wish to speak to, and a muted bell will be the signal for the actor to pick up his receiver and listen to your instructions. And the greatest thing about that system is they won't be able to talk back.'.... he was all smiles when he tried it out after we started shooting."

5 In the preparation of the script, Coleman presents a vivid insight into Hitch's working methods in the pre-production process, while at the same time Coleman debunks the portrait presented in Donald Spoto's biography of Hitch, subtitled *The Dark Side of Genius* (1983). Coleman had been upset with what he saw as Spoto's intent to "... destroy the reputation of my friend, Alfred Hitchcock," by including in the biography, "... numerous misquotes, mistakes, and outright inventions [that] damaged and destroyed many close friendships."

One of these "inventions" was Spoto's claim that John Michael Hayes wrote the script single-handedly after a few "preliminary meetings," to which Coleman responds, "Preliminary meetings, indeed! Hayes typing for days as Hitchcock dictated the entire screenplay is 'preliminary meetings'?" And then Coleman provides this wonderful anecdote about Hitch's creative process:

I sat there and listened in amazement as Hitch, pacing slowly around his office, described in detail the opening scenes. The camera movement through the window of Jimmy's apartment to the apartments across the courtyard. A half-dressed ballet dancer, seen through her open window. And action in other apartments. Then to Jimmy's leg in a cast. He stopped for a moment and turned toward Hayes. A smile replaced his usually somber expression: "I've decided to have Jimmy asleep when Grace makes her first appearance in our film."

As he described her approach to Jimmy and the close shots of Grace waking Jimmy with tender kisses, I began to realize that Alfred Hitchcock could put more than sex and suspense in his films.

Obviously pleased with his vision of the opening scenes for *Rear Window*, he resumed his pacing and his description of the scenes for the picture. A composer in an adjoining apartment. A honey-mooning couple who move in next door. A married couple who live directly across the

courtyard. He continued to describe the other important neighbors. Who they were and how their lives affected the thinking and actions of Jimmy.

The routine of Hitch dictating and Hayes typing continued for many days. Schooldays for me and maybe for John Michael Hayes, also. We were receiving a graduate school course in screenplay development.

The day he dictated the final scene, Hitch told Hays to take a copy of the script and add the dialogue.

We watched Hayes take the pages from the typewriter, add them to the stack on the table, and leave the office.[22]

What I find interesting about this anecdote is that it could be used by both auteurists and genius-of-the-system advocates to support their positions.

The umbrella organization that houses this workshop and makes these feats possible is Paramount Pictures, an organization that played a key role in Hitchcock's career, in much the same way that the Swiss patent office played a role in Einstein's career. I've mentioned several times earlier—but it bears repeating—that the Famous Players-Lasky studio, later to be called Paramount, gave Hitchcock his first job in the film industry in 1920. In terms of film history, Paramount plays a central role in the development of Hollywood as *the* entertainment capital. Before it was incorporated as Famous Players-Lasky in 1916, this company was actually two separate film organizations: The Famous Players Film Company and The Jesse L. Lasky Feature Play Company. This latter became, in effect, the first studio in Hollywood when it produced *The Squaw Man* in 1914. The film was shot by legendary director Cecil B. De Mille, whom Bill Krohn, in his *Cahiers du Cinema* Masters of Cinema book on Hitchcock, calls Hitchcock's "idol."[23] Now a museum in Hollywood, The Hollywood Heritage Museum (aka The DeMille Barn), this modest structure established Hollywood as the ideal location for film production, one of the most important reasons being its ubiquitous and luminous sunshine. The Seeing Stars Website contains this description: "Although it was DeMille's first film (he even appeared in it as an extra), *The Squaw Man* went on to become a major box-office smash—the first hit movie made in Los Angeles. Made for only $15,000, the movie grossed over $200,000 nationwide, and led to Hollywood becoming the movie capital of the world. The little 'Famous Players-Lasky Co.' went on to become the giant Paramount Studios...."[24] Extrapolating from the above, when Hitchcock came to Hollywood in 1939, one could claim that it was the direct result of the founding and success of Paramount Studios.

Given the pivotal role that Paramount had played in his career as well as in Hollywood's history—*Wings*, a Paramount film, won the first Academy Award for best picture in 1929—it is no stretch to see *Rear Window* as Hitchcock's

tribute to the significance of this great studio. In the early '50s, Paramount was trying to regain its balance after the disastrous Supreme Court's decision on the anti-trust suit brought against the five major studios that made up the bulk of the Hollywood studio system—Paramount, MGM, 20th Century Fox, Warner Brothers, and RKO, called "majors" because they owned their own theaters. The financial fallout for Paramount can be seen from this paragraph from *The Paramount Story* by John Douglas Eames:

> In 1948 the sword of Damocles that the US government had been holding over the industry for ten years fell at last. The major companies were found guilty of anti-trust law violations and ordered to dispose of their theatre interests. Paramount was the first to comply, hiving off all the properties Zukor had so assiduously collected, and becoming once again simply a production-distribution organization at the end of 1949 (only the Famous Players circuit of Canada and some overseas theatres escaped the axe.) The immediate result was a drop in Paramount Pictures' profits from $20 million in 1949 to $6 million in 1950.[25]

In my book on the shower scene in *Psycho*, I claimed that Hitchcock was "ready for *Psycho* and the shower scene ... [and] that *Psycho* was ready for him".[26] By this I meant that circumstances were propitious for Hitchcock to create a film that would revolutionize cinema. The same kind of readiness could be applied to Hitchcock and *Rear Window*. By 1954, Hitchcock had been in the Hollywood studio system for fifteen years. During the first half of this period, he had worked under the tyrannical control of David O. Selznick, under whom Hitchcock learned to navigate the treacherous shoals of the producer-dominated studio system. In the eight years from 1946 to 1954, Hitchcock had sufficiently worked the system to become his own producer and by 1954 to realize that the "new Hollywood" of the post-Paramount Decree era would require a freelance independence. The contract with Paramount that Lew Wasserman negotiated for Hitchcock would guarantee Hitch that independence. Ken Mogg says of this deal, "Before *Rear Window* entered production, Hitchcock signed an extraordinary contract with the studio, giving him complete creative control. It was also agreed that ownership of the films his production company made would be returned to Hitchcock after eight years."[27] Hitchcock's biographer Patrick McGilligan says of this Wasserman-inspired contract: "But Wasserman's real coup passed almost unnoticed in 1954: a pioneer reversion clause that gave Hitchcock *ownership* of the five pictures he produced and directed, eight years after their initial release. The future implications of this clause would be astronomical."[28] In order for the Hitchcock workshop to create its magic, it needed the resources

of Paramount Studios, just as Paramount needed at this crucial juncture a director with the artistic and commercial credentials of Alfred Hitchcock. It was a perfectly realized symbiosis.

Without this symbiotic relationship, filmmakers would not be able to make films and perhaps attain the status of auteurs. In essence, the studio *was* the workshop, the "system" in Thomas Schatz's title, *The Genius of the System*. This "system" has been called many things: a self-contained city with its own workers, citizens, and governance; an economic and industrial entity that controlled production, distribution, and exhibition of its product; an entertainment factory that manufactured products that shaped popular culture. Perhaps its most famous name comes from the title of anthropologist Hortense Powdermaker's study, *Hollywood: The Dream Factory*, in which Powdermaker analyzes the social system of Hollywood. She says this in her introduction about Hollywood films, "My hypothesis was that the social system in which they are made significantly influences their content and meaning."[29]

I should like to take my cue from Powdermaker's social scientist point of view, but I prefer to see the studio as a scientific/technical laboratory, the main objective of which is to produce and capture the photons and waves of artificial and natural light and to present this light to an audience in the form of a spacetime continuum. In keeping with the scientific/technical focus of this study of Hitchcock, it's not too far-fetched to see Paramount Studios as analogous to the Large Hadron Collider (LHC), the major purpose of which is to speed protons up and to collide them. To this end, the largest scientific edifice ever constructed, with the most advanced technological equipment, is like the huge institution of Paramount Studios, the major purpose of which is to capture the photons and waves of light. Seen from this angle, the studio has one overriding function: to create the conditions for cameras to capture light in the chemistry of a strip of film. The primacy of the process of recording images is clear to anyone who has ever visited a studio, as my students and I had done many times when I taught a Domestic Studies course called, "The Hollywood Film Industry." One of our most important destinations was Paramount Studios, where we visited movie and television sets, both within sound stages and on location in the backlot. When the director called, "sound," and then "camera," the red recording light would go on, and everyone had to be silent and still so that the camera could do its work.

Hitchcock's camera, then, is absolute in the sense that its position—its angle—is the single most important element of production. As Hitchcock says to Truffaut, "The size of the image is used for dramatic purposes, and not merely to establish the background."[30] This has become known as the "Hitchcock Rule" of mise-en-scène construction. In Hitchcock's "pure

cinema" system, both mise-en-scène and montage play equally important roles, but it is my belief that mise-en-scène *must* precede montage as the primary element in the construction of a film. Hence, I find myself in disagreement with Hitchcock when he assigns montage the primary role in pure cinema, as he seems to do many times in interviews, e.g. "The screen ought to speak its own language, freshly coined, and it can't do that unless it treats an acted scene as a piece of raw material which must be broken up, taken to bits, before it can be woven into an expressive visual pattern";[31] and "It's limitless, I would say, the power of cutting and the assembly of the images."[32]

Countering these claims is Hitchcock's own profoundly influential early film experiences and education, in 1924–5, when he visited Germany first as an assistant director on *The Blackguard* (1924) and later as a director of his first feature, *The Pleasure Garden* (1925).

German cinema is quintessentially a cinema of mise-en-scène. In creating their images, German directors had the power to control the mise-en-scène so that the narrative was contained in the images on the screen. Since they were silent, German films had to tell their story in almost purely visual terms. For example, F. W. Murnau's *The Last Laugh*, the production of which Hitchcock witnessed firsthand in 1924, his seminal year in Germany, has few title cards and is thus an embodiment of Hitchcock's idea of "pure cinema." Hitchcock says of Murnau's masterpiece that it was "almost the perfect film...[it] had a tremendous influence on me."[33] The carefully composed mise-en-scène of German cinema can be attributed to the fact that German Expressionism was essentially a studio-driven visual style. Expressionism's striking visual design could be attained only in a milieu of tightly controlled set design and lighting patterns. So when I claim earlier that *Rear Window* is an homage to the silent cinema, I am referring to the profound influence that Germany had on Hitchcock's approach to pure cinema. I find it ironic that while Hitchcock was in Berlin soaking up German Expressionism, Einstein was there as well. In 1914, Einstein became director of the Kaiser Wilhelm Physical Institute and Professor in the University of Berlin. In that same year he became a German citizen. He stayed in Berlin until 1933. He then renounced his citizenship, left Germany, and emigrated to the United States, six years before Hitchcock would leave England.

Similar to German cinema, *Rear Window* is purely a studio-produced film. The set of *Rear Window* was the largest such construction in the history of Paramount. Herbert Coleman says of this set, "While we waited for the starting date of November 27, 1953, to arrive, Bob Burks was busy with the largest crew of electricians, grips and other workers, prelighting the largest set ever constructed on a Paramount stage."[34]

Rear Window then is a tribute, not only to Paramount Studios and to German cinema, but to the motion picture camera and to its visual complement, light. After all, the only staff that Hitch brought to Paramount to make *Rear Window* was his cinematographer Bob Burks and his camera crew. With these primary members of his workshop, Hitchcock could create his magic on the Paramount sound stage. As anyone knows who's ever been on a film set, the most important job of the director of cinematography is to light the set; this lighting pattern is worked out with the primary creative force on the set, the director. Bill Krohn's masterful study of Hitchcock's production methods, *Hitchcock at Work*, presents a very detailed look at the set construction, lighting patterns, and editing decisions of the film, with such specifics as types of lights (thousands of giant arcs and smaller lamps) and lenses (50, or 75, 150 and 250mm). But then Krohn reaches this curious conclusion about the fundamental structure of *Rear Window*: "... something that is generally overlooked about *Rear Window*: it is in the fullest sense of the word a montage film...."[35]

I wish to take issue with Krohn regarding his opinion of the film's structure, just as I did with Hitchcock above: *Rear Window* is a film built on the foundation of mise-en-scène. Perhaps the best definition of this arcane sounding term—always a tongue-twister for my students... and me—is found in John Gibbs' little gem of a book, *Mise-En-Scène: Film Style and Interpretation*:

> For the student of film, a useful definition might be: "the contents of the frame and the way that they are organized". Both halves of this formulation are significant—the contents and their organization.
>
> What are the contents of the frame? They include lighting, costume, décor, properties, and the actors themselves. The organization of the contents of the frame encompasses the relationship of the actors to one other and to the décor, but also their relationship to the camera, and thus the audience's view. So in talking about mise-en-scène one is also talking about framing, camera movement, the particular lens employed and other photographic decisions. Mise-en-scène therefore encompasses both what the audience can see, and the way in which we are invited to see it. It refers to many of the major elements of communication in the cinema, and the combination through which they operate expressively.[36]

Even in the nuts-and-bolts production of a film, mise-en-scène must take place first so that in the preliminary and final cut process there are images to assemble. The three-frame sketches that Hitchcock was fond of producing when he "made the film in his head" were essentially what the camera

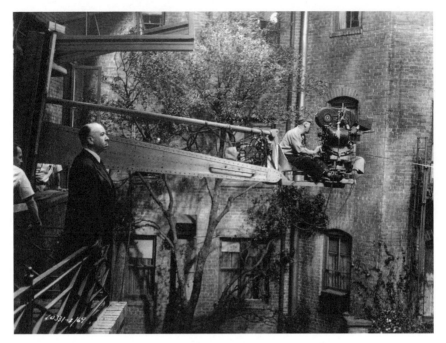

Hitchcock on the largest set ever built on a Paramount sound stage

would see from its crucial point of view. In short, mise-en-scène is axiomatic
to the film's essential nature.

Mise-en-scène would not be possible without light and its characteristic
of shaping and defining space and movement within that space. In my earlier
chapter, "In Search of Light and Enlightenment," I constructed a film equation
$C = LM$ (cinema equals light x motion), and I should like to apply that equation
to my analysis of selected scenes in *Rear Window*. I should also like to bring
Einstein into this equation, especially his theory of spacetime, and I should
like to apply that concept to a cinematic shot—one continuous running of
the camera without cuts. We know that Hitchcock was fascinated by the
camera's ability to capture spacetime in the chemical emulsion of a film strip.
His utilization of long takes in *Rope* (1948), for example, shows that he was
interested in experimenting with this cinematic characteristic, although he
didn't consider *Rope* a success. Hitchcock says, "When I look back, I realize
that it was quite nonsensical because I was breaking with my own theories of
the importance of cutting and montage for the visual narration of the story."[37]
Again I wish to take issue, not with Hitchcock's words but with the impli-
cation that montage takes precedence over mise-en-scène in his *oeuvre*. If

one looks dispassionately at Hitchcock's filmic output, one could conclude—as I have—that most of Hitchcock's visual innovations were in mise-en-scène rather than in montage. This is certainly true of *Rear Window*. Although the French critics consider the film as Hitchcock's "testament" film due to its tripartite editing pattern (subject sees; we see what he sees; we see his reaction), this cannot be the major cinematic strength of *Rear Window*. For once the pattern is established, it's simply repeated. To my eyes, there's more innovation in the lengthy exposition shot right after the film's credits. That shot is loaded with visual information more central to the film than the repetitious montage pattern. In my book on the shower scene, I devote a long chapter—30 pages—to how Hitchcock uses mise-en-scène to create suspense in scenes from *I Confess* and *Rear Window*.

As I said earlier, "As all filmmakers eventually realize, a shot in a film is a perfect embodiment of spacetime, with the relativity of each depending on the movement and position of the camera, which melds spacetime into one through the capturing of light rays." When David Bordwell talks about the "mysterious power" of the cinema, I think he means this spacetime characteristic of a cinematic shot. The gigantic *Rear Window* set, then, is Hitchcock's laboratory where he experiments with the mysterious power of mise-en-scène.

If time and space are not separate entities but rather one concept, as Einstein claims, nothing illustrates this better than *Rear Window*, a film totally constructed of spacetime units in the form of cinematic shots created on the Paramount sound stage "lab." In aesthetic-scientific terms, a cinematic shot melds past, present, and future with three spatial dimensions—I am considering depth of field as a concrete third dimension in the film image—to create the diegesis of the film, a term narratologists use to define the created world in a work of fiction. The Greenwich Village neighborhood of the protagonist L. B. Jefferies is just such a diegesis, a world totally created within the sound stage at Paramount by artificial lights. If a photograph is "... the creation of a permanent record of the existence of light in a given place and at a given moment in time," as Leo Enticknap claims, then there are actually two photographic records of light in *Rear Window*. The first is the record of the *Rear Window* production at Paramount Pictures Corporation, directed by Alfred Hitchcock in 1953–4. The second is the record of the light in the diegesis of the film *Rear Window*, with its Greenwich Village apartment and its cast of characters.

On the production level, (let's call this "Level A"), we can discuss the position and status of *Rear Window* in the Hitchcock canon and analyze its production methods and aesthetic characteristics as a film; on the diegetic level (let's call this "Level B"), we can discuss the various themes, setting, and characters. The intermediary between these two light levels is the motion

picture camera, which simultaneously, records an historical artifact that captures the actors, costumes, technology, etc. of a particular moment in spacetime and then creates a diegesis, the spacetime of which transcends artifact to become art. In discussing *Rear Window*, I'll switch between Levels A and B regularly, sometimes combining them.

An example of Level A analysis is Bill Krohn's *Hitchcock At Work*, which is a revealing picture of how the Hitchcock workshop functioned in the production of *Rear Window*. In terms of Level B types of criticism, there is the outstanding analysis of the diegesis of *Rear Window*, Stefan Sharff's, *The Art of Looking in Hitchcock's Rear Window*, which contains this credo in Chapter 1, entitled "The Art of Seeing, The Art of Looking": "The aim of this study is to give a lucid exposition of the subject of cinema art, an art that is abundantly demonstrated in Alfred Hitchcock's *Rear Window*. I will attempt to identify the 'materials' utilized by the master, and then proceed to a deeper level of analysis based on the principle of grammatization of his cinema language."[38]

I'd like to introduce a third level, "Level C," that approaches *Rear Window* from a scientific/technical angle and that draws a bit from Levels A and B. In my interview with Sean Carroll from Caltech, we discussed the topic of his new book, *From Eternity to Here: The Quest For the Ultimate Theory of Time*, which takes as its subject the concept of entropy. Carroll explains his thesis in these paragraphs from the Prologue:

> It's clear that the universe evolves as time passes—the early universe was hot and dense; the current universe is cold and dilute. But I am going to be drawing a much deeper connection. The most mysterious thing about time is that it has a direction: the past is different from the future. That's the *arrow of time*—unlike directions in space, all of which are created pretty much equal, the universe indisputably has a preferred orientation in time. A major theme of this book is that the arrow of time exists because the universe evolves in a certain way.
>
> The reason why time has a direction is because the universe is full of irreversible processes—things that happen in one direction of time, but never the other. You can turn an egg into an omelet, as the classic example goes, but you can't turn an omelet into an egg. Milk disperses into coffee; fuels undergo combustion and turn into exhaust; people are born, grow older, and die. Everywhere in Nature we find sequences of events where one kind of event always happens before, and another kind after; together, these define the arrow of time.
>
> Remarkably, a single concept underlies our understanding of irreversible processes: something called *entropy*, which measures the "disorderliness"

of an object or conglomeration of objects. Entropy has a stubborn tendency to increase, or at least stay constant, as time passes—that's the famous Second Law of Thermodynamics. And the reason why entropy wants to increase is deceptively simple: There are more ways to be disorderly than to be orderly, so (all else being equal) an orderly arrangement will naturally tend toward increasing disorder. It's not that hard to scramble the egg molecules into the form of an omelet, but delicately putting them back into the arrangement of an egg is beyond our capabilities.[39]

It may very well be that the "mysterious power" of the cinema resides in this very aspect of entropy, for the physics of cinematic spacetime defy the physics of "ordinary" spacetime; this feat is accomplished through the mise-en-scène of the cinematic shot. This aspect of pure cinema is comprised not only of the arrow of time but of the arrow of space; moreover, this arrow can move backwards, can reverse itself in ways that are impossible in real space and time. Take, for example, the artifact (Level A) of *Rear Window*, which will always unfold in the light and space captured in the emulsion of the film in 1953–4. Jimmy Stewart will always be playing L. B. Jefferies, and Grace Kelly will always be Lisa, etc. If we were to subject a typical shot from the film to a Level B analysis, we could play the shot or scene over and over again, and it would unfold in the same cinematic spacetime—unless we were to slow it down—or reverse it. In this way, we can always unscramble an egg back to its original form. This is what Sharff says about the "exposition" shot at the beginning of *Rear Window*:

> The film starts with an elegant, almost 360 degree panoramic camera sweep around an interior courtyard with garden. The roving camera-eye passes over a series of windows showing people starting the day and, finally, comes upon a close-up of protagonist L. B. Jefferies (James Stewart) asleep, sweating profusely, outdoor thermometer showing 93°. He is in a wheelchair, a full cast on his left leg. From the paraphernalia in his cramped apartment we surmise that he is a photographer for a leading magazine. All the above is in silent-film fashion, without any commentary.[40]

This opening shot establishes the cinematic technique of *Rear Window*, which is to isolate the camera in Jefferies' apartment, making the space an observation post, or—better yet—a laboratory, from which the Hitchcock workshop can observe the human subjects of the Greenwich Village apartments. The portals to these human subjects are windows, through which light passes and gets recorded via the lens/window of Hitchcock's absolute camera. Sharff says about *Rear Window*: "The epicenter of the film is the notion of looking,

observing and seeing across from the gazer... ."[41] One could also say, though, that the epicenter of the film is the way the camera functions in the equation $C = LM$. Hitchcock chooses to limit his absolute camera in *Rear Window*, only occasionally moving outside the apartment.

Sharff is correct in his statement that the windows that reveal bits and pieces of the characters' lives are actually "... frames for the screens of the small movies that are a part of the big film."[42] Hitchcock's camera records these movies, along with the reactions of the various characters who share the "observation" booth of Jeffrey's' apartment: Jeff, Lisa, Stella, and Detective Doyle. Hitchcock's absolute camera records the "small movies" of the characters who inhabit the Greenwich Village apartment from the distant vantage point of Jeff's apartment. This disciplined approach to camera placement seems to violate, somewhat, the Hitchcock Rule about the importance of an object being reflected in its size in the mise-en-scène. Of course, Hitchcock presents us occasionally with an enlarged view of a character via Jeff's telephoto lens: e.g. the medium shot of Thorwald wrapping knives and saws in newspapers. But for the most part, Hitchcock's camera stays at long shot or extreme long shot range as it observes the lives of Miss Torso, Miss Lonelyhearts, the dog-loving couple, the songwriter, and finally, and most importantly, the bickering Thorwald couple. Within Jeff's apartment, though, we see a different kind of mise-en-scene, with medium and close-up shots predominating as Jeff and Lisa try to figure out what has happened to Mrs. Thorwald, while at the same time they are trying to solve the problems in their own relationship.

Analyzing Hitchcock's mise-en-scène strategy in terms of the entropy theory might help us to understand Hitchcock's overall intention in *Rear Window*. In accomplishing the capturing of light in the process of recording cinematic shots, the Hitchcock workshop is engaging in a paradoxical entropy exercise. The twin arrows of spacetime preserve a state of low entropy in the artifact of the film. The various characters don't age with time, and the sets on the Paramount sound stage remain forever constructed and lit. In the art of the film, however—in the diegesis—characters' lives are in a state of high entropy: the "orderly arrangement" of their lives "will naturally trend toward increasing disorder," in Sean Carroll's words.[43] I believe this paradox is the essence of Hitchcock's cynical *Weltschmerz*. Truffaut says of Hitchcock's oeuvre, "In America, you respect him because he shoots scenes of love as if they were scenes of murder. In France, we respect him because he shoots scenes of murder like scenes of love."[44] In the world that Hitchcock creates in *Rear Window*, love will eventually lead to murder, as it does with the Thorwalds. The inevitable disorderliness of human affairs will undermine the relationship of the newlyweds, as they start bickering at the end of the

film. Miss Lonelyhearts is saved from suicide by the songwriter's creation of the "Lisa" song at the end of the film, but will each character's essential loneliness be enough to temporarily halt entropy? Miss Torso's Stanley finally arrives home from the army, but he seems more interested in food than in Miss Torso. The Thorwalds' apartment is being repainted, but it will eventually house a new bickering couple. Even Jeff and Lisa are not immune to such moral disorder: Jeff now has *two* broken legs, and Lisa has donned informal garb; but when she realizes that Jeff is asleep, she puts down her travel book and pulls out her *Vogue* magazine.

If we consider Jeff's apartment to be the primary spacetime of the film, we can understand why mise-en-scène predominates there. Hitchcock positions his camera so that the confines of the tiny apartment emphasizes Jeff's isolation—and his vulnerability. But there is another level of spacetime, and this is made up of the mini-films arranged around the courtyard. In this secondary level, montage does indeed play as central a role as mise-en-scène, for it is only Jeff's observations—and ours as well—that give meaning to these movies. For the most part, these are silent films; we—and the other spectators in Jeff's apartment—hear faint sounds and see lips move, but we essentially interpret the meaning of what we see from the actions we observe.

What Jeff sees—or thinks he sees—is what Hitchcock feared all of his life: the human potential for evil, even in innocuous looking apartments in the heart of a great metropolis. It is Hitchcock's great accomplishment that he captures this moral entropy through a major work of art that has withstood the ravages of time, thanks mainly to his absolute camera.

4

Two princes of Dark Energy

I'd like to begin this chapter with an extraordinary claim by the eminent physicists Stephen Hawking and Leonard Mlodinow in their book, *The Grand Design*:

> We each exist for but a short time, and in that time explore but a small part of the whole universe. But humans are a curious species. We wonder, we seek answers. Living in this vast world that is by turns kind and cruel, and gazing at the immense heavens above, people have always asked a multitude of questions: How can we understand the world in which we find ourselves? How does the universe behave? What is the nature of reality? Where did all this come from? Did the universe need a creator? Most of us do not spend most of our time worrying about these questions, but almost all of us worry about them some of the time.
>
> Traditionally these are questions for philosophy, but philosophy is dead. Philosophy has not kept up with modern developments in science, particularly physics. Scientists have become the bearers of the torch of discovery in our quest for knowledge.[1]

Hawking's controversial argument for the primacy of science in the quest for the answers to the big questions, in fact, was one of the props I used in formulating my approach in this study of science, technology and Hitchcock. I wish to point out, too, that Hawking's last sentence—"... the first sketches of the new concept can be traced back almost a century"—adds evidence to my claim of the key position of Hitchcock's birth in my equation, ABC/D. Harro Segeberg in an article from the anthology, *Film 1900: Technology, Perception, Culture*, says,

> If it can be convincingly argued that early cinema was to some extent related to what Einstein, Mach, and other revolutionary thinkers around

1900 were trying to show in their own way, then one could advance
the hypothesis that early cinema represented a decidedly rational...
but precisely calibrated (rather than arbitrary) aesthetics in which time and
space were no longer categories that are prior to perception, but organi-
zational forms of sensory experiences that were created in individual acts
of perception. Or, to put it differently and more concretely: Einstein's
"thought experiments" in connection with his theory that time and
space exist and vanish along with matter found a visual equivalent in film
projection, where imaginary spacetimes appeared and disappeared along
with their individual coordinates and objects.[2]

We have seen that the "early cinema" that Segeberg refers to provided the
seminal influences on the development of Hitchcock's "pure cinema." The
light tool that captured these imaginary spacetimes is the motion picture
camera, the letter A in my equation, which, as we have seen in the previous
chapter, paradoxically defies entropy in the creation of a cinematic shot but
also demonstrates the effects of entropy in the diegesis of the film.

I should like to add another scientific concept to the entropy theory I used
in discussing *Rear Window*: dark energy. This term was coined in 1998, when
two teams of astrophysicists studied the expansion of the universe through
observing exploding stars, or supernovae, and how they are moving. To the
surprise of the teams, the supernovae, which were supposed to measure
how much the universe was slowing in expansion, actually showed just the
opposite: the universe is expanding at an accelerating rate. In an article for
Smithsonian magazine, physicist Richard Panek says about this surprising
discovery, "The implication of that discovery was momentous: it meant
that the dominant force in the evolution of the universe isn't gravity. It is...
something else. Both teams announced their findings in 1998. Turner gave
the 'something' a nickname: dark energy. It stuck. Since then, astronomers
have pursued the mystery of dark energy to the ends of the Earth—literally."[3]
In his Great Courses Program entitled *Dark Matter, Dark Energy: The Dark
Side of the Universe*, physicist Sean Carroll points out that the present picture
of the universe that cosmologists subscribe to shows that the universe is
composed of five percent ordinary matter (planets, stars, galaxies, etc.),
twenty-five percent dark matter, and seventy percent dark energy. In short,
ninety-five percent of the universe is, as Carroll claims, "... this dark stuff, this
dark sector."[4]

If Hawking is correct in his assertion that scientists are the new standard
bearers of the quest for knowledge, film critics and scholars would be wise
to look at what modern science has said about the universe and apply that to
cinema. I tried to suggest such an application in my analysis of entropy in *Rear*

Window, and I should like to continue this process in my discussion of dark energy in Hitchcock's cinema. First, though, I'd like to return to Sean Carroll, who supports Hawking's position, in a way, by pointing out how humanities scholars can incorporate modern science into their heuristics. In his article "From Experience to Metaphor, by Way of Imagination," Carroll states,

> The responsibility of scientists is to discover how the universe works, but also to come back and let people know what they have discovered. Science does not sit apart from the rest of human activity; it is a craft carried out by ordinary people, and human beings themselves are inextricably part of nature. Science is an aspect of culture as surely as art or music. The universe, like our fellow humans, continually startles us with the fecundity of its imagination, and using what we have discovered about one of these remarkable phenomena to illuminate mysteries of the other is the most natural thing in the world.[5]

Carroll's last line could serve as the credo of this book, especially his mention of the "mysteries of the other" and of the application of scientific ideas to illuminate that mystery. This is exactly what I'll be doing in this chapter.

In laying the foundation of my approach to "dark energy" as a cinematic metaphor, I should like again to return to Einstein, perhaps the most famous physicist/philosopher of all time and to his *Annus Mirabilus*, 1905. At this time, the cinema was in its "childhood"—as was Hitchcock—six years old. In his *Annus Mirabilis*, Einstein produced five papers that would revolutionize physics and that would usher in the modern age. We've already looked at two of these, "Concerning an Heuristic Point of View Concerning the Production and Transformation of Light," which introduced the idea of light quanta, and ultimately quantum mechanics; and "On the Electrodynamics of Moving Bodies," which outlined the theory of special relativity and of spacetime and which served as the foundation of Einstein's general theory of relativity, with its picture of the curvature of spacetime. It was, in fact, this curvature theory that led to the discovery of dark energy as an explanation for the force that causes this curvature and the acceleration of the universe.

If we use dark energy as a metaphor, we can apply it to Hitchcock's pure cinema and to the diegesis that cinema creates. Cosmologists call it "dark energy" because it is invisible: it emits no light, but it exerts a force on the spacetime around it. The evolution of the theory of dark energy had its beginnings in a modest, cramped patent office in Berne, Switzerland, where Einstein, a third-class patent clerk, labored in relative obscurity. Einstein's biographer, Walter Isaacson, draws a fascinating picture of the young Einstein, in his early 20s, hurrying through his routine patent work so that he could

find time to indulge in his thought experiments. Isaacson quotes Einstein, "Whenever anybody would come by, I would cram my notes into my desk drawer and pretend to work on my office work."[6] This crammed desk drawer in a tiny office in a modest bureaucratic edifice in Switzerland would become the most famous space in modern science because, as Einstein claims, it was in "that worldly cloister where I hatched my most beautiful ideas."[7] At about the same time, across the channel, a very young Hitchcock, around age four or five, also had an experience in an enclosed space, but this was not an office, where "beautiful ideas" were hatched, but rather a jail cell, where Hitchcock had his terrifying experience.

The visual manifestation of this "moral fear" is the ubiquity of enclosed spaces in the mise-en-scène of Hitchcock's pure cinema. Like the jail cell, these spaces are filled with dark energy, with invisible forces of evil resulting from the essential naughtiness of human nature and causing human behavior to spin out of control. In *Rear Window*, I called this naughtiness "moral entropy," and it is associated in that film with enclosed spaces that symbolize the entrapment of the characters in their essentially fallen natures. Hitchcock's absolute camera captures entrapment through the use of apartment windows, which function as existential frames, from which characters labor to extricate themselves. Even in L. B. Jefferies' apartment, this dark energy has asserted itself through the immobilization of the main character, whose leg gets broken in the act of photographing a car race, emblemizing the hazards of capturing light on film. Hitchcock says of these small frames, "What you see across the way is a group of little stories that... mirror a small universe."[8] This universe is filled with dark energy. The nurse Stella says to Jeff: "I can smell trouble right in this apartment. You broke your leg. You look out the window. You see things you shouldn't. Trouble," to which Jeff replies, "Right now I'd welcome trouble." Of course the trouble does come in the form of murder perpetrated by Jeff's neighbor, Lars Thorwald, whom we see, mostly in miniature, trapped in the enclosed space of his tiny apartment with a nagging, invalid wife. Other characters, too, are trapped in their windows, Hitchcock being very careful to keep his absolute camera at a distance from their suffering: Miss Lonelyhearts and her attempted suicide; the childless couple whose beloved pet dog is killed by Thorwald; the songwriter whose "music block" causes agony and frustration; Miss Torso, who must fight off her amorous escorts; the newlywed couple, the husband of whom quickly tires of his wife's sexual demands; they end up quarreling at the end of the film—a potential Thorwald marriage?

In the climax of *Rear Window*, trouble does come to Jeff, who becomes the victim of Lars Thorwald when the latter attacks him in his darkened and claustrophobic apartment. Jeff tries to fend of Thorwald by flashing light

bulbs in his face, Hitchcock using the essence of cinematography—light—to literally save Jeff's life since the flashes delay Thorwald's attack just long enough for the police to arrive. The irony of the scene becomes obvious when one remembers that it was photography that almost took Jeff's life, when the race car spun out of control while Jeff was photographing it. In Thorwald's attack on Jeff, Hitchcock switches cinematic gears by presenting the attack in a jagged montage style of brief shots taken from various angles. The effect is what I call a "vortex of violence," which engulfs Jeff and almost destroys him. In the Eisensteinian montage style of the vortex, Hitchcock symbolizes violence as a circular figure that spins out of control, an accelerating universe of dark energy that perfectly embodies Hitchcock's moral fear of evil.

The two films that most effectively present dark energy as an embodiment of moral fear are *Shadow of a Doubt* (1943), and *Strangers on a Train* (1951). The two anti-heroes of these films I call "Princes of Dark Energy," for they personify the powerful destructive force of evil. In his interview with Truffaut, Hitchcock says about his villains, "The other day we mentioned a slogan: The better the villain, the better the picture. We might turn that around and say, 'The stronger the evil, the stronger the film'."[9] They are princes, too, because they occupy powerful antagonist positions in their respective films, sharing the major character role with an opposite character, almost like twin protagonists: Uncle Charlie and Little Charlie in *Shadow of a Doubt;* and Bruno and Guy in *Strangers on a Train*. The two films that contain these characters in the diegesis have similar patterns and characteristics that I should like to present before I discuss the individual films. First, and most importantly, the dominant mise-en-scène pattern of these films is constructed around enclosed spaces associated with the antagonists. In effect, Hitchcock uses his absolute camera to create a claustrophobic mise-en-scène that is filled with dark energy. In their groundbreaking study of Hitchcock's films, the French critics Rohmer and Chabrol claim, "Hitchcock is one of the greatest inventors of form in the history of cinema."[10] The form that Hitchcock uses in his mise-en-scène is characterized by light and dark contrasts, augmented by mostly eye-level but occasionally unusual camera angles, and chiaroscuro lighting effects. Just as in *Rear Window*, mise-en-scène precedes montage in Hitchcock's pure cinema formula. When montage is used, Hitchcock utilizes an Eisensteinian cutting style to present a vortex of violence that engulfs the characters.

The two Princes of Dark Energy embody a concept that Hitchcock borrowed from German Expressionism and that symbolizes the naughtiness of human behavior, the *doppelganger*, or double. When Hitchcock learned moral fear from his jailing and his religious upbringing, he recognized—and accepted—the dark side of human nature, or to extend the scientific metaphor, the

antimatter of human beings. This is how one tech-oriented Website defines this term: "Antimatter is any substance, that, when combined with an equal amount of matter, results in the complete and direct conversion of all substance to energy. Antimatter is composed of antiparticles. Each particle of matter has a corresponding antiparticle of antimatter."[11] Each Prince of Dark Energy functions as dark antimatter in the energy equation of the film. The corresponding protagonist (matter or particle) becomes entwined with the Prince of Dark Energy and is almost destroyed in a vortex of violence caused by the dark energy released when matter and antimatter combine. This scientific metaphor provides a new way of interpreting Hitchcock's most common theme: the "innocent" person wrongly accused of a crime, or its variant, an "innocent" who becomes enmeshed in the machinations of an immoral or amoral character. I employ quotation marks around the word "innocent" because, in Hitchcock's universe, no one is totally free from the effects of moral fear, "the fear of being involved with anything evil," in Hitchcock's own words. Even with Hitchcock's own brand of humor, one can detect this moral fear: "It has been said of me that if I made *Cinderella*, the audience would start looking for a body in the pumpkin coach."[12]

The first Prince of Dark Energy I'd like to discuss is Uncle Charlie from *Shadow of a Doubt* (1943), named many times by Hitchcock as his favorite film: "*Shadow of a Doubt* is my favorite because there is really a combination of character, suspense, and atmosphere" (Bouzereau 159). The character and atmosphere are powerfully presented in the scene that introduces Uncle Charlie. The scene begins with an exposition of six shots that move from an extreme long shot of a rundown urban setting, with a large bridge over a river, complete with junk cars on its bank; to a long shot of a city street with kids playing; and finally to a canted angle shot of a shabby building; and then to a final shot of a window in this building. Hitchcock once said, "All backgrounds must function,"[13] and this exposition is no exception. The final shot of a window functions as a transition to the interior scene that introduces Uncle Charlie.

Windows are ubiquitous in the films of Hitchcock, as we've seen in *Rear Window*. Why is Hitchcock drawn to windows? First, the shape of the window itself—like an inverted film frame—adds height to a largely horizontal space. Second, a window is a kind of portal or membrane that connects exteriors to interiors; consequently, the window can be an entrance point for Hitchcock's absolute camera. Third, the curtains, blinds, and shades that cover windows provide naturalistic lighting effects, particularly the venetian blind pattern of bars to suggest entrapment. Hitchcock utilizes windows in many of his films. We've seen the "silent" mini-films of *Rear Window*. Then there is the opening sequence in *I Confess*, during which the camera enters a window to reveal

a dead body and then retreats outside the window to execute a pan right to reveal the dark image of the retreating murderer. In *Psycho*, we first see the silhouette of the mysterious Mrs. Bates in a well-lit window through Marion's point of view.

In *Shadow of a Doubt*, the membrane window that connects outside to inside introduces a scene that shows the subtle power of Hitchcock's absolute camera. The scene is composed of eight shots that span 2:55 minutes, with an average shot length of 22 seconds. This relatively lengthy shot duration allows Hitchcock to establish a mise-en-scène that creates a realistic spacetime continuum and that uses the resultant setting to establish Uncle Charlie's character. In a brilliant article in the online journal *Senses of Cinema*, Murray Pomerance devotes a lengthy analysis to a single shot from *Notorious* (1946).[14] Before I analyze the interior scene with Uncle Charlie, I should like to summarize Pomerance's article because it makes important points about Hitchcock's mise-en-scène. Pomerance's major point is that a typical Hitchcock shot is *not* a part of a montage structure but actually a visual thought in itself. Pomerance begins his article with a statement that, in its own way, is as controversial as the Hawking quotation that begins this chapter: "As if to confound or dismember the conventional bromide that a shot is the essential building block of cinema, Alfred Hitchcock frequently arranges for his camera to record, and the screen to show, shots that are themselves complex filmic 'statements.' It is thus both essentialist and reductive and inane to think of Hitchcockian shots as simple assertions, edited together so as to produce ongoing and unfolding narrative revelations."[15] In itself, this is one of the strongest supports I've ever read for the primacy of mise-en-scène in Hitchcock's pure cinema. Pomerance also distinguishes between photographic shots and filmic shots. His definition of a filmic shot—"... it invokes the movement of images and the passage of time, our ongoing visual participation and our memory of movement and images seen before"—supports my contention that cinematic shots are embodiments of spacetime in their depiction of the arrow of time and of entropy in human affairs. As part of justifying his approach to mise-en-scène, Pomerance states, "Part of what has been lacking in Hitchcockian criticism—and, I might add, in film scholarship in general—is the conviction that an artist's thought can be visual...." Pomerance concludes his piece by saying of Hitchcock's mise-en-scène: "... a single shot can be extraordinarily rich with what one might call 'visual thought.'"[16]

The eight filmic statements, or shots, that comprise the boarding house scene vividly demonstrate Hitchcock's "visual thought" in action. In the opening shot, Hitchcock dissolves from the previous window shot into a long shot of Uncle Charlie's room, with the camera on the window wall and

Uncle Charlie, a study in incongruity

at the same level as the bed upon which we see Charlie lying. The camera is dollying in at the beginning of the shot and moves to a tight medium shot of Charlie on the bed; then the camera pans left to a close-up of a bed table with a glass and money on top and then tilts down to reveal an additional pile of money haphazardly strewn on the floor. Pomerance calls Hitchcock a "visual designer," and this trait is obvious in the way Hitchcock utilizes his absolute camera to reveal the visual thought of incongruity. The sparsely furnished room, with its overly ornate headboard, cheap quilt and bed table are in stark contrast to the elegantly coiffed and nattily tailored Uncle Charlie—he's wearing a dark, pinstriped suit—lying in repose while holding a cigar in one hand. Hitchcock and company—Joseph Valentine is his cinematographer— provide a chiaroscuro visual texture to the shot, with Uncle Charlie lying in shadows, while the reflection of the curtain blowing in the wind provides shifting light patterns on the wall above Charlie's bed. Hitchcock reveals a careful attention to details in his visual design of this shot: the reflection of the curtain is a reminder of the window through which the camera seemed to float, while at the same time the window—not visible to the viewer—is

the main source of light. The incongruity continues during the pan and tilt of the camera; the carelessly strewn money is obviously the source of Uncle Charlie's sartorial splendor, but the carelessness of the money's disposition shows Charlie's indifference to it. Hitchcock's choice to dolly, pan, and tilt reveals his reliance on a mise-en-scène approach to this shot; he certainly could have presented the same information through a montage technique of three interrelated shots, with simple cuts to preserve spatial continuity. However, Hitchcock decides instead to retain the spacetime integrity of the shot by fusing both the arrow of time and the arrow of space.

In the opening shot of the boarding house scene, Hitchcock uses light and motion to create a claustrophobic mise-en-scène. The low angle of the camera, combined with the confines of the narrow bed and the small room, suggests a feeling of entrapment, heightened by the incongruity between the character and the setting. The seven remaining shots in this scene reflect Hitchcock's classical orientation to scene construction. We've already discussed Hitchcock's early education in German Expressionism, with its reliance on visual storytelling and the unchained camera. We've also looked at another influence—just as powerful as German Expressionism—and that is his experiences at Famous Players-Lasky in the early 1920s, where he learned American methods of film production. In Chapter 3, I discussed what Hitchcock might have meant by "American-trained," and I should like to expand that discussion at this point to position the boarding house scene in the context of the Hollywood, or classical, style of filmmaking. During his "apprenticeship" at Famous Players and later at Islington Studios, Hitchcock was learning by a kind of osmosis what Annette Kuhn calls the "classical codes...a distinct set of expressive resources..." designed to create a "credible fictional world."[17] One could make the case that the classical style is also the Hollywood studio style, with its major goal of hiding or concealing the technology that makes cinematic shots, scenes, and sequences possible. Therefore, Hitchcock's American training was in a sense his deep immersion in this classical style.

We can see the influence of this style in the boarding house scene, with its avoidance of extreme angles, its naturalistic light sources, its invisible editing via straight cuts, and its reliance on the 180 degree rule, which Deborah Elliott describes in this way:

> The 180 Degree Rule is a product of the classical continuity style, which strived to make film "realistic" for the audience. It helps to maintain visual clarity and consistency in editing. It states that the camera must remain along the same plane in front of the characters. In any scene, an imaginary line can be drawn through the centre of the filming area, dividing it into

two equal parts....The camera must not extend past 180 degrees or out of its half of the circle....The 180 degree rule maintains continuity by allowing the viewer to absorb a sense of space and perspective. The viewer's special sense of the mise-en-scène will be disrupted if the camera moves all over or cuts to change our perspective. The 180 degree rule provides consistency for the viewer by minimizing the amount of space we see, allowing us to perceive quickly and to concentrate on a specific visual area. The 180 degree rule does not allow the artificial structure of cinematic space to be revealed.[18]

In the hands of a director like Hitchcock, the classical style preserves the twin arrows of spacetime and draws us into the diegesis of the film. As Pomerance states, a filmic shot in the classical style "... invokes the movement of images and the passage of time... ."[19] In the second shot of this scene, Hitchcock positions the camera on the opposite side of the bed, careful to preserve the architecture of the space by moving along the 180 degree arc.

At this point, it might be helpful to distinguish between the spacetime of a single shot, a "filmic shot," in the words of Pomerance, and the spacetime of two shots connected by a cut, dissolve, wipe, etc. The filmic shot is characterized by a spacetime that inextricably connects the arrows of time and space. If the first shot of the boarding house scene, which begins with a dolly and ends with a tilt and close-up of cash on the floor, were run backwards, starting with the close-up, the shot would end with a dolly backwards and a dissolve through the window to the last shot of the exposition. If however, we were to start with a long shot of Charlie lying in bed and end up with a close-up of the cash in three interconnected shots, the arrows of space and time would not necessarily be connected since the three shots could be rearranged in the editing process. Hitchcock, in fact, sees this montage technique as a decided advantage in film aesthetics. He frequently alludes to the Soviet Socialist Realism School, in particular to Kuleshov's experiments with editing, during which the arrangement of shots, not just the shots themselves, provides meaning and theme to a cinematic scene. We might then, distinguish between primary and secondary spacetimes: primary spacetime is captured in the shots oriented towards mise-en-scène, while secondary spacetime is the major characteristic of a montage approach.

There's a clear connection to physics here. In Einstein's theory of general relativity, he had to abandon the flat planes of Euclidean geometry and instead embrace the curved geometry of spacetime. In this kind of geometry, the shortest distance between two points is *not* a straight line but rather a curved line, a line across a sphere rather than a plane. The 180 degree arc is just such a curved line that allows the most efficient movement of the

camera within the scene. The second shot of the scene complements the first by having the camera view the space from the other side of Charlie's bed, on the other side of the arc. In this way, Hitchcock can introduce the second character in the scene—Mrs. Martin, the proprietor of the boarding house—who provides Charlie—she calls him Mr. Spencer—information about two visitors who are waiting for him outside.

The shots in the scene—except for #7, a point of view shot from Charlie's perspective—travel along the 180 degree arc in this pattern:

This alternating camera movement is carried out through unobtrusive cuts that keep the audience focused on Uncle Charlie. In terms of visual thought, shot 6 provides the audience with much to think about. Hitchcock's absolute camera is now on the same part of the arc as it was in shots 2, 4, and 5, and in the same position, slightly above the bed. The preceding shot, #5, is a tight medium shot of Uncle Charlie directly opposite the position of shot 3. At the end of the previous shot, shot 4, Mrs. Martin goes to the window, which had admitted the camera at the beginning of the scene, and she draws the shade. Shot 5 is a tight medium shot that shows the darkness descend upon Uncle Charlie. After Mrs. Martin leaves, he rises from the bed—one critic likens him to Dracula rising from his coffin—and shot 6 begins with the completion of the movement in shot 5, a subtle cut connecting the two shots and melding them into one seemingly continuous movement. Shot 6 is twenty-seven seconds long, and the surprising thing is that for at least twenty of those seconds, Uncle Charlie has his back turned towards the camera. Usually, in the classical style, the director stages the scene so that actors orient themselves to the camera in the quarter turn,[20] but Hitchcock eschews this positioning and instead focuses on Charlie's back from a below eye-level angle. Consequently with his dark suit and broad shoulders, Charlie towers over the audience, but faces away—an ominous presence, indeed.

As I was analyzing this scene, I came across a post on "The Society for Cognitive Studies of the Moving Image" Website. The post, written by Michele Guerra and Vittorio Gallese, is a response to this question from the cultural critic Steven Shaviro: "How can cinema have so powerful a reality

effect when it is so manifestly unreal?" The spirit of this question is similar to my remarks about the "mysterious power" of the cinema in the introduction to this book. In response to Shaviro, the commentators Gallese and Guerra make these comments: "The moving image is with no doubts the most sophisticated form of mediated intersubjectivity: the relationship we build with the characters, with the objects and the landscape which appear on the screen is very similar to the relationship we build in our daily life with people we interact with, objects we use and environments we inhabit... From the very beginning of film history, filmmakers have created a style that—like a sort of universal language—enables viewers not only to perfectly understand the meaning of what they are watching, but also to move within the space and time this style is able to build and simulate."[21] I would amend the above to read "... but also to move within *the spacetime* [my italics] this style is able to build and simulate." In effect, what Gallese and Guerra are describing is the classical style of scene construction, which has as its goal the clearest possible transmission of the film director's "visual thought." If we combine Pomerance's observations about Hitchcock's visual thought and design with Gallese and Guerra's comment about film audience's "perfectly understand [ing] the meaning of what they are watching," we can perhaps understand how and what Hitchcock is saying in shot 6. The shot begins with Uncle Charlie completing the movement begun in shot 5; he sits up and turns away from the camera. He then reaches over to the cheap bedside table, puts down his cigar, and picks up a glass. He tilts his head back, drains the glass, and looks to his left at the window (out of frame), presumably thinking of the men waiting outside. Suddenly he rises, and with a furious motion, throws the glass against the sink on the opposite wall, the glass shattering so violently that Charlie has to duck his head to protect his eyes from the shards. The shot concludes with Charlie moving towards the window, with the camera following and coming in for a profile shot in tight medium range. As he raises the window shade, the sunlight bathes his handsome profile in brilliant whiteness. In addition, the curtains provide a visual pattern of bars and diagonal lines that are reflected on Charlie's face. If Hitchcock's visual thought in this scene is, in addition to incongruity, entrapment, his visual design certainly underscores that idea. Uncle Charlie's furious outburst reflects his frustration with his predicament, while at the same time the vertical and diagonal lines created by the window sash, shade, and curtain, tend to reinforce his entrapment in the tiny apartment. The bright sunlight on his face also underscores his handsome profile and emblemizes Hitchcock's mantra about the "necessity" of making the villain a handsome man, else how would he get close to his victims? The scene concludes with two shots: one, the penultimate, is a POV shot looking from Charlie's window perch

down upon two men waiting on the opposite street corner. The last shot repeats the position of shot 6 and shows Uncle Charlie leaving his cramped room. The camera holds for a few seconds on the empty doorway, with the rectangular window reflected on the hallway wall.

Why does Hitchcock hold the shot in this way? Perhaps he wants his viewers to think about what they have just seen; for, after all, Hitchcock and company have just presented an extremely complex portrait of one of the film's main characters. Even though there is dialogue in the scene, mostly spoken by Mrs. Martin, the information—the thoughts—are presented visually, mainly through mise-en-scène. The montage is purely functional and serves to preserve the architectural integrity of the scene through almost invisible cuts. The visual thoughts that Hitchcock presents are incongruity, entrapment, and violence. The energy behind the furious explosion of glass against sink is certainly dark; its origins are unknown, mysterious, and frightening. The camera pauses on the last shot because Hitchcock wants to give us pause.

If we use dark energy as a cinematic metaphor, we can see how cosmology and cinema are related. The dark energy of the universe causes space to expand in a surprising way. Before dark energy was discussed and named in 1998, Einstein was struggling to incorporate the effects of gravity into his special theory of relativity; his solution to the struggle was to create a general theory of relativity, which theorized that gravity was actually the curvature of spacetime. The universe was not empty space but rather a bendable fabric that stretched and gapped due to the forces generated by the mass of objects, such as stars and planets. In other words, objects bend the fabric of spacetime and thus exert influence on objects around them. I should like to posit that Uncle Charlie, the Prince of Dark Energy, is just such an object in the spacetime of the diegesis of *Shadow of a Doubt*. Like the other Prince whom I'll discuss, Charlie bends the spacetime around him, causing other characters in that spacetime to react to his "mass," or his dark energy.

The social sciences have a similar concept articulated in the family systems theory of therapy. Dr. Murray Bowen, the founder of this therapeutic approach, believes that individuals cannot be understood in isolation from one another, but rather as parts of an organic whole. One Website describes the system in this way: "Members of the system are expected to respond to each other in a certain way according to their role, which is determined by relationship agreements. Within the boundaries of the system, patterns develop as certain family member's behavior is caused by and causes other family member's behaviors in predictable ways. Maintaining the same pattern of behaviors within a system may lead to balance in the family system, but also to dysfunction."[22] To describe one such dysfunction, family system

therapists have appropriated a theory from the physical sciences: entropy. If we recall this term from the discussion of *Rear Window*, we'll remember that entropy "... measures the 'disorderliness' of an object or conglomeration of objects...."[23] When a force such as Uncle Charlie enters a family system, as he does soon after he leaves the boarding house, he tends to increase the entropy of that system. In the Hitchcockian universe, such entropy is moral disorder, which unleashes forces—dark energy—that threaten to destroy the system.

I remember my wife taking me to a seminar on the family systems approach to therapy. To illustrate what happens to a family when one member behaves irrationally due to addiction or mental illness, the lecturer set up a mobile with six family member cutouts on balancing wires. In effect, the family members gently bobbed in a delicate balance of forces. Then, the lecturer attached a clothespin to the bottom of the father figure, and as the father got pulled down by gravity, the other family members bobbed up and down violently and gyrated. Everyone's position changed. This was a vivid example of the disruptive effect one member can have on the whole system.

The family systems theory supplements and reinforces the theory from physics that states that objects bend spacetime, effectively impacting other objects around them. When Uncle Charlie enters the Newton family system in the small town of Santa Rosa, he brings with him the dark energy of moral fear. In the energy quotient of the film, Uncle Charlie transfers this dark energy to his niece, Little Charlie. In this way, Hitchcock establishes his double theme, and he accomplishes this formally by juxtaposing the two exposition scenes in the beginning of the film. We've already seen the six-shot exposition that introduces Uncle Charlie. The second exposition is made up of the same number of shots—six—and they begin with an extreme long shot of a town nestled in a valley. In the next five shots, Hitchcock brings us closer to this town, eventually settling on one pleasantly situated house, and on a window of this house, shot with the same canted angle as the boarding house window. The mise-en-scène pattern of the two scenes is exactly parallel, and the next shot duplicates the one that presented Uncle Charlie: a dissolve into a below eye-level tracking shot showing a young woman reclining on a bed, but this time in a brightly lit, attractively furnished bedroom.

We know from a previous scene depicting Uncle Charlie sending a telegram to his sister Emma in Santa Rosa that this young lady must be his niece, Little Charlie. But this bit of plot information isn't really necessary because Hitchcock has made his *doppelganger* connection crystal clear through the linking of cinematic forms. In *Rear Window*, Hitchcock links cinematic forms through the repetition of window/mini movie screens. The

cuts connecting the windows to each other and to the interior space of Jeff's apartment are straight continuity cuts that establish a "credible fictional world,"[24] in the words of Annette Kuhn. The cuts that link the two exposition scenes in *Shadow of a Doubt* represent a different kind of montage, however. They are not parallel editing, per se, since there's no evidence that the two scenes are happening at the same time. Rather they represent an Eisensteinian technique, whereby scenes are connected intellectually rather than spatially. We'll see this same kind of editing technique in *Psycho*, in the famous eye-to-tub drain dissolve at the end of the shower scene. In creating a cinematic space rather than a spacetime, Hitchcock has moved beyond the "credible world" of the classical style into a filmic parallel universe that exists above and beyond the diegesis of the film. Hitchcock hints at this parallel universe in *Shadow of a Doubt* and *Psycho*, but he develops it fully—and brilliantly and profoundly—in his masterpiece, *Vertigo*.

In the remainder of the film, Hitchcock chronicles with frightening clarity the introduction of moral fear into Little Charlie's family and social systems, in the person of Uncle Charlie, the "Merry Widower Murderer." Hitchcock uses his favorite mode of transportation—trains—to bring Uncle Charlie into Santa Rosa, where Little Charlie and her family are awaiting his arrival. In perhaps an homage to the pioneering Lumière Brothers' short film, "Arrival of a Train at a Station," Uncle Charlie's train pulls into the station, belching clouds of black smoke. What an ominous arrival!

Throughout the remainder of the film, Uncle Charlie's presence bends the moral fabric of the Newton household, introducing murder into the family living room, "where it belongs," in Hitchcock's facetious but telling quip. In a series of scenes set in enclosed spaces, Uncle Charlie releases his dark energy into the world of Santa Rosa, about which Hitchcock says. "It may be her world, but it is not *the* world." I've noted above that Hitchcock said many times that *Shadow of a Doubt* was his favorite film, although to be fair one should note that he denied this to Truffaut. Hitchcock claims, "I wouldn't say that *Shadow of a Doubt* is my favorite picture; if I've given that impression, it's probably because I feel that here is something that our friends, the plausibles and logicians, cannot complain about...that impression is also due to my very pleasant memories of working on it with Thornton Wilder."[25] But clearly, *Shadow of a Doubt* was dear to Hitchcock's heart, and I should like to offer up a reason for this fondness based on the theory of dark energy. The moral fear that Hitchcock learned from his jailing experience and from his Jesuit education arises from an involvement with "anything evil." The catastrophic effects of such an involvement are stunningly portrayed in *Shadow of a Doubt*, the quintessential depiction of the effects of moral corruption on an American family. In my interview with physicist Sean Carroll, he says of the

structure of the universe: "... we live in a universe where most of the stuff is invisible, but it affects the visible stuff and pushes around the visible stuff." Uncle Charlie's "invisible stuff" is his dark energy, which because it emits no light, cannot be seen but it exerts a powerful force, nonetheless, by pushing "around the visible stuff." Carroll says, "...dark means not effectively interacting with light." If we take light here to be both scientific and mythical, Uncle Charlie's essential darkness puts him squarely in the mold of the most powerful Prince of Dark Energy, Satan. Hitchcock's Catholicism—and in a more comprehensive sense his Christianity—would have familiarized him with an essential characteristic of Christian thought: the attractiveness of evil, the powerful pull towards naughtiness in human behavior. The most powerful dramatization of Satan is in Milton's *Paradise Lost*, of which the critic David Daiches says of Satan and his doomed followers: "They represent the attractiveness of plausible evil."[26] The mystic visionary poet Blake claimed that Milton's *Paradise Lost* perversely and inadvertently made Satan the hero of the great epic poem, showing how his charisma makes him outshine the putative hero, Christ. Blake says in the "Marriage of Heaven and Hell": "The reason Milton wrote in fetters when he wrote of Angels & God, and at liberty when of Devils & Hell, is because he was a true poet and of the Devil's party without knowing it." One could claim, with good evidence, that Hitchcock was also of the "devil's party," but of course, unlike Blake's Milton, he knew it and in fact delighted in the creation of his Princes of Dark Energy. As Hitchcock famously said: "We are all criminals ... and we follow the Eleventh Commandment: 'Thou shall not be found out'."[27] Thus it is to Satan one turns when trying to comprehend the depths of Uncle Charlie's evil. Satan's association with darkness is described in Book I of *Paradise Lost*, where Milton introduces the vanquished Satan and his followers:

Him the Almighty Power
Hurl'd headlong flaming from th' Ethereal Sky
With hideous ruin and combustion down
To bottomless perdition, there to dwell
In adamantine Chains and penal Fire,
Who durst defy th' Omnipotent to Arms.
Nine times the Space that measures Day and Night
To mortal men, hee with his horrid crew
Lay vanquisht, rolling in the fiery Gulf
Confounded though immortal: But his doom
Reserv'd him to more wrath; for now the thought
Both of lost happiness and lasting pain
Torments him; round he throws his baleful eyes

That witness'd huge affliction and dismay
Mixt with obdurate pride and steadfast hate:
At once as far as Angels' ken he views
The dismal Situation waste and wild...(44–60)

Like Uncle Charlie, the fallen Satan is confined to...

A Dungeon horrible, on all sides round
As one great furnace flamed...(61–2)

The "lost happiness" in Milton's description of Satan's fall is echoed in Uncle Charlie's cynical lament of the superiority of the past to the present as he talks about the world of his parents: "Everybody was sweet and pretty then, Charlie. The whole world. A wonderful world. Not like the world today. Not like the world now. It was great to be young then."

When Uncle Charlie enters the Newton household, his attractiveness draws the characters to him and upsets the delicate balance of the family system. In the most general terms, the Newton home becomes a hiding place for a mass murderer. So the space of the household itself becomes compromised and dangerous, full of dark energy. At the dining room table, for example, Uncle Charlie distributes expensive gifts to the members of the Newton family—gifts bought with the money he has stolen from his murder victims. One of these gifts is a ring for Little Charlie, which Uncle Charlie presents to his niece as if it were an engagement ring. There's no denying the sexual attraction that Little Charlie feels for her Uncle and vice versa; and Hitchcock and his scriptwriter, the great playwright Thornton Wilder, deepen and develop the sexual connection between the two characters by having Uncle Charlie move into Little Charlie's bedroom and into her bed, while Little Charlie moves into her little sister's bedroom. One should recall at this point that Uncle Charlie and Little Charlie are introduced by shots of them in bed, in the same position. In addition, Little Charlie accompanies her Uncle in his trips to Santa Rosa, holding his arm and looking lovingly and adoringly at him. She says to him, "I love to walk with you! I want everyone to see you." The ring that Little Charlie reluctantly accepts from her Uncle turns out to be jewelry from one of Uncle Charlie's victims. Uncle Charlie's offering of a ring to Little Charlie triggers this extraordinary declaration from her: "Oh, I'm glad that [my mother] named me after you and that she thinks we're both alike. I think we are, too. I know it. We're not just an uncle and niece; we're something else... we're sort of like twins, don't you see?" The hint of incestuous desire and transgression adds to the corruption and evil of Uncle Charlie's dark energy. Uncle Charlie's dark energy also affects the other characters in the Newton

household. Joe Newton, Little Charlie's father, plays seemingly innocent murder games with his next-door neighbor, Herb, each one trying to outdo the other in creating the perfect murder. At the same time, Uncle Charlie makes real the imaginative murders of Joe and Herb; he decides that Little Charlie knows too much about him and thus must die. He tries to kill her two different times in the Newton home, once on the outdoor stairway, and once in the garage. Ignorant of their part in harboring the lethal Uncle Charlie and facilitating his murderous plan, the Newton household provides him safe haven and thus protects him—and encourages him: through Joe's work at the local bank, Uncle Charlie has chosen his next victim, the wealthy widow, Mrs. Potter.

Uncle Charlie also bends the spacetime of Santa Rosa itself. He makes a substantial deposit $440,000.00—in Joe Newton's bank; he is invited to address the local women's club; he makes a monetary gift to the creation of a children's hospital; the local minister says to him, "We feel you're one of us"; finally, he is eulogized in a huge funeral, attended by most of the Santa Rosa residents. The irony, of course, is that only Little Charlie and her policeman boyfriend, Jack, are aware of Uncle Charlie's true nature. Thus dark energy not only permeates the world of Santa Rosa but it also remains largely invisible. Little Charlie's sweetheart, Jack, tries to explain Uncle Charlie to her: "The world's all right. It just goes a little crazy sometimes, just like your Uncle Charlie." We'll hear similar words in *Psycho*, when Norman tries to explain his mother's behavior to Marion.

The turning point in the film occurs in the dark, smoky "Till-Two" bar, where, in the claustrophobic darkness, Uncle Charlie reveals himself to his niece, imparting his fatal secret that he is indeed the Merry Widow Murderer. This is the darkest interior scene in the film, "a dungeon horrible," in Milton's words; for this place is Uncle Charlie's twisted mind, the source of his dark energy. Uncle Charlie says to Little Charlie: "You're just an ordinary little girl in an ordinary little town… At night you sleep your ordinary, untroubled little sleep filled with peaceful, stupid dreams. And I brought you nightmares. You live in a dream. How do you know what the world is like? Do you know that the world is a foul sty? Do you know if you rip the fronts off houses, you'd find swine?" Uncle Charlie finishes this diabolical speech with a statement that sums up his nihilism and that connects him again to the greatest of all nihilists—Satan: "The world is a hell! What does it matter what happens in it?"

In presenting Uncle Charlie as an attractive, but at the same time, abhorrent co-protagonist, Hitchcock is raising profound questions about the mystery of evil. Little Charlie's explanation of her uncle's behavior—"He hated the world"—is inadequate; it does not explain the source of this hatred. Little Charlie's mother, Emma, relates the story of Uncle Charlie's boyhood bicycle

Little Charlie and Uncle Charlie: a transfer of dark energy

accident, which resulted in a fractured skull and which led to a personality change in the young boy. However, this is a physiological change, not a moral one. Milton's explanation—*felix culpa*—"the fortunate fall"—makes sin the supreme test of moral choice: man is morally better off in the fallen state, for then he is able to choose the good. But this does not answer the question of why he would choose the evil. Milton's overall intent in *Paradise Lost*—to "Justify the ways of God to Men"—finds a parallel in the overriding intent of physics and cosmology—"to explain the laws of the universe to man." There is a further parallel: The moral conundrum of the attractiveness of evil and of the dark side of human nature finds an echo in the inability of science to explain a fundamental force in nature. Brian Greene says of dark energy in *The Hidden Reality: Parallel Universes and the Deep Laws of the Cosmos:* "'Dark' also describes well the many gaps in our understanding. No one can explain the dark energy's origin, fundamental composition, or detailed properties... ."[28]

Near the end of the film, Uncle Charlie has "transferred" his dark energy to his niece; in the physics metaphor, Uncle Charlie's antimatter combines with

Little Charlie's matter to convert their substances to destructive energy. After it appears that the Merry Widow Murderer has been apprehended, Uncle Charlie decides to stay in Santa Rosa, even though Little Charlie knows that he is the real murderer. On the dark porch of the Newton house, with both characters bathed in darkness, Little Charlie threatens Uncle Charlie: "So go away, I'm warning you! Go away, or I'll kill you myself!" In one of the great ironic twists in all of Hitchcock, Little Charlie makes good her threat against her uncle. She succeeds in outmaneuvering him on the moving train as he tries to throw her off: she ends up throwing him off instead, directly in the path of an oncoming train. Hitchcock and his editor Milton Carruth cut this scene in an Eisensteinian montage style that creates a vortex of violence that engulfs both characters. The brief scene is a direct culmination of the violence we first observed in Uncle Charlie in the boarding house scene, where he shatters a glass in the sink. In the train scene, the characters are again in a claustrophobic setting in a railroad car. Uncle Charlie pursues his niece, grabs her, and enfolds her in a violent embrace with his powerful hands, hands that he used to strangle his victims, perhaps Hitchcock's favorite way of dispatching his characters. At this point, it would be helpful to remember Truffaut's remarks about Hitchcock's absolute camera: "... he shoots scenes of murder like scenes of love." The scene lasts only 1:47 minutes and is made up of twenty-seven shots, averaging about 4 seconds apiece, an accelerated editing pace that seems to keep up with the accelerating train. Hitchcock creates a vortex of violence by fragmenting the space in a series of quick cuts taken from different angles and focal lengths. The effect is to engulf the characters—and the audience—in a swirl of murderous dark energy.

Eight years after *Shadow of a Doubt*, Hitchcock would create another Prince of Dark Energy, this one perhaps more lethal, more disturbed, and more dangerous than Uncle Charlie: Bruno Antony in *Strangers on a Train* (1951). Although I hold in Chapter 4 that *Rear Window* initiated Hitchcock's greatest period of filmmaking, one could also claim, with good reason, that this period begins two films earlier, with *Strangers on a Train* (1951), followed by *I Confess* (1952), the latter being a favorite of the French New Wave directors, Claude Chabrol and Eric Rohmer. One very good reason for considering Hitchcock's greatest period to encompass 1951–64 (*Strangers on a Train* to *Marnie*) is that Hitchcock's most important collaborator, cinematographer Robert Burks, began his work with Hitchcock on *Strangers on a Train* (1951). Burks shot all of Hitchcock's greatest films in this period, except for *Psycho*, which was filmed by John Russell.

In presenting Bruno Antony as a Prince of Dark Energy, Hitchcock and Burks create a masterful mise-en-scène, in which enclosed spaces filled with dark energy predominate. In addition, the *doppelganger* motif is introduced

in a pattern similar to *Shadow of a Doubt*, but with one major difference. The two exposition scenes introducing Uncle Charlie and Little Charlie take place in a cinematic space, rather than in a spacetime. In other words, the connection between the two scenes is not in contiguous spaces within the diegesis of the film but in an aesthetic space, what Segeberg means when he describes a film "... aesthetics in which time and space [are] no longer categories that are prior to perception, but organizational forms of sensory experiences that [are] created in individual acts of perception."[29] In *Strangers on a Train* the scene that introduces the two *doppelganger* characters takes place in the contiguous spacetime of an actual location, the sidewalk outside of the Washington, D.C., Penn Station, where two taxis deposit two characters who walk into the station. Hitchcock, Burks, and editor William Ziegler create an incredibly economical opening scene that introduces the two main characters, suggests some of their personal characteristics, presents the film's themes, and initiates the major plot line—all in 2:15 and twelve shots! Hitchcock chooses an unusual and somewhat disorientating location and angle for his absolute camera—just a little above the sidewalk— so that we see only the characters' legs and feet. In the first seven shots, Hitchcock cuts back and forth between the feet of the two characters as they leave their cabs and walk towards the station. In alternating shots, Hitchcock shows one set of feet, in striped trousers and two-tone dress shoes, walk from the right side of the screen to the left; and in the next shot, another set of feet, shod in plain shoes, walk from the left side of the screen to the right. In having the characters walk toward each other, but in separate shots, Hitchcock suggests that there is something drawing the characters towards one another. If both characters were shown in the same shot, their movement toward one another could be arbitrary, unstructured. However, by cutting the shots together, in parallel editing fashion, Hitchcock says something very structured and non-arbitrary: spacetime is being bent by the characters' inexorable movement towards one another. The last two shots of this opening scene show the two characters being brought into physical contact with one another: One character accidentally kicks the shoe of the other as they both settle into a table in the railroad car. It is as if the foot is drawn into the other character's dark energy orbit.

This opening scene shows the power of Hitchcock's absolute camera in several key ways. The first shot is a long shot of the exterior of the train station: the arched entrance in the background of the shot reveals a somewhat misty and obscured image of the Capitol. The credits run over this opening shot, and when they are finished a cab enters the arch and pulls up next to the camera, which dips down to a low angle. The first set of legs and shoes gets out of the cab. The way Hitchcock creates this shot is to suggest that the cab is drawn

inexorably to the camera. In addition, it seems to materialize from the misty Capitol Building in the background. In *Shadow of a Doubt*, Uncle Charlie's dark energy subverts the moral climate of a single town: Santa Rosa. In *Strangers on a Train*, however, the stakes are greater. The looming Capitol suggests that the story will unfold in the Washington, D.C., setting, where Bruno, the Prince of Dark Energy, is a member of a wealthy and influential family. Moreover, his unsuspecting double, Guy Haines, is seeking a divorce to marry the daughter of a prominent senator. When Bruno draws Guy into his murderous plot, the moral fabric of the nation's capital is bent and twisted.

Perhaps the most subtle shot in this opening scene occurs two-thirds into the scene—in shot 8—which is positioned on the front of the train as it pulls out of the station. What we see seems innocuous at first: sets of railroad tracks woven together and crisscrossing in the switching yard. Because Hitchcock positions his camera on the train engine, the viewer's point of view becomes that of the train itself as it crosses over several interwoven tracks and eventually settles on one set of rails. Why does Hitchcock include this shot in the economically structured opening scene? It comes right after a shot, again from a low angle, that shows the backs of passengers, including our two sets of legs and shoes, as they enter the train station. We have not seen the characters' faces, only their contrasting clothing and two tennis rackets that belong to the second set of shoes. In his *Masters of Cinema* volume for Cahiers du Cinema entitled *Hitchcock*, Krohn states, "*Strangers on a Train* begins with a metaphor for cinema much favored by Hitchcock...a moving train."[30] I'd like to explore the implications of Krohn's provocative claim about trains not only in Hitchcock's work but in Einstein's as well.

In my equation, C=LM, the letter M stands for motion, and it is certainly true that Hitchcock was drawn to trains because they move. There is something pleasing about kinaesthesia, "... the sensation by which bodily position, weight, muscle tension, and movement are perceived."[31] Of course, this perception of movement can be primary—that is, one can actually board a train and experience the pleasure of moving—or secondary—one can watch a film of a train and experience movement aesthetically, in much the same way the audience did for the Lumière Brothers' first film showing in 1895. The paradox, of course, is that the seated film viewer is in a fixed frame of reference, as is the screen he is observing. However, within that screen, motion takes place on several levels, the most obvious being the movement of the camera and its frame, through panning, dollying, tilting, etc.; and also movement within the visual field that the camera frame covers: vertical, horizontal, and diagonal movement of characters and objects. The train, then, is a fixed frame of reference when the action takes place within it, as it does

in the beginning of *Strangers on a Train*. But like the film frame itself, the railroad car has its own levels of motion: there's motion within the confines of the coach itself, and then there's movement of the coach through space as viewed through the windows of the coach. So if one were sitting in a movie theater watching *Strangers on a Train* in 1951, one could experience at least five dimensions of movement: the motion of the frame if the camera were dollying; the motion of the actor if he were moving along with the camera; the motion of the train along the tracks; and the motion of characters and objects as seen through the window. No wonder Hitchcock loved to use trains as film sets!

In terms of "pure cinema," the train represents the perfect opportunity to present a claustrophobic mise-en-scène. The characters' movements are restricted not only by the confines of the individual railroad cars, but also by the number of cars constituting the train itself. In addition, unlike other vehicles, a train cannot stop and start easily or conveniently, so a character becomes "trapped," as it were, in the spacetime of the railroad car and by the characters within it. A train moves within a fixed spatial dimension limited by the tracks it must move upon. A set of railroad tracks resembles a strip of film; both have standard gauges and prescribed movement: a train on the tracks and a film through the gates of a projector. A reel of 35mm film contains the potential of past, present, and future within the individual frames; a train travels through spacetime in a fixed route and on a strictly controlled timetable.

Einstein was fascinated by trains for many of the same reasons that Hitchcock was. In an interview for the journal *Daedalus*, physicist Peter L. Galison, author of *Einstein's Clocks, Poincare's Maps*, says of Einstein, trains, and relativity:

Only by criticizing the foundational notions of time and space could one bring the pieces of the theory—that the laws of physics were the same in all constantly moving frames; that light traveled at the same speed regardless of its source—into harmony. And this is where the trains and clocks enter. Suppose, Einstein reasoned, that you wanted to know what time a train arrived in a train station. Easy enough: you see where the hand of your watch is at the time the engine pulls up alongside you. But what if you wanted to know when a train was pulling into a *distant* station? How do you know whether an event here is simultaneous with an event there? Einstein insisted that we need a simultaneity-fixing procedure, a definite system of exchanging signals between the stations that would take into account the time it took for the signal to get from one station to another. By pursuing this insight, Einstein discovered that two events that

were simultaneous in one frame of reference would not be simultaneous in another. Moreover, since a length measurement involves determining the position of the front and back object *at the same time*, the relativity of simultaneity meant that *length* was relative as well. By removing the absolutes of space and time, Einstein restructured modern physics.[32]

There are other train connections as well in the conception of *Strangers on a Train*. Hitchcock was on a California-bound train after the East Coast previews of *Stage Fright* when he began to read Patricia Highsmith's novel *Strangers on a Train*. On the train with him was his wife and long-time collaborator, Alma, and another reliable collaborator, Whitfield Cook. Hitchcock's biographer Patrick McGilligan describes what happened on that train trip: "It was on the train back to California that the director was reading a new book by a first-time author Patricia Highsmith. He was accompanied by Mrs. Hitchcock and Whitfield Cook, who passed around the galleys. Highsmith's story concerns two people who meet accidentally on a train. One is a psychopath who enunciates his theory of a perfect crime: swapping murders with a total stranger. Turning the pages of the new book excitedly, the three Hitchcocks began to talk about how easily *Strangers on a Train* could be transformed into another run-for-cover crime film, ... The screen rights wouldn't be very expensive, for Highsmith was still an unknown commodity—and the story would lend itself to being photographed in black and white...."[33]

So when Hitchcock includes a shot from the train's point of view in the opening scene, he is suggesting that the train will play a significant role in the film. In effect, the train becomes a character in the film by standing in for the director. If we analyze the mise-en-scène of shot 8, we notice that directly in front of the train as it pulls out of the station is a juncture of two sets of tracks; they crisscross. As the train moves towards the juncture, we wonder which set of tracks the train will "choose." The idea of choosing—of making moral choices—is central to Hitchcock's cinematic credo, for choosing goes to the very heart of Hitchcock's fear of evil, of choosing the bad over the good. The crisscrossing of the railroad tracks is also a visual symbol not only of the criss-cross plot that Bruno hatches with Guy—which we'll discuss presently—but also of the doubles theme that is introduced in the opening scene of the film.

Strangers on a Train is structured around doubles: two taxis arrive at Penn Station; two sets of legs emerge; one character owns two tennis rackets; two characters meet accidentally as two feet touch one another; one of the characters, Bruno, orders double whiskeys; Guy's lighter features two crossed tennis rackets; two murders are plotted on the train, etc. Consequently, the doubling functions thematically and structurally: on the thematic level, the double allows Hitchcock to explore both the transfer of dark energy from

antagonist to protagonist, as well as the powerful attractiveness of evil. In the structural level, the doubling of settings, actions, and characters gives Hitchcock a plot pattern for the narrative. Of structure in his films, Hitchcock says, "Construction to me, it's like music. You start with your allegro, your andante, and you build up. Don't forget even a symphony breaks itself into movements, but a motion picture doesn't. The nearest form to it is the short story. You've got to take it in at one sitting…that's why the motion picture is the nearest in its shape to the short story."[34]

One of the most significant scenes in the film—analogous to the boarding house scene in *Shadow of a Doubt*—occurs shortly after Bruno and Guy meet as the result of an "inadvertent" shoe collision. Bruno invites Guy to dine with him in his compartment since the dining car is full. Guy reluctantly accepts the invitation, and the "infernal machine" of the plot is triggered as inexorably as a train runs along fixed tracks. The scene is 4:20 long and is composed of thirty-six shots, with an average length of 7 seconds, considerably shorter than the average shot length in the boarding house scene. At first glance, the train compartment scene looks like a standard two-character dialogue, with several over-the-shoulder shots and individual close-ups of speaking characters. However, to assume this would be to underestimate the power and subtlety of Hitchcock's absolute camera. In their interview, Hitchcock explains to Truffaut his objections to the standard practice of photographing a dialogue scene: "In most pictures, when two people are seen talking together, you have a close-up on one of them, then a close-up on the other, then you move back and forth again, and suddenly the camera jumps back for a long shot, to show one of the characters rising to walk around. It's wrong to handle it that way."[35] I should like to return to Pomerance's claims about Hitchcock's visual thoughts as embodied in filmic statements. In *Shadow of a Doubt*, Hitchcock presents a mise-en-scène of incongruity, entrapment, and violence. In *Strangers on a Train*, however, he presents a mise-en-scène with one overriding visual thought: seduction. That the seduction is between the two male lead characters underscores the subversiveness of Bruno's dark energy.

When *Strangers on a Train* was being made, 1950–1, Hollywood was still in a panic about the House Un-American Activities Committee hearings and their investigations into the "subversive" activities of Hollywood liberals. These activities were not only political; they were sexual as well. Here is an example from the *Congressional Record* of March 29–April 24, 1950. Representative Miller of Nebraska is speaking:

Mr. Chairman, I realize that I am discussing a very delicate subject I cannot lay the bones bare like I could before medical colleagues. I would like to strip the fetid, stinking flesh off of this skeleton of homosexuality and tell

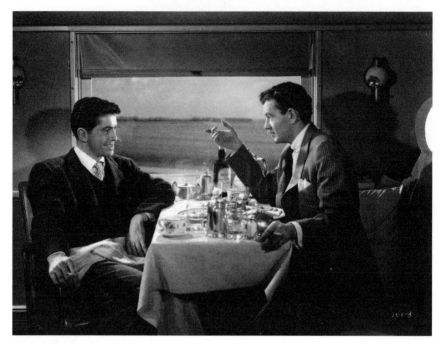

Guy and Bruno, a dark seduction

my colleagues of the House of the facts of nature. I cannot expose all the putrid facts as it would offend the sensibilities of some of you...Make no mistake: several thousand, according to police records, are now employed by the Federal Government...You must know what a homosexual is. It is amazing that in the Capital City of Washington we are plagued with such a large group of those individuals...The sex crimes in the city are many.[36]

In the film culture of the early 1950s, homosexuality was one of the most powerful taboos. It is strongly condemned by the ubiquitous and powerful Production Code, which states, under the category of Sex: "The sanctity of the institution of marriage and the home shall be upheld. Pictures shall not infer that low forms of sex relationship are the accepted or common thing."[37] So when Bruno invites Guy to his compartment, after they have had a drink together, it seems very much like an invitation to intimacy, strengthened by Bruno's openly flirtatious solicitation of Guy, including moving across the table, taking Guy's hand in his, and sitting extremely close. In one of these shots—a close-up of Bruno—Hitchcock and Burks create a lighting pattern featuring venetian blind shadows across Bruno's face. These shadows add a

sinister appearance to Bruno and create a visual pattern that will be repeated in the transfer of guilt scene later in the film.

Bruno's latent homosexuality can be seen as a direct threat to Guy's masculinity, but in keeping with Hitchcock's oft-repeated credo—"Everything's perverted in a different way"—he casts Farley Granger as Guy, knowing full well of Granger's homosexuality. Several years earlier, Hitchcock had cast Farley Granger in *Rope* (1948). In *Behind the Screen: How Gays and Lesbians Shaped Hollywood 1910–1969*. William Mann writes:

> Much has been written already about the gay subtext of *Rope*, a subtext so apparent it is practically a misnomer. Suffice it to say here that for screenwriter Arthur Laurents, it was the defining characteristic of all three major roles in the film, and served as the tension underlying all the action. He didn't shy away from the subject matter, and neither did the film's stars, Farley Granger and John Dall. Neither, for that matter, did Hitchcock. 'The actual word *homosexuality* was never said aloud in conferences on *Rope* or the set.' Laurents remembered, 'but [Hitchcock] alluded to the subject so often—slyly and naughtily, never nastily—that he seemed fixated if not obsessed.'[38]

This obsession might be explained by an incident that Hitchcock authority Ken Mogg includes in his *Senses of Cinema* profile of the director: "To gay actor/screenwriter Roger Ackland (*Number Seventeen*) he confided: 'You know, if I hadn't met Alma at the right time, I could have become a poof [a homosexual].'" Mogg comments, "There's no reason to doubt it."[39]

So if seduction is the major visual thought of the compartment scene, as I claim it is, then Hitchcock presents us *not* with a standard two-character scene but rather with a subtle, multi-layered scene featuring Bruno propositioning Guy, in much the same way as Uncle Charlie "proposes" to Little Charlie, using a ring stolen from one of his victims. In terms of dark energy, Bruno's powerful sexual presence bends the spacetime of the compartment, drawing Guy into the orbit of his diabolical plan to swap the murder of his father with that of Guy's wife—"crisscross"! The first shot of this seduction scene features an unusual camera angle; Hitchcock and Burks situate their absolute camera in the fourth wall position, at a low angle that corresponds with Bruno's prone position in the mise-en-scène. Hitchcock stages the shot so that Bruno's crossed feet dominate the shot since they are in the foreground.

In the background is the train window, through which we see the scenery streaming by. In terms of relativity, Hitchcock suggests that the "transaction" occurring in Bruno's compartment is in a different moral realm from that

of the outside world. Perhaps the fact that trains run on their own "moral" tracks is why Hitchcock uses them as cinematic metaphors. Einstein's special theory of relativity—"that two events that were simultaneous in one frame of reference would not be simultaneous in another,"—thus finds a cinematic parallel in *Strangers on a Train.*" Burks lights this first shot so that Bruno's feet are shadowed and comparatively large; they are an ominous reminder of the *doppelganger* theme and of the plot structure of crossing and crisscrossing. In this way, the crossed feet continue the visual motif of crossed tracks from shot 8 in the opening scene. The low angle and the oversized crossed feet add to the claustrophobic feel of the tiny train compartment. There is literally no escaping for Guy from the spacetime of Bruno's distorted world. By placing the camera on the same level as Bruno, Hitchcock, and Burks create identification between the audience and Bruno, slyly insinuating the spectators into his diabolical plot. Clearly, like Milton and Satan, Hitchcock is of the "Devil's party" in this scene. Fully two-thirds of the shots are devoted to Bruno; when we see Guy, it is from Bruno's point of view. In addition, Hitchcock presents Bruno in the director's typical antagonist characterization: handsome, charming, disarmingly self-deprecating, stylishly dressed—and very clever. On the MacGuffin Website, editor and Hitchcock scholar Ken Mogg discusses Hitchcock's "objectivity." Mogg references contributor JG, who analyzes the director's "dualistic approach to character and story, his ability to explore and blend numerous viewpoints." Mogg alludes to Keats' claim that Shakespeare's "negative capability," allowed him to "enter imaginatively into the very being of a fellow-creature."[40] Mogg attributes this same ability to Hitchcock's characterizations. If we couch these ideas in terms of dark energy, Hitchcock's ability to enter sympathetically into characters like Uncle Charlie and Bruno is partly the result of Hitchcock's own attraction to "anything evil" and partly recognition of the way evil warps and bends the spacetime of the scene.

The second shot of the scene features a mise-en-scène rich in thematic and structural overtones. It is a close-up of Bruno, but his face is not the dominant contrast; rather, in front of his face, on the dining table, sits an oversized lighter with crossed tennis rackets and engraved initials: "From A to G." Hitchcock and Burks choose a wide angle lens to give prominence to the lighter, which becomes a MacGuffin in the film. Ken Mogg defines the MacGuffin in this way: "The term MacGuffin was coined by Hitchcock's Scottish friend, screenwriter Angus MacPhail, for something that sets the film's plot revolving around it. It's really just an excuse and a diversion."[41] Hitchcock made many comments about the MacGuffin in his films, usually warning that the plot device is really nothing, especially to the audience.

I'd like to suggest, however, that the lighter becomes more than a MacGuffin in *Strangers on a Train*. It's more of a cataphor, which according to suspense theorist Hans Wolff is "...an advanced reference signaling some event or action that could occur later in the story."[42] (*Knight and McNight* 108–9). In their essay on Hitchcock's suspense, Knight and McKnight call cataphors, "future directed narrative cues,": they distinguish between object cataphors, such as Guy's lighter and Uncle Charlie's ring; and thematic cataphors, which help to frame our understanding of the dangers that threaten protagonists under conditions of uncertainty."[43] Bruno's seduction of Guy in the train compartment would certainly qualify as a thematic cataphor. The oversized lighter, then, is an object cataphor that will play key roles in the unfolding of plot and character in the rest of the film. In fact, the last shot of the compartment scene shows Bruno pocketing Guy's lighter, which the latter had left in his haste to exit. Within little over four minutes, Hitchcock has created a scene in which Bruno presents his outrageous proposal for swapped murders—"You do my murder; I do yours"—and secured Guy's agreement—"Sure, Bruno. Sure!" Earlier in the scene, Bruno says to Guy, "Oh, we do talk the same language, don't we?" to which Guy responds, "Sure, Bruno. We talk the same language." Although Guy is obviously being facetious and ironic here, his admission to speaking the same language as Bruno has the same thematic reverberation as Little Charlie's claim about her and Uncle Charlie: "We're sort of like twins, don't you see?" Just as Uncle Charlie's dark energy has bent the familial connection between him and Little Charlie—from niece to sister—so, too, has Bruno's proposition warped the relationship from strangers to murderous and erotic bedfellows.

Bruno's dark energy manifests itself in the scene in which he carries out his half of the murder pact with the unsuspecting Guy. The Leeland Lakes Amusement Park scene, during which Bruno murders Guy's estranged and pregnant wife, is largely without dialogue and lasts 10 minutes, featuring Bruno stalking and then strangling Miriam on the ironically named Magic Isle. Just as in the compartment scene, Hitchcock situates his absolute camera so that the audience's point of view becomes that of the psychopath Bruno as he follows Miriam and her boyfriend and flirts with her. The whole scene is cloaked in darkness, punctuated by the glaring lights of the amusement park. When Bruno follows Miriam and her amorous entourage across the lake to the Magic Isle, he is in a boat appropriately named Pluto, the legendary god of the underworld. Bruno dispatches Miriam to this underworld in a series of shots that shows the brilliance of Hitchcock's absolute camera. As Miriam runs around the embankment of the Magic Isle, laughing and screaming in an erotic touch-and-go with her boyfriends, she approaches the camera and turns to a full-faced close-up. Suddenly, from the right of the frame, a

hand is thrust into the frame, holding Guy's lighter. The gloved hand flicks the lighter, and light floods Miriam's face and reflects in her thick glasses. An off-camera voice asks softly, "Are you Miriam?" to which the surprised Miriam answers, "Why, yes. How did you...?" Her question is dramatically cut off as a dark figure, shown from the shoulders up, steps in front of her—and us—back turned, and begins to strangle Miriam, whose glasses fall off in the violent assault. We see Bruno only from the rear as he strangles Miriam. It is a startling character placement because what Hitchcock is suggesting is that Bruno is a stand-in for the audience. Bruno has drawn us—as well as Guy—into his orbit with his dark energy. The next shot—a continuation of Miriam's strangulation—is a stunning, expressionistic depiction of the killing, reflected in the distorting lens of Miriam's fallen glasses. It is one of Hitchcock's most remarkable shots: as Bruno strangles Miriam, she falls over, and he guides her body to the ground, removing his hands from her throat. His hands, reflected in the concave lens, extend like claws, very much like the lobster claws on Bruno's tie. When Hitchcock says, "The camera has a language all its own," this is surely a sterling example. Hitchcock situates his camera so that Miriam seems drawn to it, pulled in by the warped spacetime surrounding Bruno. When Hitchcock cuts to the strangulation reflected in the thick lens of Miriam's glasses, it is as if he jumped into a parallel universe, much like the electrons jumping orbits around the nucleus of an atom as described by the laws of quantum mechanics. In terms of physics, the actual strangulation, as observed, let's say, by a disinterested observer on the Magic Isle, would occur in one orbit. But then the strangulation reflected in Miriam's glasses would result from a quantum leap into a different orbit.

The scene that cements Bruno and Guy's relationship is approximately 4:40 and is composed of forty-eight shots, with an average length of 6 seconds. The cutting of these relatively brief shots is in the unobtrusive classical style. However, the mise-en-scène is purely expressionistic, with low and canted camera angles, chiaroscuro lighting, and blatantly symbolic shots. Once Guy has entered into his pact with Bruno, his character trajectory is permanently altered by Bruno's dark energy, and Guy is brought into the orbit of Bruno's world. The blatant darkening of Guy's world is shown in the first shot of this scene, which is similar to the opening shot of the film: Capitol Dome in the background and a taxi pulling up to the curb, except for one overriding difference: the shot is bathed in darkness. And the figure that emerges from the cab is a silhouette.

For the next series of shots, Hitchcock positions his camera at a low and canted angle, making Guy seem off balance, a perfect visualization of Guy's new morally precarious position, thanks to Bruno's "elimination" of the obstacle to Guy's goal of marrying the senator's daughter. From his tilted

position, Guy hears someone faintly calling his name, and we see a point of view shot of a shadowy figure behind an iron gate across the street. The next shots function in the same way as the "Till-Two" bar scene in *Shadow of a Doubt:* Bruno transfers his guilt to the unsuspecting Guy by imparting to him the facts of Miriam's murder, just as Uncle Charlie reveals to Little Charlie his dark secret. Hitchcock positions his camera so that close-ups of both characters alternate as Bruno imparts his guilty knowledge to the incredulous Guy. Hitchcock and Burks use chiaroscuro lighting to underscore Bruno's nefarious nature. The bars of the iron gate throw dark shadows over Bruno's face, making him appear sinister. With their tight framing and obscuring shadows, these alternating close-ups seem very much like a Catholic confessional, in a sense foreshadowing a similar confession in the next film Hitchcock would direct, *I Confess* (1952). In that film, Keller/Killer confesses the sin of murder to Fr. Logan, who must bear this guilty knowledge like a cross throughout the film. Like Fr. Logan, Guy takes on the guilt—and the sin—of Bruno's action. When a police cruiser pulls up across the street, Guy moves behind the barred gate, next to Bruno, symbolically becoming drawn

Bruno and Guy, a transfer of guilt

into Bruno's guilty space. From this point on in the film, Guy will re-enact the primal jailing of the young Hitchcock: incarcerated, innocent, but guilty.

Just as in *Shadow of a Doubt* and *Rear Window*, Hitchcock presents a scene that shows the results of Guy's absorption of Bruno's dark energy: matter and antimatter combine in an explosion of violence. The merry-go-round scene in *Strangers on a Train* is Hitchcock's most extended scene of violence. Its swirling force—a merry-go-round out of control—is the perfect embodiment of Hitchcock's fear of involvement with evil. In Hitchcock's moral universe, all it takes is a single act—in this case an errant bullet that hits the merry-go-round operator—to transform a graceful, spinning carousel into a vortex of pure terror.

Einstein's most famous equation—$E = mc^2$—was part of the revolutionary theories he proposed in his annus mirabilis—1905. The paper that Einstein sent to the journal *Aminnalen der Physik* has the deceptively simple title, "Does the Inertia of a Body Depend on Its Energy Content?", but it had the complex effect of a revolution in physics, one that led ultimately to the construction and deployment of the atomic bomb in 1945. Isaacson describes the origin of Einstein's famous equation, an origin directly connected to the phenomenon of light: "Coupling Maxwell's theory with the relativity theory, he began (not surprisingly) with a thought experiment. He calculated the properties of two light pulses emitted in opposite directions by a body at rest. He then calculated the properties of these light pulses when observed from a moving frame of reference. From this he came up with equations regarding the relationship between speed and mass." In his paper, Einstein concluded, "The mass of a body is a measure of its energy content"–$E = mc^2$. [44]

When the merry-go-round explodes into a vortex of terror, it is Hitchcock's way of showing cinematically what Einstein proposed scientifically: that energy and mass are "different manifestations of the same thing". [45] Stated in terms of dark energy, Guy's seemingly innocuous meeting with Bruno draws Guy into his orbit of dark energy through the moral warping of spacetime, just as the innocent act of arriving home late from a train ride in London resulting in the young Hitchcock being locked in a jail cell. The carousel scene lasts 3:45, with seventy shots, averaging 3.2 seconds each. Using an expressionistic editing style reminiscent of Eisenstein's Odessa Steps Sequence, Hitchcock constructs this amazing scene so that the horses on the carousel seem to be animated with Bruno's destructive dark energy.

Hitchcock positions his camera outside, within, and underneath the crazily spinning ride to capture the full fury of the vortex, as Bruno's "mass" is converted to pure, sinister energy. Outside the carousel, the spectators to this unusual sight stand still in shock, while on the carousel Bruno and Guy engage in a vicious fight, complemented by a child absorbing the fury and

lashing out with his tiny fists at Bruno. Not even children are immune to the unleashed fury! In a surprising climax reminiscent of the exploding bus in *Sabotage*, Hitchcock violates his dictum that the hidden, metaphorical "bomb" in his suspense theory must never explode. Instead of slowing down the runaway carousel, the operator, trying to stop the fury, causes instead a catastrophic collapse of the whole edifice, which explodes in a chaos of fragmented horses and crushed and twisted steel. Bruno dies in the wreckage, unrepentant to the end, but Guy is exonerated by Bruno's possession of the lighter.

Earlier in this chapter, I claimed that *Strangers on a Train* could be considered the film that initiated Hitchcock's greatest period, his *Anni Mirabiles*, if you will. There is another reason, though, why *Strangers on a Train* is significant in the Hitchcock canon, and that is its presentation of the spinning or circular figure, as a symbol of chaos and evil. Later in the decade, Hitchcock would use this circular figure, in *Vertigo*, as a symbol of madness and obsession, and then in a crowning achievement, in *Psycho*, as a symbol of nothingness, of absolute, existential, zero—a black hole.

5

Psycho: A New Paradigm

When dark energy was discovered in 1998, it created what Thomas Kuhn calls a "scientific revolution" in his seminal book, *The Structure of Scientific Revolutions*. Such a revolution overthrows a reigning paradigm, or theory, and forces scientists to revise their thinking and to conduct experiments to verify the new paradigm. This is what Kuhn says about these new paradigms:

> The most obvious examples of scientific revolutions are those famous episodes in scientific development that have often been labeled revolutions...major turning points in scientific development associated with the names of Copernicus, Newton, Lavoisier, and Einstein. More clearly than most other episodes in the history of at least the physical sciences, these display what all scientific revolutions are about. Each of them necessitated the community's rejection of one time-honored scientific theory in favor of another incompatible with it. Each produced a consequent shift in the problems available for scientific scrutiny and in the standards by which the profession determined what should count as an admissible problem or as a legitimate problem-solution. And each transformed the scientific imagination in ways that we shall ultimately need to describe as a transformation of the world within which scientific work was done. Such changes, together with the controversies that almost always accompany them, are the defining characteristics of scientific revolutions.[1]

In his Preface, Kuhn identifies the major influences on the development of his ideas about scientific revolutions. What I find interesting—and relevant to my approach—is that none of them is scientific in the strict sense of the term. Among the most important are A. O. Lovejoy's *Great Chain of Being;* the linguist B. L. Whorf's study of the impact of language on world views; W. V. O. Quine's discussion of the conflict between analysis and synthesis; Jean

Piaget's theories about child development; and Stanley Cavell's writings and teachings on ethics and aesthetics. Most film scholars know Stanley Cavell as the author of the indispensable book, *Pursuits of Happiness: The Hollywood Comedy of Remarriage*. Kuhn maintains, "That Cavell, a philosopher mainly concerned with ethics and aesthetics, should have reached conclusions quite so congruent to my own has been a constant source of stimulation and encouragement to me."[2] Because of the myriad influences on Kuhn's ideas, I hope to show that much of what he says about "normal science" and scientific revolutions can be applied specifically to Hitchcock's *Psycho* and perhaps more generally to cinema itself, at least as that cinema was practiced in the studio system during Hitchcock's greatest period.

If we accept that in the studio era Paramount was very much like a laboratory, which is the claim I make in Chapter 3, then it is no great leap to consider the workers in that laboratory practicing a kind of science. This is what Kuhn calls a "particular scientific community."[3] The studios in the classical period of Hollywood, from the late 1920s to the early 1960s, were self-contained production facilities, or scientific communities, with artists, technicians, lawyers, businessmen, accountants, publicists—all dedicated to the production of films, artistic products composed of the photons of light. In my chapter on *Rear Window*, I discuss the relationship between director and collaborators, opting for the workshop model, or scientific community.

The structure of the studio system is similar in many ways to the structure of "normal science," as Kuhn defines the term. Kuhn states, "In this essay, 'normal science' means research firmly based upon one or more past scientific achievements, achievements that some particular scientific community acknowledges for a time as supplying the foundation for its further practice."[4] Ian Hacking, in his introductory essay for the fourth edition, summarizes Kuhn's thoughts on the tripartite form of normal science: "(1) determination of significant facts; (2) matching of facts with theory, and (3) articulation of theory."[5] Essentially, this process is what studios in the classical period of Hollywood did in the conception, production, and distribution of films. An idea for a film, whether an original idea or an adaptation, was presented to the studio producers; if the idea was accepted, a fairly rigorous process of development was undertaken. From this process of winnowing the chaff from the wheat, a few ideas got the green light for production. A shooting script was prepared. The producers chose among their talent pool for casting the film. During production, the dailies were viewed by the producer and director. The shooting ratio assured that trial and error—mini experiments— would hopefully result in a quality finished film. Previews were arranged for the finished product. Changes were made. Perhaps more scenes were shot. The film was then ready for distribution and exhibition, with the critical

establishment and the audience ready to pass judgment. Throughout this whole process, the significant facts of film production were matched to the reigning theories about which films would be successful and which not. Then, when the film was distributed and exhibited, the studio matched the facts of exhibition—critical reviews, box-office receipts—with the theory about the film's performance. If the film failed, then the film's reception was matched against the theory, and changes were made to the theory, or the theory was discarded for a new one that would fit the facts. Edward Jay Epstein in *The Big Picture* gives a snapshot of this studio system at the peak of its power:

On March 20, 1948, the elite of Hollywood, braving freezing temperatures and gale-force winds, filed past the newsreel cameras into the Shrine Auditorium in Los Angeles for the twentieth annual presentation of the Academy Awards. Once inside, they discovered a stage that had been transformed into a towering birthday cake, with twenty giant Oscar statuettes in place of candles.

The studios had much to celebrate that night. Their movies, the most democratic of all art forms, had become the principal mode of paid entertainment for the vast majority of Americans. In an average week in 1947, 90 million Americans, out of a total population of only 151 million, went to a movie, paying on the average forty cents for a ticket. Nor was this massive outpouring, about two-thirds of the ambulatory population, the product of expensive national marketing campaigns. It was simply the result of regular moviegoers going to see whatever was playing at their neighborhood theaters.

Most of these moviegoers didn't go to the theater to see a particular film. They went to see a program that included a newsreel; a short comedy film, such as the Three Stooges; a serial, such as Flash Gordon; animated cartoons, such as Bugs Bunny; a B feature, such as a western; and finally, the main attraction. In 1947 in America, movie houses were more ubiquitous than banks. There were more than eighteen thousand neighborhood theaters. Each had only one auditorium, one screen, one speaker (located behind the screen), one projection booth, and one marquee. Every week, usually on Thursday, a UPS truck picked up the previous week's reels and delivered the new ones. The new film's title on the marquee and the listings for it in the local newspapers constituted all the advertising most movies got.

Virtually all of these movies and shorts came from regional exchanges owned and operated by seven distribution companies that were, in turn, owned by seven Hollywood studios: Paramount, Universal, MGM,

Twentieth Century Fox, Warner Bros., Columbia, and RKO. In little over a generation, these studios had perfected a nearly omnipotent mechanism for controlling what the American public saw and heard. It was known, collectively, as the studio system.[6]

The studio system that Epstein describes, through research and development, created paradigms for future films and filmmakers. The paradigm is one of Kuhn's most important concepts, and it bears directly on my discussion of *Psycho*. Kuhn defines paradigms in this way: "...universally recognized scientific achievements that for a time provide model problems and solutions to a community of practitioners."[7] We can find a cinematic equivalent to the paradigms that Kuhn describes, not only in the technical paradigms, such as sound, color, and digitalization that transformed the industry, but also in genre. In many ways, a genre *is* a paradigm, a theory about which types of films will be successful if they are subsumed under the studio's rubrics: westerns, screwball comedies, gangster films, horror films, etc. What Kuhn describes about the importance of scientific paradigms can be applied to the genres that studios produced: "The study of paradigms...is what mainly prepares the student for membership in the particular scientific community with which he will later practice. Because he then joins men who learned the bases of their field from the same concrete models, his subsequent practice will seldom evoke overt disagreement over fundamentals. Men whose research is based on shared paradigms are committed to the same rules and standards for scientific practice. That commitment and the apparent consensus it produces are prerequisites for normal science, i.e., for the genesis and continuation of a particular research tradition."[8] Thomas Schatz in his, *The Genius of the System* (1981) says the same thing in cinematic terms.

The filmmaker's inventive impulse is tempered by his or her practical recognition of certain conventions and audience expectations; the audience demands creativity or variation but only within the context of a familiar narrative experience. As with any such experience it is difficult for either artist or audience to specify precisely what elements of an artistic event they are responding to. Consequently, filmic conventions have been refined through considerable variation and repetition. In this context, it is important to remember that roughly 400 to 700 movies were released *per year* during Hollywood's classic era, and that the studio depended increasingly upon established story formulas and techniques. Thus any theory of Hollywood filmmaking must take into account the essential process of production, feedback, and conventionalization.[9]

When a particular film paradigm, or genre, could no longer be used as a predictive type, then that paradigm needed to be modified to fit the new facts, or the paradigm needed to be discarded. Kuhn provides many scientific examples of discarded scientific paradigms, including Copernicus overthrowing the Ptolemaic universe and Einstein overturning the Newtonian theory of space and time. In the world of American studio films, a vivid example of paradigm alteration and then discarding was the western genre, which was the most popular genre almost from the beginnings of the film industry. In the 1950s, however, a new set of social factors made the western seem outdated or irrelevant. The paradigm underwent changes: the adult western, the ironic western, the revisionist western, the satiric western. Eventually, when the social forces of the 1950s reached their culmination in the 1960s, the western paradigm began to disappear. Today, no studio—in the new studio era—can bank on the western paradigm. Hitchcock, himself, never worked in the western genre, knowing that this type of film was not his kind of material. However, one can find echoes of the western paradigm in some of his films, in particular *Saboteur* and *North by Northwest*. Truffaut discusses with Hitchcock one of the effects of reigning paradigms:

Truffaut: Let's get back to the American film scene. One of the more unfortunate aspects of Hollywood is that film-making is arbitrarily separated into distinct classification. There are the directors who make what are rated as 'A' pictures and the others who make the 'B' and 'C' films. And short of a sensational hit, it appears to be very difficult to switch from one category to another.

Hitchcock: That's right. They stay on one line all the time.[10]

When Hitchcock proposed his idea to Paramount for *Psycho* in 1959, he had no real idea of how this modestly budgeted film would change film history by forging a new paradigm. The social forces that helped to deal a death-blow to the western were creating the conditions for a new paradigm. Most relevant to cinema was the weakening of the social power of the Hollywood Production Code, which had been in force since 1934. The Code decreed what could or couldn't be said or shown on the screen and was a direct reflection of the social forces that had created it. This is what the General Principles statement—written by Father Daniel Lord, a Jesuit, and Martin Quigley, a Roman Catholic layman—says about the approach of the code.

The motion pictures which are the most popular of modern arts for the masses, have their moral quality from the minds which produce them and

from their effects on the moral lives and reactions of their audiences. This gives them a most important morality.

1 They *reproduce* the morality of the men who use the pictures as a medium for the expression of their ideas and ideals.

2 They *affect* the moral standards of those who thru [*sic*] the screen take in these ideas and ideals.[11]

The moving pictures had fought censorship since their early beginnings, but in the early 20s, as movies became more sophisticated technically and artistically, they presented a threat to the prevailing morality of the time, the same morality that would create Prohibition. After the "Fatty" Arbuckle scandal, the studio producers formed the Motion Picture Producers and Distributors Association (the MPPDA), which in 1922 hired Will Hays, former Post Master General and Republican National Committee Chairman, to head up this new organization. Hays helped to create the Production Code in 1930, which was essentially a list of moral "do's and don'ts." With the introduction and evolution of sound and with the concomitant growth of the studio system's power and social range, the Code was revised and expanded and reintroduced in 1934. Joseph Breen, a Catholic layman, oversaw the application of the Code, which forbid as historian Robert Sklar describes, "...a vast range of human expression and experience: homosexuality, which is described as 'sex perversion,' interracial sex, abortion, incest, drugs, most forms of profanity, and scores of words defined as vulgar, including s-e-x itself."[12]

During the late 1950s, the Code became weakened by a number of factors, including the retirement in 1954 of the powerful Code Chief, Joseph Breen; the influx of licentious foreign films that lacked the Code's seal of approval; the advent of television in the 1950s; the burgeoning of youth culture, including rock music and social rebellion; the sexual revolution, and the initial stirrings of the anti-war movement and the civil rights protests. These social factors, and others, paved the way for the creation of a new paradigm through a cultural revolution that is very much like Kuhn's scientific revolutions, which "...are the tradition shattering complements to the tradition-bound activities of normal science."[13] It is my contention that *Psycho* is the film that helped to create this new paradigm. No less a critic than Paul Monaco, in his essential volume *The Sixties: 1960–69* in the nine-volume *History of American Cinema*, agrees with me on this point. According to Monaco, *Psycho* introduces a new kind of film, "the cinema of sensation," which heralded a "powerful new visual aesthetic."[14]

Hitchcock's *Psycho* has had the same kind of revolutionary force as Einstein's special theory of relativity in 1905 and Picasso's *Les Demoiselles*

d'Avignon in 1907. In my book on the shower scene in *Psycho*, I claim that the shower scene is the most important scene in film history. In a sense, the scene epitomizes the significance of *Psycho* in cinema history. In his essential biography of Hitchcock, *Alfred Hitchcock: A Life in Darkness and Light*, Patrick McGilligan claims that Hitchcock is the most written-about director of all time and that *Psycho* is the most written-about film.[15] Currently, there are ten books on *Psycho*, including mine, with more on the way. *Psycho* spawned two sequels, *Psycho II* (1983) and *Psycho III* (1986); a prequel, *Psycho IV* (1990); and a remake, *Psycho* (1998). In addition, Stephen Rebello, author of *Alfred Hitchcock and the Making of Psycho*, is the producer of a new film entitled *Hitchcock* (2012), which takes place during the making of *Psycho*. Moreover, the television network A&E is planning a 10–episode series entitled *The Bates Motel*, which covers the years leading up to the events in *Psycho*.

As a result of the above, *Psycho* and the shower scene have become the most powerful icons in popular culture history. The shower scene itself is ubiquitous: it has appeared in several episodes of *The Simpsons;* in Steven Spielberg's television series *Amazing Stories;* in *Law and Order*, *Murder She Wrote*, and *Saturday Night Live*, among others; as homage in Mel Brooks' *High Anxiety* (1977) and Brian De Palma's *Dressed to Kill* (1980); in museum exhibitions at the Museum of Modern Art in New York and Oxford. This last exhibit featured the premiere of Douglas Gordon's *24 Hour Psycho*, which showcased an extended version of Hitchcock's film, with the original running time of 1:49 minutes expanded to 24 hours.[16] In this version, the shower scene lasts almost 53 minutes!

An indication of just how deep *Psycho's* impact has been on American culture is found in the Pulitzer-Prize winner Don DeLillo's novel. *Point Omega* (2010). In a review of the book in the *New York Times*, Charles McGrath states:

> Mr. DeLillo got the idea for the book, he said recently, in the summer of 2006, when, wandering through the Museum of Modern Art, he happened upon Douglas Gordon's "24 Hour Psycho," a video installation that consists of the Alfred Hitchcock movie "Psycho" slowed down to two frames a second so that it lasts for an entire day instead of the original hour and a half or so. "I went back four times, and by the third time I knew this was something I had to write about," he said, adding, "Most of the time I was the only one there except for a guard, and the few people who came in left quite hastily." The slowness of the film, and the way it caused him to notice things he might otherwise have missed, appealed to him, Mr. DeLillo said: "The idea of time and motion and the question of what we see, what we

miss when we look at things in a conventional manner—all that seemed very inviting to me to think about."

So he wrote a scene, now the novel's prologue, in which two unnamed characters, an older man and a younger one, visit "24 Hour Psycho," and he later added an Epilogue set in the same gallery. The action of the book takes place in between those brackets...[17]

In the Prologue, DeLillo's narrator says about one of the characters:

The nature of the film permitted total concentration and also depended on it. The film's merciless pacing had no meaning without a corresponding watchfulness, the individual whose absolute alertness did not betray what was demanded. He stood and looked. In the time it took for Anthony Perkins to turn his head, there seemed to flow an array of ideas involving science and philosophy and nameless other things, or maybe he was seeing too much. But it was impossible to see too much. The less there was to see, the harder he looked, the more he saw.[18]

This passage reminds me of what Brian Greene says about Einstein's theory of relativity, "There's a profound link between motion in space and the passage of time. Roughly speaking the more you have of one, the less you have of the other."[19] No other film in the history of cinema has had this kind of cultural impact and influence.

When I was planning my book, I was tempted to include Norman Bates in my chapter on Princes of Dark Energy, for he, like Uncle Charlie and Bruno, warps the moral fabric of the diegesis of *Psycho*. Yet, Norman is of a different order of evil. Norma and Norman Bates are two separate characters housed in one person. Norman is trapped in his own body, sharing his skin—and soul—with his mother, Norma Bates, whom he has murdered and who as a consequence psychologically possesses her son. He had killed her because she would no longer accept him as her lover and took up with another man. Norman kills him as well as his mother. In the parlor scene of *Psycho*, Norman says to his unsuspecting victim Marion: "... we're all in our private traps—clamped in them. And none of us can ever get out. We scratch and claw, but—only at the air—only at each other. And for all of it, we never budge an inch." Norman represents a special kind of doppelganger. In *Shadow of a Doubt* and *Strangers on a Train*, Uncle Charlie and Bruno draw an "innocent" character into their orbits and attempt to destroy them. Norman, himself, however, has been drawn in and trapped. In effect, his time and his motion have been suspended: he is in a black hole.

When Einstein first proposed his general theory of relativity in 1916, he was aided in the application of his theory by a brilliant mathematician and astrophysicist named Karl Schwarzschild, director of the Potsdam Observatory. Schwarzschild, while serving in the German military in World War One, found time to provide calculations of the gravitational field of objects in space as predicted by Einstein's general theory of relativity. One of his calculations dealt with what the gravitational field would be inside a spherical, non-spinning star. As Isaacson explains it, "...something unusual seemed possible, indeed inevitable. If all the mass of a star (or any object) was compressed into a tiny enough space—defined by what became known as the Schwarzschild Radius—then all of the calculations seemed to break down. At the center, spacetime would infinitely curve in on itself...In such a situation, nothing within the Schwarzschild Radius would be able to escape the gravitational pull, not even light...Time would also be part of the warpage as well, dilated to zero...A traveler nearing the Schwarzschild radius would appear, to someone on the outside, to freeze to a halt."[20] This bizarre scenario is, of course, a black hole, a concept Einstein never quite accepted. The irony is commented upon by the theoretical physicist Freeman Dyson, "...Einstein was not interested. The question remains: how could he have been blind to one of the greatest triumphs of his own theory? I have no answer to this question. It remains one of the inexplicable paradoxes in the life of a genius."[21]

Although Einstein never really accepted the concept of black holes, I should like to appropriate the concept as an apt metaphor for the paradigm of *Psycho.* In my analyses of *Shadow of a Doubt, Rear Window,* and *Strangers on a Train,* I discuss Hitchcock's montage style of the vortex of violence, which he employs to show the results of an encounter with evil. In each of the films, a *doppelganger* character represents the dark side of the protagonist—Thorwald/Jefferies, Uncle Charlie/Little Charlie and Bruno/Guy. The evil character's dark energy warps the spacetime of the film's diegesis and draws the protagonist into a vortex of violence that engulfs the characters. Hitchcock presents this vortex in an Eisensteinian montage style that visually represents the moral chaos of an encounter with evil.

I've thought quite a lot about the etiology of this vortex image in Hitchcock's work. In his book on the Jesuit influences on Hitchcock, *Soul in Suspense,* Neil Hurley argues that Hitchcock's two primary fears are enclosed space and heights.[22] We know from many Hitchcock interviews that he was—or claimed to be—an unusually fearful man. For example, Tom Snyder, in a 1973 interview with Hitchcock, asks him, "What frightens you?" to which Hitchcock replies, "Most anything...I'm scared stiff of anything that's to do with the law."[23] Following Hurley's lead, I claim in my book on the shower scene that Hitchcock's primal fears involve claustrophobia and acrophobia.

Certainly, the fear of enclosed spaces can be traced back to Hitchcock's childhood jailing. The causes of his pervasive acrophobia are harder to trace, however. Certainly there is evidence in the Hitchcock canon of the dangers of falling from high places, of dangling dangerously over the abyss, in films as widely separated in plot and time as *The Lodger* (1926), *Young and Innocent* (1937), *Saboteur* (1942), *Shadow of a Doubt* (1943), *Rear Window* (1954), *To Catch a Thief* (1955), *Vertigo* (1958), and *North by Northwest* (1959). Claustrophobic images are just as ubiquitous. One thinks of the canopied bed, site of the attempted rape and then self-defensive murder in *Blackmail* (1929); the train compartment in *Strangers on a Train* (1951); Jeff's cramped apartment in *Rear Window* (1954); and, of course, the most claustrophobic space of all, the shower in the Bates Motel.

There's no question that unreasonable and ubiquitous fears are actually phobias, resulting from unresolved childhood conflicts between the id and the superego, according to Freud. The vortex of violence, then, can be seen as the yoking together of claustrophobia and acrophobia into a spinning figure that spirals into death and despair. That spinning figure reaches its culmination in the shower scene of *Psycho*.

In using scientific metaphors for Hitchcock's films, I've been drawing mainly upon the physical sciences, mostly physics and cosmology. But there has been another scientific revolution that parallels that one: Freudian psychology. It is no coincidence that Freud coined the term "psychoanalysis" in 1896, the year after the film industry was founded in Paris by the Lumière Brothers, and three years before Hitchcock was born. The art that best represents the science of psychology is the cinema, mainly because of film's special ability to portray the inner workings of a character's mind. The cinema does this, of course, through various techniques, such as flashbacks, point of view shots, and dream sequences.

Hitchcock was fascinated by Freudian psychology, and by psychoanalysis in particular. Hitchcock's biographer, McGilligan, says that the director "...wasn't unfamiliar with Freud's writings, having first browsed them in the 1920s, when Freud cast a shadow over all art and literature; and he was more than capable of expanding, for example, on symbols (preferably sexual) and artifacts."[24] In fact, while working under contract to David O. Selznick, Hitchcock directed *Spellbound* (1946), which contains an homage to the science of psychoanalysis in the credit sequence. In addition, Hitchcock convinced Selznick to contract with the famous surrealist Salvador Dali to design a dream sequence for the film loaded with Freudian symbols.

Hitchcock has become an iconic figure, in fact, because of the way he incorporates psychology and psychoanalysis in his films. In a fascinating entry

Storyboards for shower scene

on the Website for the Freud Museum, Ivan Ward, the museum's director of
education, uses Hitchcock to explain phobias:

The phobia is a conditioned response to traumatic experience. In the
post-Freudian films of Alfred Hitchcock, numerous characters exhibit
phobias. The trauma theory is enlisted to explain their motivation or to
affect narrative resolution. Thus the eponymous heroine of *Marnie* has
a murderous childhood secret expressed in her fear of lightning and the
colour red; the policeman who let his partner drop and suffers ever after
from a fear of heights, falls for the wrong girl in Vertigo; the psychiatrist
without a past unaccountably fears the white of a tablecloth in Spellbound.
When Hitchcock himself was asked if he had ever been really frightened
about anything, he would simply reply: "Always" (Spoto 1983). On other
occasions he would tell a story from his childhood. He was always terrified
of being alone, but at six years old, after committing some domestic
misdemeanor, his stern father sent him to the police station with a note.
The duty officer dutifully read the note and locked young Alfred in a cell for
some minutes. He was scared of policemen after that, but the experience
taught him an important lesson in life: "Don't get arrested."[25]

I should like then to enlist both Einstein and Freud in my discussion of the
paradigmatic elements in *Psycho*. The scientific revolutions launched by these
two seminal figures forever changed the cultural landscape of the twentieth
century. And Hitchcock was in a unique position to incorporate the ideas of
Freud and Einstein in his work, particularly in *Psycho*. The vortex of violence
brings together the potent phobias in Hitchcock's own life. His legendary
fastidiousness and his need to control all the potentially chaotic elements
of film production can be partly explained by his fear of losing control of
his impulses, symbolized by the spinning vortex. His Jesuit inspired fear
of involvement with anything evil, when combined with his free-ranging
sense of guilt from his boyhood jailing, results in a paradoxical response to
evil: fascinated by it and repelled by it simultaneously. In the interview with
Tom Snyder, Hitchcock elaborates on his fear of involvement with the law:
"...although I'm fascinated by it...I'd hate to be involved in it myself."[26]

That *Psycho* embodies this paradox is part of its paradigmatic status in
cinema history.

When Marion Crane gives in to her impulse to steal $40,000 from her
boss, she is launched into the dark universe of evil. As she drives west, away
from Phoenix and towards the promise of a new life with her boyfriend Sam,
she is inexorably drawn to the Bates Motel; her car seemingly floats in the
darkness and rain towards the neon sign and the looming house on the hill.

Whenever I see this scene, I am reminded of Bruno's boat floating towards the Magic Isle, where he will kill the unsuspecting Miriam.

In my book on the shower scene in *Psycho*, I break down the scene into three acts, and it is to the third act, "The Descent of Marion: The Ascent of Norman/Norma," that I shall now turn. In this part of the scene, the attacker has left the bathroom, and Marion has begun sliding down the shower wall. She reaches out to steady herself and grabs the shower curtain, which pulls free from its shower rod. Marion falls across the tub wall, her head slamming into the bathroom floor. Hitchcock then cuts to a shot of the showerhead and, next, to a high-angle shot of Marion's splayed legs; the camera pans left to follow the water—and blood—as both mingle and flow towards the drain. When the camera reaches the drain, it stops and then dollies in for a close-up of the drain, which is pulling the bloody water, counterclockwise, into its gaping black hole. Then in an astonishing and audacious dissolve, the drain metamorphoses into a close-up of Marion's eye. The camera then revolves clockwise, in the opposite direction from the water, creating a powerful vortex.

Not long after *Psycho* was released, the physicist John Wheeler coined the term "black hole" for the phenomenon that Schwarzwald had described and Einstein rejected. As Gary Zukav describes it in *The Dancing Wu Li Masters*, "A black hole is an area of space which appears absolutely black because the gravitation there is so intense that not even light can escape into the surrounding areas...all of the laws of physics break down completely, and even space and time disappear."[27] Brian Greene in *The Hidden Reality* claims, "The idea that there might be such extreme arrangements of matter seems nothing short of ludicrous." However, as Greene points out, astronomers have proven that black holes do indeed exist and that they "...are both real and

The astonishing bathtub drain-to-eyeball dissolve: a black hole

plentiful," including a huge black hole in the center of our very own Milky Way galaxy.[28]

With the vortex of violence reaching its apex in the shower scene of *Psycho*, Hitchcock had created a new kind of film that would forever change cinema. One of the most important aspects of the new paradigm of *Psycho* is the character of Norman Bates, himself. Hitchcock's screenwriter Joe Stefano had adapted Norman from the Robert Bloch novel *Psycho*, which was published by Simon and Schuster in 1959 as part of their Inner Sanctum Mystery Series. Stefano and Hitchcock changed Bloch's overweight and middle aged character into a boyish, charming serial killer. Bloch had patterned his character on an actual killer named Ed Gein. Hitchcock's and Stefano's Norman Bates had evolved from the charming psychopaths Uncle Charlie and Bruno. However, Bates is different from these earlier characters in several key ways, one of which is his polymorphous perversity. I've mentioned earlier Hitchcock's fascination with Freud's theories and with psychoanalysis in general. He would most certainly have been familiar with Freud's concept of polymorphous perversity, which is "a psychoanalytical term for human ability to gain sexual satisfaction outside socially normative sexual behaviors...Polymorphous perverse sexuality continues from infancy through about age five, progressing through three distinct developmental stages: the oral stage, anal stage, and phallic state...Freud taught that during this stage undifferentiated impulse for sexual pleasure, incestuous and bisexual urges are normal. Lacking knowledge that certain modes of gratification are forbidden, the polymorphously perverse child seeks sexual gratification wherever it occurs."[29]

Psycho's screenwriter, Joe Stefano, was in psychoanalysis while he was writing the script, so Freud's "fingerprints" are all over the film. As Joe told me in our interview for my shower scene book, "I felt that working on *Psycho* helped my analysis, and being in analysis helped my writing on *Psycho*."[30] Freud points out that polymorphous perversity is usually repressed through a process of childhood amnesia. Joe Stefano works that idea into the film in the penultimate scene, during which the psychiatrist "explains" Norman's history as told by the mother, Norma, who has now taken over Norman's identity, effectively reducing him to an infantile state. As the psychiatrist Dr. Richman implies, Norman and his mother had an incestuous relationship that was interrupted by Norma taking on an adult lover. In a fit of rage, young Norman poisons both of them, committing both homicide and matricide. Dr. Richman says of Norman, "His mother was a clinging, demanding woman, and for years, the two of them lived as if there was no one else in the world. She met a man...and it seemed to Norman that she 'threw him over' for this man. Now that pushed him over the line, and he killed them both. Matricide

is probably the most unbearable crime of all, most unbearable to the son who commits it. So he had to erase the crime, at least in his own mind. He stole her corpse."

In essence, the incestuous relationship between mother and son thrusts Norman into a psychological black hole, where both light and time are trapped inescapably. Consequently, when the mother slashes Marion Crane to death in the shower, she reenacts the matricidal killing, pouring Marion's life blood into the black hole of the shower drain. In the hands of Hitchcock and Stefano, Norman Bates becomes a new paradigmatic character, clothed in the language of Freudian psychoanalysis, and presented to the audience in a daring and shocking way. The weakening of the Production Code allows Hitchcock and company to create a character who shatters the reigning taboos of popular culture, including incest, necrophilia, voyeurism, and transvestism. In fact, one could claim that Norman is the first in a long line of psychotic serial killers, including among others, Michael Myers from *Halloween* (1978), Buffalo Bill and Hannibal Lecter in *Silence of the Lambs* (1991), John Doe in *Seven* (1995), Patrick Bateman in *American Psycho* (2000), the Zodiac killer in *Zodiac* (2007)—all of whom exhibit, in one way or another, the psychopathic characteristics of Norman Bates.

There is a major difference, however, between the above films and *Psycho:* the depiction of violence in these films is much more explicit and graphic than in the original *Psycho*, which was released in 1960. In the middle of that tumultuous decade, the long-reigning but now seriously weakened Production Code finally came to an end, replaced by a rating system. This change was seismic in the "new" Hollywood, with its studio system in turmoil and with its unsteady accommodations to the challenge of television and a new youthful audience. In my book on *Psycho* I claim that it was the shower scene that dealt the death-blow to the Production Code. I believe that the shower scene encompasses more than just the slashing scene; it begins, I believe, with Marion sitting at the desk and figuring out how much of the $40,000 she has spent, and ends with a 34-second shot that shows the brilliance of Hitchcock's absolute camera, which pans, dollies, and then tilts to reveal through the motel window the ominous house on the hill. As bravura as this shot is, it is the brief slashing scene that precedes it that revolutionized cinema, creating what Thomas Kuhn calls "a scientific revolution" in cinematic terms. The scene bursts onto the screen in a furious vortex of violence: thirty-four shots in a little under 40 seconds. The scene literally assaults the audience, ripping up their psyches just as the knife rips Marion's flesh. When the scene was over, the cinematic world had experienced a seismic shift.

What makes *Psycho* paradigmatic is more than just the character of Norman Bates; the real revolution is in the yoking together of explicit sex and

violence in a scene that splinters and fragments the cinematic space, in the same way that Picasso's *Les Demoiselles d'Avignon* fragments the artistic space of the canvas. The jagged, expressionistic montage style collapses "normal" space and time into an Einsteinian black hole, from which the space and time of the films of the studio era would never escape.

6

The quantum universe of *Vertigo*

In 1905, Einstein wrote to his friend Conrad Habicht about four papers that Einstein had been working on. The first, Einstein explains, "...deals with radiation and the energetic properties of light and is very revolutionary... The second paper is a determination of the true size of atoms by way of the diffusion and internal friction of diluted liquid solutions of neutral substances. The third proves that...particles of the order of magnitude of 1/1000 milli-metres suspended in liquids must already perform an observable disordered movement, caused by thermal motion. The fourth paper...is an electrody-namics of moving bodies, applying a modification of the theory of space and time."[1] The fifth paper, not mentioned by Einstein, is an addendum to the fourth paper and contains his most famous equation, $E = mc^2$, which connected mass, energy, and the speed of light and which led to the discovery of atomic energy.

These five papers, which introduced quantum theory, the structure of atoms, the relativity of spacetime, and the power of the atom, would revolutionize physics and science. More importantly, they would create the contours of the modern world, the world that Hitchcock grew up in and the world that he creates and recreates in his films.

In the previous chapter, I claimed that *Psycho* caused the equivalent of a scientific revolution in the world of cinema by smashing an old paradigm and creating a new one. I should like to make an additional claim that piggybacks on the former one. In previous chapters, I have attempted to apply scientific concepts and several of the revolutionary scientific theories that evolved out of Einstein's work to the films of Alfred Hitchcock: entropy in *Rear Window*; dark energy in *Shadow of a Doubt* and *Strangers on a Train*; black holes in *Psycho*. I have also made a more comprehensive claim—the boldest one, I think—that film encompasses in its most basic unit—the cinematic shot—the

spacetime characteristics of Einstein's special theory of relativity. Film accomplishes this amazing feat by capturing the photons of light in the chemical emulsion of a strip of film. Light is the key to Einstein's major theories, as it is to this book I am writing.

I would now like to take my approach one step further by applying—or adding—an additional theory to Hitchcock's greatest film, *Vertigo*. That theory is quantum mechanics. However, before I tackle this most complicated and mysterious theory, I should like to discuss the position of *Vertigo* in the Hitchcock canon. When Hitchcock directed *Rear Window* for Paramount in 1954, he was considered by critics to be the "Master of Suspense," a droll figure whose best work was in the thriller genre, with the wrong man theme predominating. Then something unusual happened. French critics, associated with the avant-garde film journal *Cahiers du cinema*, were revisiting Hollywood films of the 1940s and 1950s that had been unavailable to them because of World War Two and its European aftermath. The French critics constructed the auteur theory in order to re-examine cinema—American cinema, in particular—and to reorder and to realign Hollywood films based on the role of the director as an auteur, the prime creative force. In 1957, Claude Chabrol and Eric Rohmer published a slim volume entitled *Hitchcock: The First Forty-Four Films* that would prove to be enormously influential in Hitchcock's career. Francois Truffaut conducted a series of interviews with Hitchcock over several days and then published the results in a book entitled *Hitchcock* in 1966. It's true that the Chabrol-Rohmer book was not available in English until 1979, and the Truffaut book not until 1967. However, the English language critic Robin Wood acted as a kind of go-between and introduced French opinions of Alfred Hitchcock to English-speaking critics. In his 1965 volume, *Hitchcock's Films*, the first line poses this provocative question, "Why should we take Hitchcock seriously?" Robin Wood provides an extended comparison of the filmmaker, Hitchcock, to the great Elizabethan dramatist, Shakespeare. Commenting on the popular appeal that Hitchcock and Shakespeare evoke, Wood defends both artists: "...if we somehow removed all trace of 'popular' appeal from Shakespeare and Hitchcock, then we would have lost Shakespeare and Hitchcock."[2] Wood's query whether we should take Hitchcock seriously was answered by an avalanche of publications over the next forty-five years, reflecting the full range of criticism and scholarship: structuralism, feminism, Marxism, psychoanalytical, etc. What occurred was a veritable reconstruction of Hitchcock's critical reputation. As McGilligan claims, "The critics of *Cahiers and Positif*—an equally serious rival French journal—began to redefine Hitchcock as an artist in such a persuasive, assertive fashion that the rest of the world was ultimately forced to take notice."[3]

Robert Kapsis' *Hitchcock: The Making of a Reputation* analyzes the process by which this reassessment has taken place. He describes his approach in this passage from the first chapter:

My subject in this book is the creation of reputation in the art world of film, and I use Alfred Hitchcock's career and legacy as a genre director and film auteur as a case study. I analyze the impact of self-promotion, sponsorship by prominent members of the film community, and changing aesthetic standards of the critical acceptance of Hitchcock as a significant film artist and how this acceptance, in turn, affected the reputation of the thriller genre. The transformation of Hitchcock's reputation is an intriguing case study of how the figure of an "artist" or "auteur" is socially constructed and of the forces which influence reassessments of reputation and cultural meaning. By showing how critics have varied over time in their evaluation of Hitchcock thrillers, the study also illuminates the conditions that are crucial in shaping the historical reception of films and other artifacts of culture.[4]

The phenomenal growth of Hitchcock's reputation—and the concomitant rise in the influence of his films—can be seen in the holdings of OhioLink. This system, the first of its kind, links the library holdings of the eighty-four colleges—both public and private—in Ohio. It is a vast intellectual resource for students, teachers, and scholars. Under the subject heading of Hitchcock, there are 256 entries, 105 of which are books and videos about Hitchcock. In addition, OhioLink lists 179 entries under biographies, encyclopedias, bibliographies, etc. Under "Criticism and Interpretation," there are ninety-seven entries, seventy published in the last fifteen years. On *Psycho*, alone, ten books are listed, all but two of which have been published since 1990.

I should like to return to Robin Wood's argument that Hitchcock can be compared to Shakespeare and Mozart as a "universal artist."[5] In Chapter 3, I compare Hitchcock's output from 1954–64 to Shakespeare's great plays written between 1600–5, and Mozart's operas, composed and performed between 1780–91. Within these lists of masterpieces from the Shakespeare and Mozart canon, though, four stand out as masterpieces of masterpieces—the best of the best: for Shakespeare, *Hamlet*, *Macbeth*, *King Lear* and *Othello*; for Mozart, *The Marriage of Figaro*, *Don Giovanni*, *The Magic Flute*, and *Cosi Fan Tutte*. Within Hitchcock's output, three stand out as the best of the best: *Vertigo*, *North by Northwest*, and *Psycho*. I have discussed the significance of *Psycho* in the previous chapter, arguing for its importance in cinema history as the forger of a new paradigm. I should like to invoke Kuhn's paradigm idea in discussing *North by Northwest*, before I turn to *Vertigo*.

If it can be said that *Psycho* created a new paradigm, then it can be said of *North by Northwest* that it became the consummate expression of an already existing paradigm—one that Hitchcock had helped to create earlier, during the English phase of his career. That paradigm can be called the "comic/spy thriller." During the 1930s, Hitchcock had become the most famous and successful film director in England, mainly through the creation of six films that came to be called his "thriller sextet": *The Man Who Knew Too Much* (1934); *The 39 Steps* (1935); *Sabotage* (1936); *The Secret Agent* (1936); *Young and Innocent* (1937); and *The Lady Vanishes* (1938). It was, in fact, the success of these films that led to David O. Selznick offering a contract to Alfred Hitchcock, an offer that would change film history.

The major characteristics of the thriller sextet are the following:

1 An "innocent" protagonist wrongly accused

2 Picaresque structure: "Man on the Run"

3 Double chase

4 Clueless, ineffective, or corrupt police or spy agencies

5 Female co-questor

6 Confusion of appearance and reality

7 Charming villain

8 Assuming of new identities

9 Pastoral ending; marriage as consummation of romantic and social ideal

It should be pointed out that these characteristics of the comic/spy thriller paradigm don't apply to all of the films in the thriller sextet. Thomas Kuhn points out in his chapter on crisis and paradigm, "There are always difficulties somewhere in the paradigm/nature fit..." But in creating *North by Northwest* in 1959, Hitchcock brings the comic/spy thriller to perfection by including *all* the elements of the paradigm, but tweaking them in surprising ways. One important reason for this perfection is that Hitchcock had his "dream team" collaborating with him on the film. In my chapter on *Rear Window*, I opt for the Hitchcock workshop model. In Thomas Kuhn's terms, Hitchcock and collaborators form a scientific community in order to bring their paradigm to perfection. This dream team had the following collaborators: Robert Burks, cinematography; Bernard Herrmann, music; George Tomasini, film editor; Herbert Coleman, associate producer; Robert F. Boyle, production design;

Saul Bass, title design; Peggy Robertson, script supervisor; Ernest Lehman, screenwriter.

Hitchcock sets key parts of the action on the famous train, the 20th Century Limited, described by Michael L. Grace as "...a repository of the comings and goings—of the rich, tycoons and stars—their habits of dress or drinking, their minds and their manners. The Century was operated like a private club and the lengthy dining car aptly named the Century Club...to luxury travelers it was the last word in conservative opulence." Grace also points out that the term "red carpet treatment" originated with the 20th Century Limited's practice of having passengers walk on the crimson carpet to get to their cars.[7]

In Chapter 1, I discuss Einstein's and Hitchcock's fascination with trains. Their interest has several elements in common, namely time, light, and space. Einstein's work in the Swiss patent office introduced him to the problems associated with trains and time schedules, and these problems eventually led to his special theory of relativity. Time, light, and space, in addition, are the elements of Einstein's thought experiments, and they are usually associated with trains. Here for example is his discussion of an aspect of relativity from the chapter entitled "On the Idea of Time in Physics," from his book, *Relativity: The Special and General Theory:*

Lighting has struck the rails on our railway embankment at two places A and B far distant from each other. I make the additional assertion that these two lighting flashes occurred simultaneously. If I ask you whether there is sense in this statement, you will answer my question with a decided "Yes." But if I now approach you with the request to explain to me the sense of the statement more precisely, you find after some consideration that the answer to this question is not so easy as it appears at first sight... For, like every other general law of nature, the law of the transmission of light *in vacuo* must, according to the principle of relativity, be the same for the railway carriage as reference-body as when the rails are the body of reference. But, from our above consideration, this would appear to be impossible. If every ray of light is propagated relative to the embankment with the velocity, then for this reason it would appear that another law of propagation of light must necessarily hold with respect to the carriage—a result contradictory to the principle of relativity.

In view of this dilemma there appears to be nothing else for it than to abandon either the principle of relativity or the simple law of the propagation of light *in vacuo*. Those of you who have carefully followed the preceding discussion are almost sure to expect that we should retain the principle of relativity, which appeals so convincingly to the intellect

because it is so natural and simple. The law of the propagation of light *in vacuo* would then have to be replaced by a more complicated law conformable to the principle of relativity.[8]

Like Einstein, Hitchcock uses trains in creative ways. In fact, his love of trains reaches its apex in *North by Northwest*. He manages to incorporate all of the major characteristics of the thriller paradigm within the train itself. Roger O. Thornhill is the "innocent" protagonist, wrongly accused of a crime. He is not quite innocent since he admits to Eve Kendall that he had been divorced twice and that he drinks too much. Thornhill is the man on the run for a crime he did not commit. His means of escape is the 20th Century Limited, which runs daily from New York City to Chicago. Thornhill is being chased by the police on the train, at the same time that he is chasing George Kaplan, and the real perpetrators of the crime, Vandamm and his henchmen. The police who are chasing him are following the wrong man, and this chase is aided and abetted by the FBI, who have "set up" Thornhill as a fall guy. Thornhill, who has now taken on the identity of the elusive Kaplan, is aided on his search by the female co-questor, Eve Kendall, who seduces him on the train. She, however, is a duplicitous double crosser. It turns out that her seduction of Thornhill is part of Vandamm's plot against him. In effect, the train allows Eve both to fall in love with Thornhill and to betray him at the same time. As Thornhill is trying to escape the police on the train, he assumes a different identity. He doesn't realize that on the train is his main adversary, the charming villain, Phillip Vandamm. At the end of the film there is a dramatic dissolve from the Mount Rushmore monument, where Eve is hanging on to Thornhill's hand, to the upper berth on the 20th Century Limited, where Thornhill pulls up his new wife, Eve Thornhill, into a pastoral paradise. Hitchcock and company end the film on a slyly salacious note as the train enters the tunnel, a symbol of the activities taking place inside the compartment.

In Einstein's theory of relativity, just as two events cannot happen in the same space, so no two events can happen at the same time. Hitchcock suggests a similar idea in dramatic and cinematic terms in his films that use trains as settings. As I suggest earlier, in *The Lady Vanishes*, the "truth" of Miss Froy's reality is relative to the person experiencing her presence. Miss Froy's reality in space and time is not absolute. In *Strangers on a Train*, Bruno's murderous compact with Guy is valid to Bruno, but not to Guy. What is real—in the spacetime of Bruno's compartment—is relative to the observer. In *Shadow of a Doubt*, the reality of Uncle Charlie's murderous nature is revealed to his niece in the penultimate scene of the film, as he tries to throw his niece off the train. To an observer outside the train—to the townspeople of Santa Rosa, including Charlie's own family—Uncle Charlie

is a benevolent, charming, loving character. To his niece on the train, Uncle Charlie is a monster, willing to sacrifice his "beloved" niece to save his own skin.

In *North by Northwest*, the train becomes a symbol of the relativity of truth and the elusiveness of identity. As Einstein realized, the measurement of space and time is different for each observer. For Roger Thornhill, on the run from the police, time has indeed contracted at the same time that his space has expanded: the 20th Century Limited speeds westward at 60 mph. When he first meets Eve Kendall, he believes her to be an innocent bystander who had helped him evade the police when he first got on the train. She, however, is not what she appears: we learn later that she is working for Vandamm. The latter believes that Thornhill is actually George Kaplan; Thornhill, who does not know Vandamm is on the train, earlier believed that Vandamm was Lester Townsend, but when the "real" Townsend is murdered before Thornhill's eyes, he does not know who is who. The complexities of *North by Northwest* reveal that Hitchcock had found a cinematic equivalent to Einstein's special theory of relativity. Arthur Miller, author of *Einstein, Picasso*, states in an article on Henri Poincare, "Einstein met Poincare' in 1911; they disagreed on relativity theory. Picasso never met either and was unaware of Einstein's existence when he created *Les Demoiselles d'Avignon*, which contained the seeds of Cubism."[9] Earlier I mention Segeberg's concept of a "complex co-evolution" of ideas rather than a direct influence. Certainly, Einstein and Picasso demonstrate that co-evolution at the turn of the twentieth century. This co-evolution is a mystery, as if there are sub microscopic particles of thoughts, ideas, and images that correspond to the particles of quantum mechanics. Steve Martin, in his play, *Picasso at the Lapin Agile*, fictionalizes a meeting between Einstein and Picasso at the Famous Parisian café in 1904, just before both would shatter the reigning paradigms of nineteenth century art and science. Martin provides a hilarious scene during which Picasso and Einstein argue about whether art or science is more culturally significant.[10] Similarly, filmmaker Nicolas Roeg in his 1985 film *Insignificance* imagines a meeting between Einstein and Marilyn Monroe in his hotel room during the McCarthy hearings in the 1950s. Monroe is in New York filming *The Seven Year Itch* and visits Einstein after she escapes the film set. Of course, she is wearing her white dress, the one that reveals her famous legs in the subway grate scene. Roeg provides a marvelous scene during which Monroe explains the theory of relativity to the incredulous Einstein.[11]

This kind of mysterious co-evolution can also occur in unexpected places. Physics teacher Monica Witt was hiking in the Bolivian desert when she came upon an astonishing sight: an old, abandoned locomotive with the most unexpected and bizarre inscription on its side, Einstein's most important

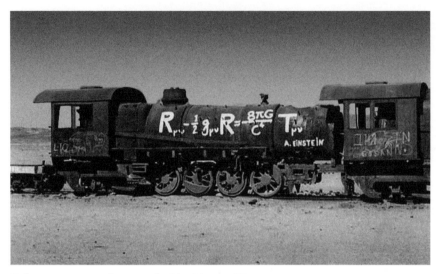

Relativity train as photographed by Monica Witt

equation, his "field equation." This is how the Physics Central Website describes "the equation on the train." (which sounds suspiciously like *Strangers on a Train!*):

> A train that describes how one might travel through spacetime was discovered in the Bolivian desert by a physics teacher. The old locomotive itself must have pushed the boundaries of space and time due to its mysterious location in the desert and its signs of old age. The unique feature of the train is the expression painted on the engine and signed by A. Einstein. Whether Albert Einstein painted or used this train himself remains unknown. But the significance of the painted expression goes beyond historical accuracy. While everyone can recite Einstein's famous equation $E = mc^2$, few know that he went even further to describe the relationship between mass and the shape of spacetime. This equation not only answers the question of how gravity works, but it also describes black holes, gravity waves, bending of light, planetary motion, and the shape of the universe. For instance, the left side of the equation with the R's represents the curvature and shape of spacetime and hence the path that an object will follow. The right side of the equation with the big T represents the mass and energy density of a star or planet. Putting the two sides of the equation together says that a massive object like a star or planet will curve the surrounding spacetime. As a result this also curves the path of

other objects moving past such as comets or satellites. Unfortunately the mathematics involved in this equation is quite advanced. In fact it was said that only a handful of people in the world understood it when Einstein proposed his theory of relativity. This kind of mathematics is called tensor calculus which is like regular calculus but in multiple dimensions. With such an intimidating mathematical equation staring at you from a train, one can take comfort in recognizing some of the symbols such as 8 and π. π is a familiar term from geometry and interestingly enough that fraction helps to convert the mass energy density into the geometry of space and time.[12]

In 1959, Einstein had become a permanent fixture in both scientific and popular culture. Whether Hitchcock knew the specifics of relativity theory is not really known, but he certainly had constructed the equivalent in his dramatization of Roger O. Thornhill's decline, fall, and resurrection via pure cinema.

Psycho creates a new paradigm; *North by Northwest* consummates an already existing one. *Vertigo*, however, is in a different class all together: it is Hitchcock's most original film, his greatest example of pure cinema, the ultimate expression of his absolute camera. The irony, of course, is that it was a commercial failure and thus somewhat of a disappointment to Hitchcock. The most comprehensive treatment of Hitchcock's masterpiece is the marvelous book by Dan Auiler, entitled *Vertigo: The Making of a Hitchcock Classic*. I don't want to re-hash the arguments that Auiler puts forth to explain the incredible growth of Hitchcock's reputation *after* he had completed his greatest films. I've outlined much of that argument in earlier chapters. Nor is there need to re-examine the making of the film since Auiler covers that area extremely well. I would, however, like to expand upon a comment Auiler makes in the chapter entitled, "Premiere and Beyond": "The director's career may have been on the wane in the sixties and seventies—certainly his last great film was *Marnie*, which has deeply divided critics over the years—but his critical reputation was approaching its zenith."[13] It seems, however, that Auiler's opinion about the zenith of Hitchcock's career was premature.

More than a decade after Auiler's book was published, Hitchcock's reputation and fame have increased geometrically. He is as popular today in the public imagination as Einstein was after he had launched his special and general theories of relativity and after they had been proven by experiments. There is a wonderful anecdote about Charlie Chaplin and Albert Einstein. Chaplin, the most famous movie star in the world, had invited Einstein in 1931 to attend a private screening of Chaplin's latest film, *City Lights*. As the two men drove to the film, crowds gathered to cheer and wave at the celebrities. Chaplin turned to the amazed physicist and exclaimed, "They cheer me

Einstein and Chaplin at a private screening of City Lights *in 1931*

because they all understand me, and they cheer you because no one under-stands you..."[14]

Chaplin's statement is a good segue to my opinion on *Vertigo*: I don't think critics—nor audiences either—"understand" the film. What I mean is that the film is impervious to attempts to pin its meaning down. The only parallel I can draw is suggested by Robin Wood's comparison of Hitchcock and Shakespeare: *Vertigo* is Hitchcock's *Hamlet*. The great literary critic Harold Bloom in his 2003 book entitled, *Hamlet: Poem Unlimited* calls it "unlimited" in its range: "Its length and variety are matched by its experimentalism. After four centuries *Hamlet* remains our world's most advanced drama."[15] Bloom's comments could be applied equally to Hitchcock's *Vertigo*. The cinematic event that confirms *Vertigo's* "variety," "experimentalism," and "advanced drama" is the September 2012 issue of the British Film Institute's prestigious film journal *Sight and Sound*. Since 1952, *Sight and Sound* has published the results of a survey of international film critics on the ten greatest films ever

made. Every ten years thereafter, the journal has published its results. The list became a perfect barometer of changing tastes and shifting critical standards, especially when these standards concern Hitchcock and *Vertigo*. The first time that *Vertigo* makes the list is the 1982 poll, where it is tied for seventh place with *L'avventura* and *The Magnificent Ambersons*. This standing is a reflection of Hitchcock's growing reputation as a "serious" director. The 1992 poll shows *Vertigo* in fourth place, and the 2002 poll has *Vertigo* in second place. In my book on the shower scene, which was published in 2009, I predicted that in the 2012 survey *Vertigo* would supplant *Citizen Kane*, which has amazingly held the top spot for fifty years, as the greatest film ever made. Sure enough, the 2012 poll made my prediction come true. In addition, Alfred Hitchcock also took first place in the poll of the top 25 directors. What is even more significant about the 2012 poll for *Vertigo* is that the sampling of critics was almost four times as large as the 2002 poll: 846 critics in 2012 as opposed to 145 in 2002.

To me, the *Sight and Sound* poll is further evidence of the extraordinarily high standing Hitchcock has attained within the scholarly and academics community as well as in the public eye. It seems that wherever one looks, one finds Hitchcock! Take, for example, this headline from the Popular Culture section of Cleveland's *The Plain Dealer* newspaper: "It's Almost As if Hitchcock—*shudder*—Never Really Died." Daniel Bubbeo of *Newsday* opens the piece by stating "An Alfred Hitchcock frenzy is taking place in Hollywood and on Broadway." He then lists four productions that reflect the Hitchcock mania sweeping the country: 1) the HBO film entitled *The Girl*, which details Hitchcock's obsession with Tippi Hedren during the production of *The Birds* and *Marnie*; 2) the Fox Searchlight biopic entitled *Hitchcock*, based on Stephen Rebello's landmark study, *Alfred Hitchcock and the Making of Psycho*; 3) the A&E series *The Bates Motel*, a ten-episode prequel to *Psycho*; and 4) the Broadway adaptation of Hitchcock's 1940 film *Rebecca*.[16]

I believe that what is happening to Hitchcock can be explained partly by Thomas Kuhn's theory of scientific revolution, during which one worldview is replaced by another competing one. The new worldview, I believe, is that Hitchcock is our cinematic Shakespeare; that Hitchcock's fifty-seven films have the same position in popular culture that Shakespeare's thirty-eight plays "have"; that *Vertigo*, like *Hamlet*, is the crowning achievement of Hitchcock's art.

In the *Sight and Sound* issue announcing the results of the 2012 poll, critic Peter Matthews says of *Vertigo's* number one position: "*Vertigo*, which concerns the effort to model a real woman into an ideal, is nowadays certainly diagnosed as another reflexive text: the ultimate demystification of stardom and its origins in male fantasy. Such rational readings hold water, but leave me dissatisfied. They cannot account for a delirious excess that paradoxically

borders on abstraction and renders the film a true nonpareil in Hitchcock's career."[17] This "delirious excess that paradoxically borders on abstraction" sounds very much like a description of poetry, and it is cinematic poetry, I believe, that accounts for *Vertigo's* greatness as a work of art. In *The Poetry of Physics and The Physics of Poetry*, physicist Robert K. Logan claims, "There is poetry in physics and physics in poetry." He states as one of the goals of his book to "...examine some of the impacts of physics on the humanities and arts."[18] This has also been my goal in examining the physics of cinematic spacetime in Hitchcock's films. I should like, then, to look at the physics of poetry by applying the theories of quantum mechanics to Hitchcock's *Vertigo*. Arthur Miller, author of *Einstein, Picasso* (2002) says "...20th century developments in relativity theory, quantum physics, electronics and biotechnology have brought about an increasing interplay between art and science."[19]

Quantum mechanics had its origins in 1900, five years before Einstein's groundbreaking paper, and one year after Hitchcock's birth. Max Planck's study of the electromagnetic radiation given off by a hot body showed that light is not a continuous wave but rather a series of individual bundles called quanta, or photons. The photon theory of light was given a theoretical foundation by Einstein in 1905, further amplified an expanded by Niels Bohr and Werner Heisenberg. In summary, quantum mechanics reveals a world of microscopic particles that are governed not by certainty, but by probability. As Brian Greene explains it in *The Fabric of the Cosmos*, quantum mechanics is "a revolutionary set of laws that have completely transformed our picture of the universe."[20] This scientific revolution, in Thomas Kuhn's terms, shows that the structure of reality is based on probability and uncertainty. The epitome of this new picture of reality is Heisenberg's uncertainty principle, which states that it is impossible to measure both the position of a particle and its velocity at the same time. If you measure one, the other changes.

The scientific components of quantum mechanics are incredibly complex and—as Briane Greene states, "deeply mysterious." It is that mystery that I should like to appropriate for *Vertigo*. I find it significant that, as in so many important theories of modern science, light is a key ingredient in quantum mechanics. In cinema, the photons of light that are captured in the emulsion of film are activated by the light from a projector and then these photons enter the eyes of a film viewer. What happens next has been a mystery ever since the cinema was born in 1895. However, as I point out in the Epilogue, the new field of neurocinematics is helping scientists demystify the viewing experience. Nevertheless, when Hitchcock made *Vertigo* during 1957–8, no one really understood the neurology of film viewing.

Hitchcock pays a tribute to the mystery of cinema in the extraordinary credit sequence in *Vertigo*, which, I believe, is a reflection of the essential

mystery of the film. On the Website *Art of the Title*, there appears this statement about the credit sequence of *Vertigo:* "There is a threshold in art and design where a work can become so iconic as to transcend its own scope and become a symbol for its medium."[21] Hitchcock had a key collaborator in the design of the credits—Saul Bass—who, according to Dan Auiler, asked the avant-garde filmmaker John Whitney to design animated spirals for the credits. Bass states, "I wanted to achieve that very particular state of unsettledness associated with *Vertigo* and also a mood of mystery. I sought to do this by juxtaposing images of eyes with moving images of intense beauty. I used Lissajous figures, devised by a French mathematician in the nineteenth century to express mathematical formulae...."[22]

The credit sequence begins with the Paramount logo and then the Vista-Vision trademark. The word "vision" is the essence of cinema, the power of sensing with the eyes, but also the additional meaning of appearing in the mind, though not necessarily to the eyes. The Vista-Vision logo is replaced with an off-center, extreme close-up of a woman's face. A right triangle formed by the intersection of the left vertical and horizontal edges of the frame presents us only with a quadrant of the face. The camera pans left and zooms in for a close-up, now revealing only the large, voluptuously shaped, lipsticked lips, the bottom lip reflecting slivers of light. The name "James Stewart" appears above these lips. The camera then tilts up to reveal a pair of eyes, looking out at the viewer, carefully made up with mascara. In the dark pupils are reflected star-like particles of light. As the name "Kim Novak" appears on the bottom of the frame, the eyes, but not the face, turn right and then left, as if fearfully searching for some danger. When the eyes return, they gaze back on the viewer, and then the camera simultaneously pans left and zooms in for an extreme close-up of one eye. Then from the middle of the frame, the words, "in Alfred Hitchcock's" appear, and then the camera zooms in again, making the eye cover almost the entire screen. Suddenly, the screen is bathed in red. The eye opens wide, as if in terror; the pupil contracts, and from its middle appears a small glowing white bar that zooms toward the audience. As it gets closer, the word becomes visible: "*Vertigo.*" The word moves to the top of the screen and disappears. Taking its place in the middle of the pupil is a purply, swirling spiral rotating counter clockwise. The eye disappears, and the spiral gets larger until it fills the entire screen. Other spirals, of different colors and shapes, and rotations, replace it as the credit sequence unfolds. The last spiral dissolves back into the enlarged eye and pupil. Again, a small white bar appears and zooms toward the audience. This time the words say "Directed by Alfred Hitchcock," with the director's name in large capital letters. The screen fades to black, and then the film's major story line begins. During this whole credit sequence, Bernard Herrmann's hypnotic score highlights the swirling spirals.

A vortex of violence

What do we make of these strange, hallucinatory, provocative images? A hint to this mystery is contained in David Deutsch's, *The Beginning of Infinity*. Deutsch attempts to answer the question, "How do we know so much about the universe when we really can't see very much of it with our eyes?"

> *How* do we know? One of the most remarkable things about science is the contrast between the enormous reach and power of our best theories and the precarious, local means by which we create them. No human has ever been at the surface of a star, let alone visited the core where the transmutation happens and the energy is produced. Yet we see those cold dots in our sky and *know* that we are looking at the white-hot surfaces of distant nuclear furnaces. Physically, that experience consists of nothing other than our brains responding to electrical impulses from our eyes. And eyes can detect only light that is inside them at the time. The fact that the light was emitted very far away and long ago, and that much more was happening there than just the emission of light—those are not things we see. We know them only from theory.[23]

Let's say that the theory we are using to know the universe is the quantum theory, which posits that uncertainty rules, that we can't really "know;" we can only choose from a basic set of probable scenarios. With this in mind, we look at the fragmented face of a female figure. We don't know who she is or why she is staring out at us, just as we are staring in at her. Her eyes shift, seemingly in fear, from left to right; her pupils dilate. Her world is bathed in red. Then, from within her eyes, strange, hypnotic spiraling figures move toward us, transfixing us, dizzying us. These spinning figures are reminiscent of the vortexes of violence that we have seen in *Shadow of a Doubt*, *Strangers on a Train*, *Rear Window* and *Psycho*. The spiraling figures are also symbolic of the vertiginous feelings characteristic of acrophobia.

It is significant that there is not just one spinning figure, but rather several, some spinning clockwise, others counter clockwise. In the sub microscopic world of quantum mechanics, electrons have different spins; if these electrons become entangled, they spin in complementary ways, even if they are separated by billions of miles. Einstein who never quite accepted quantum mechanics, called the phenomenon of entanglement, "spooky action at a distance." Of the probability that rules the world of basic particles, Einstein said, "God does not play dice with the universe."

I believe, though, that God *does* play dice with the universe of *Vertigo*, that the "particles" of the film—the characters in the film—behave in unpredictable ways, even "spooky" ways. I should like to illustrate these "spooky" and unpredictable ways by borrowing and adapting one of the most important tools ever invented for the theories of physics: Feynman diagrams. Richard Feynman, an American theoretical physicist, invented the diagrams to simplify complicated and lengthy calculations in the field of quantum electrodynamics, or QED for short. This is what the historian of science, David Kaiser, says about quantum electrodynamics:

QED explains the force of electromagnetic—the physical force that causes like charges to repel each other and opposite charges to attract—at the quantum-mechanical level. In QED, electrons and other fundamental particles exchange virtual photons—ghostlike particles of light—which serve as carriers of this force. A virtual particle is one that has borrowed energy from the vacuum, briefly shimmering into existence literally from nothing. Virtual particles must pay back the borrowed energy quickly, popping out of existence again, on a time scale set by Werner Heisenberg's uncertainty principle.[24]

Richard Feynman introduced his diagram idea to a select group of theoretical physicists in a 1948 meeting in rural Pennsylvania. The diagrams, he explained, would help physicists in understanding the likelihood of electrons moving

A Feynman diagram as constructed by cosmologist Martin Bojowald

as free particles and then emitting or absorbing virtual photons. As Kaiser explains, "Feynman diagrams helped to transform the way physicists saw the world, and their place in it."[25]

Below I've adapted Feynman's diagrams to show the complexity of the characters' relationship to one another and to the plot of *Vertigo*, which was made ten years after Feynman introduced his diagrams. In physics terms, the characters are virtual particles that briefly borrow energy—sometimes in the form of identity—and then disappear into the vacuum. Kaiser says, "In principle, electrons could interact with each other by shooting any number of virtual photons back and forth. The more photons in the fray, the more compli-cated the corresponding equations."[26] The following list of characters contains names and identities, with corresponding plot points and character arcs. Most of the names are repeated, with numbers that indicate a new identity or role in the film. In a sense, the characters are like the electron particles in a Feynman diagram; they interact with each other and then shoot off a photon, or another character that has been changed or eliminated by that reaction. Like a Feynman diagram, the more photons/characters in the fray, the more complicated the equation and the plot. After the list of names, I've designed diagrams based on Feynman's ideas to suggest the depth and complexity of *Vertigo*'s plot. I'm assuming that my readers know the film's storyline.

Characters

Scotty 1, John Ferguson, the main character after he has dangled from the rooftop and experienced his vertigo. He has now retired from police work and is trying to adjust to his new identity.
Scotty 2: After John Ferguson has a mental breakdown.

Madeline 1: The "real" Mrs. Elster, seen only as a dead body.
Madeline 2: Judy 1, disguised as Madeline 1 for the first half of the film.
Madeline 3: Judy 2, disguised as Madeline 3 in the second half of the film.
Elster : Gavin Elster, the antagonist, husband of Madeline 1, lover of Judy 1, creator of Madeline 1.
Judy 1: Judy Barton, lover of Elster, made over to Madeline 1, love mate of Scotty in the first half of the film.
Judy 2: Judy Barton, love mate of Scotty in the second half of the film, made over to Madeline 3.
Carlotta 1: Carlotta Valdes, the "historical" Carlotta, suicide victim, supposedly the "possessor" of Madeline 2, and the subject of the painting in the palace of the Legion of Honor Art Museum.
Carlotta 2: The ghost-like possessor of Madeline 2, created by Elster, and the subject of Scotty's nightmare that plunges him into madness.
Carlotta 3: A combination of Carlotta 1 and Carlotta 2, the subject of Midge 1's self-portrait.
Midge 1: Marjory Wood, Scotty 1's long-time girlfriend.
Midge 2: Midge 1 as Carlotta 2 in self-portrait.

Diagrams

A. Judy 1 ──────▶　────────▶ Elster
　　　　　　　　　◀──┐
　　　　　　　　　　 └──▶ Madeline 1

Elster has an affair with Judy 1 and convinces her to pattern herself after Madeline 1

B. Elster ──────▶　────────▶ Madeline 1
　　　　　　　　　◀──┐
　　　　　　　　　　 └──▶ Madeline 2

Elster brings Madeline 2 to life and passes her off as Madeline 1.

C. Scotty 1 ──────▶　────────▶ Madeline 1
　　　　　　　　　　◀──┐
　　　　　　　　　　　 └──▶ Madeline 2

Scotty 1 believes Madeline 2 is actually Madeline 1 and takes on the task of following her and protecting her.

D. Madeline 2 ⟶ Madeline 1

 Carlotta 2

Madeline 2 becomes Madeline 1 and feigns possession by the ghost of Carlotta 2.

E. Scotty 1 ⟶ Elster

 Madeline 2/ Carlotta 2

Scotty 1 is persuaded by Elster that Madeline 2 is possessed by dead ancestor Carlotta 2.

F. Scotty 1 ⟶ Madeline 2

 Judy 1

Scotty 1 believes that Madeline 2 is real, not knowing that she is really Judy 1.

G. Midge 1 ⟶ Scotty 1

 Madeline 2

Midge 1 discovers Scotty 1's love for Madeline 2.

H. Midge 1 ⟶ Carlotta 3

 Scotty 1

Midge 1 does a self-portrait, based on Carlotta 1, infuriating Scotty 1.

I. Judy 1 ⟶ ⟶ Judy 2
 ⟶ Scotty 2

Judy 1, upon seeing Scotty 2, becomes Judy 2.

J. Scotty 2 ⟶ ⟶ Judy 2
 ⟶ Madeline 2

Scotty 2 convinces Judy 2 to change her appearance to conform to Madeline 2.

K. Judy 2 ⟶ ⟶ Madeline 3
 ⟶ Scotty 2

Judy 2 becomes Madeline 3 and is embraced and loved by Scotty 2.

L. Madeline 3 ⟶ ⟶ Carlotta 2
 ⟶ Scotty 2

Madeline 3 wears the jewelry of Carlotta 2 and is discovered by Scotty 2.

M. Madeline 3 ⟶ ⟶ Scotty 2
 ⟶ Judy 1

Madeline 3 admits to Scotty 2 her role as Judy 1 in the death of Madeline 1.

I am sure that there are other diagrams that can be drawn—more complex, with more lines of connection between characters. However, the important thing is that the diagrams reveal a world of destructive illusions and of obsessive, violent love. Scotty, like Hamlet, is betrayed at every turn. Both are stripped of their illusions and find a world full of poison. In the three great films that come at the end of the 1950s, Hitchcock creates a world where

characters are caught up in dark energy, in swirling, spinning vortexes of violence, and in destructive illusions of romantic love.

In a moving tribute to Hitchcock's films in the August 2012 issue of *Sight and Sound*, which features Hitchcock on the cover, the Mexican film director Guillermo del Toro says, "Hitchcock is among the most influential artists of the twentieth century. His films have influenced music, painting, sculpture, television, literature—even architecture. But the true measure of his influence is that we often describe and understand certain works of art, or experience we have in life beyond cinema, with an adjective: 'Hitchcockian.' As with other giants of world art, to invoke Hitchcock's name is to summon up a flavor, a feeling—the essence of his work."[27]

7

The physicists speak

If Hawking and Mlodinow are right in their belief that scientists are the new philosophers, then we should listen very carefully to what scientists are saying, particularly physicists. To that end, I traveled from one end of the country to the other, from New Jersey and Pennsylvania to California, to speak to scientists about their work and the intersection of their work with that of artists and filmmakers. I had started my journey with a guiding metaphor—dark energy—and it had led me from the films of Alfred Hitchcock to the thought experiments of Alfred Einstein.

The physicists I spoke to were interested in bridging the gap between science and the humanities, and consequently both had written books that treated concepts in both philosophical and scientific terms. Martin Bojowald's *Once Before Time: A Whole Story of the Universe* is a philosophical investigation of the "dominant theoretical edifice" that modern science has constructed to comprehend the universe: quantum mechanics and general relativity. As Bojowald states, "Understanding nature on the large and the small scale has become possible, from the whole universe in cosmology all the way down to single molecules, atoms, and even elementary particles by means of quantum theory."[1] Sean Carroll's book *From Eternity to Here: The Quest for the Ultimate Theory of Time* is a clever play on the title of the 1953 Fred Zinneman film, *From Here to Eternity*. In the Prologue, Carroll states, "Cosmology, the study of the whole universe, has made extraordinary strides over the past hundred years. Fourteen billion years ago, our universe (or at least the part of it we can observe) was in an unimaginably hot, dense state that we call 'the Big Bang.' Ever since, it has been expanding and cooling...a century ago, we didn't know any of that – scientists understood basically nothing about the structure of the universe beyond the Milky Way galaxy."[2]

Carroll and Bojowald wrote their books at the beginning of the twenty-first century; Einstein was born in the last quarter of the nineteenth century; the cinema was founded at the end of the nineteenth century; Hitchcock was

born at the bridge of the nineteenth and twentieth centuries; Einstein's annus mirabilis took place in the first years of the twentieth century. This timeline alone is evidence of the strong link between cinema and science.

Interview With Sean Carroll, Senior Researcher, Caltech

PS: Okay, Professor Carroll, I'm going to start out with a big question: Can you tell us what cosmology is and what cosmologists do?

SC: Cosmology is the study of the whole universe, at once. So everything else is a subset of cosmology in some sense. You know, all the rest of science looks at things on smaller scales. Cosmology looks at the whole universe, either the whole universe we can observe or even the whole universe beyond what we can actually observe. Cosmologists do lots of things. Most cosmologists are observers or experimenters; they look at the universe; they collect data, with telescopes or satellites; they try to figure out what is going on or what has gone on in the universe. Some like me are theoretical cosmologists. So we try to invent models that predict how things should work in the universe and compare them to the data. So, we've learned the universe is big, has a hundred billion galaxies; it's expanding; it's been 13.7 billion years since the Big Bang when everything started.

PS: Is a cosmologist a physicist? I mean is it a branch of physics? Or is physics a branch of cosmology?

SC: Cosmology is part of physics, and it is closely connected with astrophysics. It is sort of in between what you would call ordinary physics and ordinary astronomy.

PS: In your article, "From Experience to Metaphor by Way of Imagination," you talk about using some of science as metaphor and trying to apply science in non-scientific areas to see if there is a way the groups could talk to each other. So is there any way you can talk about the latest discoveries in cosmology and what they might mean for non-scientists, for people like me in the arts and humanities, for example?

SC: Well, I think there are many ways. The way that I like to put it is

that when scientists like me try to understand the way the natural world works, we naturally want to do better and better. Whatever understanding we have now, we want to improve upon it. And so what we do is when we have a theoretical model, we want to see if it fits the data we have. Then we also want to use that model to suggest places we should look that we don't understand. And these are either literal places or metaphorical places that get further and further away from everyday experience, because science understands as well as it can the world immediately around us and then it tries to understand the world further and further away. So, we go from looking at things here on earth to looking in the sky at planets and galaxies. We go from looking at things very, very small, such as atoms and subatomic particles, and we also look at extremes of environments, things moving close to the speed of light, things under high pressure, high temperature, things under unusual conditions. So we discover weird things; we discovered relativity, right? Space and time are all mixed together. We discover quantum mechanics that says that things you can observe about the universe are different from the things that really exist about the universe. We discover that the expanding universe is not eternal. At least part of the universe we observe is not eternal: it has a lifetime. It came from a point 13.7 billion years ago. We discover these things called dark matter and dark energy; we find them in the stuff we are made of. You and I are made of atoms, which are made of particles that we understand and so stars and planets and all the other things we see in the universe are also made of atoms and the same set of particles just in different sets of combinations. But that is only four percent of the universe. We can weigh the universe; we can actually put the universe on a scale and figure out how much of it there is. Four percent is ordinary matter. You look, and there are things that surprise you or that confuse you—so you inherit a theory. Twenty-three percent dark matter, this new kind of particle that we haven't yet discovered but that has a gravitational field; and 73 percent dark energy, the kind of stuff that isn't even a particle; it's just sort of spread throughout space. So, that is an example of trying to match our theories to data. It is the trying to understand data in extreme environments, from the very edges of what we can reach empirically, that forces us to come up with crazy ideas. It's not like someone said, "Well, maybe there should be dark energy. Wouldn't that be neat?" You look at the universe, and the universe tells you certain things that

surprise you. Not only are galaxies moving away from us; they are accelerating; they are moving faster and faster. That's a surprise, so you invent dark energy to accommodate that empirical surprise. So the data that the universe gives us—forces us—to come up with ideas that we wouldn't otherwise come up with. We have these ideas that you can then use to explain the universe and inspire artists and storytellers and other creative types, to come up with different kinds of stories, different source material for plots and for metaphors and similes. So, everything, from relativity to quantum mechanics, to dark matter to dark energy—these are all fascinating to think about in terms of storytelling or what kind of artistic creations can be inspired.

PS: And not just science fiction. I'm sure science fiction writers love these cutting edge discoveries that they can use to stimulate their imaginations. But, I'm wondering whether there is any way that what you are discovering could be used by people who are not creators of science fiction.

SC: I think science fiction, as you say, is an obvious purpose, but it's certainly not at all the only purpose. Probably the best and most famous example is Tom Stoppard's play *Arcadia*, which is about two families that are separated by over 100 years but that live in the same house. They are talking about ideas from thermodynamics and mechanics to chaos theory and so forth, all of which come from science. And of course, it's not just like they are sitting around talking; some of the ideas they talk about are being reflected in the plot of the play and the connections between one family and another. There is no science fiction whatsoever; there is no separation from reality. But you know we live in a world governed by science. So, it is not only in speculation that these ideas can play a role. Stoppard's play presents different ways of thinking about and conceptualizing things that storytellers and artists would be talking about anyway.

PS: I think about Einstein in connection with what you are saying. He is sort of a pop culture hero and a scientist, too. I am amazed that he could concoct his thought experiments in the same way that a writer comes up with the plot of a play. I know I'm not going to get it right, but he imagines people sitting in a train going the speed of light and then shining a beam of light. This metaphor seemed so much more exciting than a lot of formula on the blackboard, although you have to turn it into math. That to me seemed as exciting or as close to an artistic creation as a science creation.

SC: I think in both cases, there is puzzle solving involved. If you are making a Hollywood blockbuster, you want to get your protagonist to a certain place at a certain time, with a certain gizmo. So how do you make that happen with a natural flow of a story? You are solving a puzzle; you have pieces that you aren't sure how to fit together. And science is exactly the same way; you are trying to solve a puzzle you don't know the answer to yet, but you have pieces. You have clues from data. You also have a logical structure or a theory you are trying to work with. So, putting things together in both senses is about telling a coherent and convincing story.

PS: In your essay, "From Experience to Metaphor," you state that the ideas of modern science are sometimes "startling and alien," and that they can provide unique metaphorical source material for literary creators. When I read that, I thought, "This is exciting, not just for literary creators, but maybe for a cinema scholar and a critic as well." Maybe some of these metaphors or some of these ideas that seem so exciting and bizarre could even be applied to film criticism. So, I thought, let's try this: the theory of dark energy and dark matter seems to me a perfect way of applying the "startling and alien" ideas to cinema. So perhaps you could tell us a little bit about what these things are.

SC: Dark matter and dark energy are equally and absolutely great source materials for metaphors because what's going on is we are trying to understand what the universe consists of, what it is made of, and what the ingredients are. But we can't see all of the ingredients, so we try to infer the existence of things. The good news is we see a lot; we get a lot of information from what we see. Let me give you an example: imagine that the moon is completely transparent, that the moon is completely invisible. It's there, same mass, same location, same orbit and everything, but you can't see it. But you would still know it is there, and the reason you would know is that the moon gives rise to tides here on earth. If you see the tides, and collect data about the tides around the world, and how they behave and so forth, you could not only come up with a hypothesis that there is some mass out there perturbing and pushing and pulling the oceans of the earth, but you could also figure out how far away it is, how heavy it is, what its orbital period is—all of these things. Basically the moon gives rises to a gravitational pull that affects things here on earth and you can infer that therefore it must exist. And, this is not a thought experiment; this is how we discovered the planet Neptune. Uranus was already there; it was moving around,

but its orbit wasn't quite right, and someone said, "Well, if you posit the existence of an unknown mass or planet that is pushing around the orbit in just the right way it should be there and you should find it," and that is how we found Neptune. So that is a good example. So in modern cosmology, we'll be doing this again to discover both dark matter and dark energy. So dark matter *is* matter; it's just like ordinary particles, but you just can't see them. There is more of them, more dark matter than ordinary matter, so what that means is in a galaxy most of the gravitational pull in the galaxy comes from the dark matter, not from the ordinary matter. So you can look at how stars move through a galaxy; and how gas and dust move through a galaxy and kind of map out the total gravitational field of the galaxy. You can compare it to the gravitational field that should be caused by the matter you see, but there is a mismatch. This prompts you to invent this idea of dark matter, and then you use that idea to make other predictions for other galaxies, for the evolution of the universe, for the growth of structures in the universe from the early times, when there weren't any galaxies, to today, and it fits and it fits over and over again. And likewise with dark energy, which pushes apart the galaxies and slows down their rates of growth. You can again discover it, discover the phenomenon, come up with the idea of dark energy to explain it and then match it to more data so you are eventually on the right track. So overall the picture we have is that we live in a universe where most of the stuff is invisible, but it affects the visible stuff and pushes around the visible stuff. You can say we are like the lights on a Christmas tree in a dark field. You don't see the tree, but you can see the lights on it, so you can infer the existence of the tree. Or we are like a martini; we are the little olive in the martini; we are the part you can see, because you can see right through the gin and vermouth. The olive is not the important part; it's a small part, but it is the visible part: the martini itself is transparent. So, the idea I think is that we live in a world where most of the stuff is invisible to us and where that stuff plays a crucial role in how we act, how we behave, how we are influenced. But we can't see it, and we have to infer its existence. The metaphors write themselves. It is not that hard to come up with how this will inspire someone or give you a new way of looking at storytelling.

PS: What about the term "dark"? We'll work our way into Hitchcock in a minute, but does "dark" mean something in physics that it doesn't mean in ordinary language?

SC: It means almost the same thing, but not quite the same thing. What it really means is invisible. So dark means not effectively interacting with light. So not only does it not glow; it's not shining, but it does not reflect light; it does not absorb light. It is not that it is just black; dark is different than black. If you had a black something, you could see it because it would get in the way of other things. But light passes through dark matter completely without being affected. That is not such a weird phenomenon. The air is dark; it is completely invisible. You can see right through it (well, perhaps not here in Los Angeles), but on a perfect day, the air is just like dark matter; you can't see it. However, you can see the air if you use the right instruments, whereas with dark matter and dark energy, as far as we can tell, there are no instruments that we have that have enabled us to see it. We are trying, but we have not yet been able to see it.

PS: In your series of lectures entitled "Dark Matter, Dark Energy" for the "Great Courses" series, you talk about WIMPS as the prime candidate for the particle that makes up dark matter. What is a WIMP?

SC: Well, WIMP is an acronym for "weakly interacting massive particle." It is a great time to be thinking about this. We are entering a period over the next five years, maybe ten years; during which dark matter science is really going to change a lot. We've reached a point where our detectors, our instruments, have a plausible chance of finding dark matter, making it no longer dark and thus visible for the first time. The interesting thing is the variety of different techniques, all which are creeping up on it; one technique is called "direct detection." You build a machine; you put it underground so it's shielded from radiation and cosmic rays and things like that. A dark matter particle comes in and bumps into an atom, and this happens all the time but so rarely and the world is so noisy you don't notice it. But, down here you make it very, very quiet until you can notice when a dark matter particle hits an atom and your detector deposits a little bit of energy, and you are sort of able to say this dark matter particle would act this way and a neutron would act a different way so you tell the difference between dark matter and a neutron. That machine is coming on line. These experiments have been around for a while, but they are finally getting to the sensitivity range where you will not be surprised when they find something. Another thing to look at is "indirect detection." You think the world is full of dark matter, but dark matter particles come together and annihilate. It is rare; otherwise, they would be doing it all the time, but occasionally

two dark matter particles can bump into each other and create photons. So, they are high energy photons, and we are looking for these high energy photons, for example, in the center of our galaxy, where there should be a lot of dark matter. There is a satellite called a Fermi satellite that looks for these high energy photons coming from different parts of the universe. The problem is there are plenty of things that make high energy photons, and it is hard to distinguish dark energy from other things. And finally, we are trying to make dark matter in the lab; we have the Large Hadron Collider in Switzerland.

PS: Some people worry that the collider is going to create a black hole. I think a science fiction story is going to come out of this!

SC: Oh, there is more than one. One of the things they could try to make is dark matter. The problem is, if you made it, how do you know it's dark matter? But the good news is we have all these different techniques coming together, and there have been some tantalizing hints. There is an experiment called Panella, a balloon in Antarctica that looks at the sky and detects not only electrons, but also positrons, which are anti-electrons. And it turns out there are a lot more positrons hitting this experiment than you would expect. Where are they coming from? One of the leading proposed explanations is that the positrons come from dark matter particles annihilating into each other and creating positrons. Now, that is all very speculative, but people get very excited, so they asked, "Well, if you are making positrons, why aren't you making these other particles?" This is what theoretical physicists ask. We are trying to explain these phenomena in ways that are consistent with everything else that we know. We haven't yet had firm evidence that dark matter has been detected, but we've had tantalizing clues, and we hope that in the next couple of years we'll know even more.

PS: As you are talking, I'm thinking of the way you measure particles and what you see. I think there is a connection to film, in an indirect way. We have lenses on telescopes and we have light. And you know this is the cinema; it is lenses and light, and of course a recording medium. Filmmakers are artists, but they are also technicians too, and they have technicians working for them. And they sometimes have scientist working for them. You know, the cinema comes out of the scientific discoveries of the nineteenth century in optics, physics, chemistry—and these discoveries were all brought together, at the turn of the twentieth century, at almost the same time that Einstein came up with his general theory

of relativity. There is a kind of connection here between physics and cinema in that we are dealing with light; we are dealing with observation; we are dealing with lenses, and we are even dealing with the construction of spacetime in a cinematic shot. And when in your course you talk about Einstein's general theory of relativity, his construct of spacetime, I thought there is a connection.

SC: One way to put it is that, when you are making a movie, for example, and you can say this about writing a novel, you make choices. So when you view a scene, and the movie is effective, you are thinking you are in the scene. The movie maker thinks about how the scene is framed, how it is lit, how the sound is, the soundtrack, the music, the depth of field, what is in focus, what is not in focus, all of these issues. And likewise, scientists think about general relativity and quantum physics, the extension of the universe. These theories came out of experiments, and the experimenters needed to make choices about money, time, intellectual resources and the goal of the experiment. In addition, scientists are concerned about what you are going to look for, what you are going to throw away. The Large Hadron Collider, for example, collides protons together a billion times per second. Once it is working, you are going to get a billion collisions per second. You don't just take a snapshot of it; you take a megabyte of data for every single collision. As you quickly do the math, a megabyte of data, a billion times a second is a lot of data, and in fact it is far more data than any available technology can actually store, so you can't record it to a disc. So what you have to do is a billion times a second, quickly look at the event, via a trigger, which decides that this event looks interesting or boring. And if it is boring, you throw it away, and if it is interesting you keep it. You keep only a small number, so what you keep is the one in a billion event. You are throwing away almost all of the data that you are constructing because you can't keep it all. So you are making choices of what is interesting and what is not. The same thing is true for many artists: once you have a blank canvas in front of you, or a movie camera with a bunch of unexposed film, you start making choices of what to do and what not to do. There are an infinite number of things you can do, but there is only one thing you are going to do.

PS: And you are going to do it with lenses and light and subject matter. I know cinematographers get upset when people write books about Hitchcock and how he composed his shots and how supposedly he never looked through the camera. But he had a wonderful

cinematographer, who was a craftsman, technician, scientist in a way, who understood the way light is captured, the way a certain kind of lens bends the light rays and how those things get registered on a certain kind of film stock. The cinematographer is like a scientist who takes technical and artistic choices. And that is why the cinema seems to me a perfect combination of art, technology, and science. But a lot of people don't understand it or talk about this combination, and that is why I'm interested in doing this book.

SC: Just like Hitchcock never looked through a camera—Einstein never did an experiment. He was a theorist. He relied on people getting their hands dirty and going in there and collecting data and getting surprises brought back about the world. Then he could sit in his coffee shop, as I do, and try to think about what it all means and get the glory for doing so, but there is a tremendous amount of effort that is going into making choices of what data to collect and what it all means.

PS: Talking again about metaphors and about artists, there are two influential biographies of Hitchcock: one is called *The Dark Side of Genius: The Life of Alfred Hitchcock*, by Donald Spoto, and that was not a very flattering picture of Hitchcock as a person, but very complimentary of Hitchcock as an artist. And then there was a kind of reaction to that, another biography entitled *Alfred Hitchcock: A Life in Darkness and Light*, by Patrick McGilligan. I think both biographers are using darkness in several different ways. One is darkness and light as obviously the palate that a filmmaker uses, but darkness in the first biography was really talking about a dark side, you know the dark side of a human being. Do you see any way of thinking about that idea in terms of dark energy and dark matter?

SC: Well, I think we use darkness and lightness in ordinary human experiences as metaphors for good and evil. I don't think there is any connection there with ordinary matter and dark matter, or anything like that. So let's instead look at the connection of mystery vs. clarity. From there, there is a huge connection: the ordinary matter we see is evident, and is clear and immediate in front of us, but the dark matter is mysterious. It is most of the universe; it effects what goes on; it is much more important to the history of the universe in some ways than ordinary matter is, but it is still mysterious. It is working behind the scenes in some sense, not at the surface level, so it is not immediately apparent. So in that sense, yes I think there is a lot of connection.

PS: I think that when I was working on my book on the shower scene in *Psycho* and looking at the images that Hitchcock created, I realized that he created them in a way similar to the way Einstein came up with his ideas. He thought about what he exactly wanted to see in the camera. He knew what a 50mm lens would capture, and he knew what a certain angle would capture. I know he did work on the technology; he had this intuitive sense of what he was capturing, how light looked and so forth. So he would think everything through and construct the film in his head, and then he would always say, "When I'm finished with the script or finished with the storyboards and the work-up, I wish I didn't have to go and shoot the film." Because then, it is like the Hadron Collider, you know you are going to keep one in a billion and throw a lot of it away. So, when I was watching Hitchcock's images, I was thinking that the world that we see, the objects that we see are certainly important in his film frame. I mean this is how he develops character and gets a sense of setting and so forth. But there is so much of his cinematic world we are not seeing on the frame that seems even more important than the world we see. And so I think, to me, that dark energy and dark matter are good ways of saying, "Just because you don't see it, just because it is not visible, that doesn't mean it is not important in a sense."

SC: Yes, in fact you can go a little bit beyond that, and even say the parts you do see are representing—in some sense are sort of illuminating indirectly—the parts that are really there, the parts you can't see. In the universe, we don't see the matter because it is mostly dark matter, but to what extent is the physical matter telling you where the dark matter is—and questions like that. So, I think the interesting thing is that what you see is affected by and can be used to figure out what is really there by something you can't see. But it is not the same as what is really there; I think that is true in both cosmology and in cinema.

PS: As you are talking I'm thinking of Hitchcock's film *I Confess*, a 1952 film about a priest who hears the confession of a murderer, someone who works in the rectory. The setting is in Quebec City, a very Catholic city. Then the priest gets accused of the murder, because the real murderer was dressed as a priest and was observed leaving the scene of the crime. So it is a typical Hitchcock story, an innocent person wrongly accused, but the priest can't clear himself because he can't break the seal of the confession. Throughout the film, Hitchcock presents crosses and crucifixes to

give you a sense of the religious background of the world the priest
finds himself in. And I'm thinking, "So you see a cross on the top
of a church or you see Father Logan coming in after mass with
his vestments with the big cross on the back: Those crosses are
images and they load the frame itself with the story of Christianity.
You can see the cross but you can't see the way that the cross and
what it symbolizes affect every aspect of the world of the film."

SC: That's right. When you look at an image like that, you are not just
looking at a set of pixels, arranged on a screen; there is meaning
behind that and it comes in a context. So, there is a lot more there.

PS: I think too, in dark energy and dark matter, the world that you see is
such a small part of the world you don't see and is totally affected
by it. That is the same kind of thing and can be applied to an image
done by a master creator, who has figured out a way of involving
the audience in these images and making those things they see
somewhat important, but making the things they don't see even
more important.

SC: Yes, and I should also mention of course that we use words like
dark matter and dark energy, and they have very specific meaning
with cosmology, but the four percent of the universe that is ordinary
matter, not all of that is easy to see. Just like air is ordinary matter,
but you can't see it. If you looked at the sky using different tools,
using visible light, radio waves, gamma rays, gravitational waves, or
something like that, you'd see different aspects of the universe, just
as different filters on a lens show us different images. Astronomers
take that to an extreme. The difference between a radio telescope
and an ordinary optical telescope is basically a difference in filter.

PS: Going back to Einstein and the concept of spacetime, when
you take a film shot made up of individual frames, you really are
capturing on that piece of film spacetime: space and time are not
separate entities; they're one and the same.

SC: Yes, that is right.

PS: Could you explain spacetime in ways we could understand it?

SC: It is a little bit of a complicated story. In one sense, it is perfectly
obvious that space and time are similar to each other. Mainly in this
sense: if you want to find something in the universe, you can tell me
where it is and when it is. For example, if I wanted to meet here
in this office, I need to tell you it is in Lauritsen Hall, fourth floor,
room 459, and we had to agree 10:00 am, on a certain Friday. Right?
So both space, the location of objects in the universe, and time,
when things happen, function as labels that help us find events

that synchronize. So that's kind of obvious. But on the other hand, there is also a huge difference; space is not something you can arrange and move right and left, forward and backward. There is no preferred direction to space, whereas time pushes us through: we go from the past to the future; thus there is this directionality. We tend to live our everyday lives not thinking about space and time as similar because space is something we can arrange things in, whereas time is something that just happens whether we like it or not. So it was Einstein and his collaborators and colleagues in the early twentieth century who went to the next step and said actually space and time really are the same, even though they seem very different. The right way to think about the universe is not to split it up into space and time. Two different people will have two different notions of what space is and what time is. If you are moving close to the speed of light, your idea of time throughout the universe is different than someone who is stationary. So the reason why we all agree on telling time in the universe is because we are all moving slowly with respect to each other compared to the speed of light. With the deep down laws of nature, think of time as really a lot like space. For example, if you travel from Cleveland to LA and you ask how many miles you traveled, the answer depends upon how you got there. What route you took. Did you go through Montana or did you go down through Arizona or did you try to take a straight line? No one is surprised by that. It is obvious that the distance you traveled depends upon the route you took. But people are surprised by the statement that the amount of time it takes to go from one event in the universe to another depends on the route you take. But that is exactly what Einstein shows. He shows that if you sit here in this room with a clock, and I zoom out at the speed of light with a clock and come back, you and I have experienced different amounts of time. Just as when we experience different amounts of distance when we traveled from Cleveland to LA on different paths. You take a different path through the universe; you experience different amounts of time.

PS: So what would be the implications for people who are, I guess I want to say in ordinary time and space? If space and time are the same, if there is a spacetime rather than one thing and then another thing, would it mean that people experience time in a different sense? I know that in some circumstances time seems to slow down. Does that really mean that it slows down? Or is it the way we experience it?

SC: It is a little bit complicated. The first thing you say is that since none of us are traveling close to the speed of light, in some sense it doesn't matter, for our everyday lives or even for our fairly advanced levels of life. The pre-Einstein way of thinking about space and time is through Newton. Isaac Newton had an idea that space and time were both absolute. They existed, but they were separate: there was space and there was time. And that is perfectly okay when thinking about getting through our everyday lives; we don't need to think about relativity. But there are these interesting questions about how fast time moves or how fast we move through time. And there I think you have to be very careful about distinguishing between the perception of time and something like the real rate at which time is ticking. A glib and nevertheless an accurate definition of time is the time that clocks make. Okay, but then you say well, what is a clock? A clock is something that ticks, something that does something repeatedly over and over again in a particular way. The earth spinning around on its axis spins around 365–and-a-quarter times every time it orbits around the sun. That tells time because it is predictable; one thing happens a certain number of times every time something else happens. When we experience time seeming to be faster or slower, that is because we have biological clocks. We have our heart rate; we have our electro-chemical nervous system; we have our breathing, but our biological clocks are not very reliable. We have adrenaline going through or we are tired, or we are more or less alert at times, so we experience time to go differently just because we are not very good or very accurate time keepers. On the other hand, Einstein says that if you move at different rates through the universe or if you travel through different gravitational fields, like if you are here on earth or if you are in orbit, the total amount of time you would measure, compared to someone elsewhere, will be different. So for example, our satellites in orbit—GPS satellites used to find where you are—they beam signals down and we measure the amount of time elapsed between these signals, but they are in a different gravitational field when they are in orbit. So Einstein says compared to us, their clocks tick at a different rate, and he is right and if we didn't know that within a minute GPS would be completely useless. It would tell us we were miles away from where we are. So these effects are real, but in our everyday lives, as long as we are not in orbit or traveling near the speed of light we can generally all experience time in the same way.

PS: I think about the way a filmmaker can manipulate time and slow it

down by shooting a whole bunch of frames a second or can speed time up by doing the exact opposite thing. So, is a filmmaker, in a way, doing a little experiment in time the way Einstein might have done?

SC: Yes, in some sense the finished product of a film is very, very rigid in respect to time. It will always take five minutes for this thing to happen no matter where you show it. But within that five minutes the filmmaker can choose to show more or less time speeded up or slowed down, not to mention flashbacks, or reverse chronologies, or all of those innovative narrative things that filmmakers do. So the goal of the filmmaker is to take advantage of the fact that on the one hand the film proceeds at twenty-four frames per second, but on the other hand, the narrative time to which that corresponds is completely fluid. So that is something to play with. So yes, you can make things seem to go faster or seem to go slower. We usually think things in the past effect things in the future, but in the course of the movie, you learn about things that happen in the future before you learn about things in the past and the perception of those cause and effect relationships is effected by that. So, that is why flashbacks are interesting because you learn about something that happened in the past and how it shapes what is going on right now. So, that is one of the great time tools that filmmakers use.

PS: I just thought of something: Hitchcock does use flashbacks, but he doesn't use them very often. But in one of his films, *Stage Fright* he uses the false flashback: a character comes in and tells a story about what had happened and of course we the audience are cued to believe that what the filmmaker is presenting to us or what a character is presenting to us is true. Then we find out later that it was a false flashback, that the truth was something else. So I'm thinking that the false flashbacks and the true events are like parallel universes within which a filmmaker can select different senses of time. Did this really happen or what is happening on the space that we see, didn't really happen but it did in a sense happen because we watched it happen. And all of a sudden we think, "Wow, we are in a very special kind of world when we watch a movie."

SC: Yes and there are unreliable narrators, who present to us events that didn't happen, but in a sense they did, because we saw them happen. I'm thinking of the *Usual Suspects* and the series of events supplied by the unreliable narrator Kaiser Sozay. There is a certain trust the audience places in the filmmaker that the film will

somehow make sense. As we go through our everyday lives, we look at people on the street or in the line in the ATM or whatever: there is no guarantee there is some coherent narrative to what we see going on around us. But most of the time in a film there is coherence, a structure so that there is some reason why we are seeing events in this order and at this rate of speed, with these narrators explaining them to us.

PS: Especially true for filmmakers. If we have an unreliable narrator telling us a story and then we find out that we've been duped, it can either put us off or make us watch the film. For example, take the film *Psycho*: Hitchcock set it up so the audience is taken "down the garden path," thinking they are watching a movie about a woman who has stolen $40,000 and she has a change of heart when she gets to the Bates Motel. She talks to this sort of sad, pathetic character, talks about being in a trap, and then she realizes that she did something terribly wrong, so she needs to return and give the money back. So the audience is thinking this is a very attractive woman and she has this relationship with this guy and she is going to get married, so she steals money to make this happen. But then she sees this sad young man at the motel and has a change of heart. She will give the money back. With this new resolution she takes a shower and out of the blue gets slaughtered and the film completely changes: it is as if it goes on another parallel narrative track that forces the audience to sort of think back to what they had watched before and this is how the suspense works.

SC: That is right. It is a great tool in the storyteller's tool kit. We think of events proceeding from the past to the future, but that doesn't mean the storyteller has to tell us those events reliably in the order they happen. A more contemporary example is in *Lost*, the TV show. One of the highlights for me was, I guess, in season four. All along in season one and two the flashback was an absolutely crucial hell of a ride. And then they show us these scenes in season four that look like they are showing us flashbacks, and it eventually dawns on us several episodes into it that they are flash forwards. They are showing us the future of what happens. They have totally screwed with our preconceptions of causation and time.

PS: Yes, and I think it works very well in cinema because you can essentially put these things in the same frame. Shots follow one another in the same cinematic rectangle. It's not like it is on page two and then to go up to page 80 in different parts of the book. Essentially, even though a scene takes place earlier, it still takes

place in this spacetime construct on that same frame, almost simultaneously.

SC: Yes, there is the narrative time with the audience and then there is the chronological time with the story.

PS: Let's come back to Einstein. If someone is traveling close to the speed of light in a space ship, would events happen there in a different time than on Earth? Would they be slower up there compared to what we experience?

SC: One crucial thing I forgot to emphasize is that to the person on the spaceship everything is completely ordinary. That is because the way that we experience time is we have internal biological clocks synchronized in certain ways to external clocks. So I have a watch, and you maybe sit here and count to sixty. I might be able to more or less tell you how long a minute is without looking at my watch. But really it's my sense of time being compared to these physical mechanisms. If both my watch and I go into a spaceship, we are both going to be effected in the same way by our journey. So, I always perceive one second per second. Now I never feel because I am in a spaceship or near a black hole or something like that time has slowed down. It is only when I compare myself to someone who is not on that spaceship to someone who is sitting here in the office in a different gravitational field that the total amount of time I will experience is different for me than for them. That comparison is tricky; the whole point of Einstein is that there is no such thing as two distant events happening at the same time.

PS: The filmmakers love parallel editing: you know, two scenes happening at the same time but in different places. Would Einstein say, "Wait, you can't do that. You better slow one of them down because they can't happen simultaneously."

SC: No, you just cannot do that. There is no such thing as "the same time." Just as you have a map of the United States and you divide it into longitude and latitude. You can say two things are the same latitude, like two cities are the same latitude on the map. If someone else drew a different grid of the United States, they would have different ways of saying the two cities are on the same part of their grid. And it doesn't matter; it is two different ways of drawing a grid on the United States. There is nothing real. The way that we draw lines of latitude is not inherent in the Earth; it is just a convenient thing for us. Sometimes I think it is true that the way we divide the universe up into moments of time is just convenient for us, but it is not inherent in how the universe works.

PS: That is fascinating. Maybe we should end with something that C. P. Snow said about the two cultures. He said we've artificially constructed these two cultures, one a science culture and the other one a humanities culture, and we are not talking to each other. In fact we are over weighted in our education towards the humanities. So he thought every educated person should know, for example, the Second Law of Thermodynamics, but most educated people don't. Do you think that scientists and humanities people don't talk the same language or don't try to talk in the same way; do you still think there is this cultural divide?

SC: Yes, it is perfectly obvious. There is a divide between science and everything else, in particular the way scientists speak and the way storytellers speak. A lot of it is scientists' fault, and I think it is important to overcome this. But science works pretty well without help from other people. I think it might work even better and would be more fun and more interesting if it took other fields more seriously, but we don't need them; you don't need to understand poetry to do work in particle research, for example. In fact, I would go so far as to say that a lot of scientists are sort of implicitly anti-intellectuals in that they look down at things other than what they are doing. A true intellectual spirit has a respect for all the things that people are doing, rather than saying some are important and some are not important. I think that the world would be a better place if science were made more acceptable—if science were a part of everyone's toolkit. More importantly, it would just make our lives more interesting if knowledge about science were taken for granted among educated people. I think a lot of it, though, is scientists' fault. Why, when we teach Introduction to Astronomy, do we start with the boring part? Certainly when we teach physics, we start with the boring parts. You know a history major could take the introductory physics course and think it was about incline planes and pulleys and the most boring parts of the universe and never hear about dark energy or black holes or extra dimensions, and I have no idea why that is, to be honest.

PS: When I was planning this project—to investigate the films of Hitchcock through science and technology—I looked around to see if there were other books that tried to approach the material in this way. I didn't find any. The idea of applying scientific thinking and scientific concepts to the things we see on the screen is not so startling. Film and television are products of science and technology. If it weren't for science, there wouldn't be any film, and I think few

people understand the science behind the art. Seeing film with the help of science and technology would help us understand what a filmmaker sometimes does intuitively or maybe does carefully and thoughtfully the way I think Hitchcock did without calling himself a scientist.

SC: Being able to think about things scientifically, understanding some of the basic ideas, such as the Second Law of Thermodynamics, (which I just wrote a book about by the way), knowing there are such things as dark matter and dark energy, understanding what quantum mechanics is and how conservation of energy works, the basic principles of calculus for example—knowing these things forms how you look at the world in useful ways, I like to think. So even if you are not someone who uses thermodynamics in their everyday lives, understanding that the difference between the past and the future is elementarily based on this thing called entropy, which tends to increase and measure the disorder of the universe is really very illuminating about how we think about what happens in the world. So again, you can be a very good scientist without understanding poetry; you can be a very good poet without understanding physics, but maybe you would be a better poet if you broadened your horizons, your conceptual horizons by understanding a little bit about how scientists look at the world.

PS: Do your colleagues understand or agree with some of the stuff you have done outside the field, such as writing about metaphors, for example? So would you say the scientists at Caltech have an appreciation for the humanities?

SC: Some do, but it is a minority. Again, you don't need that to be a successful scientist. And therefore, it is hard to be a successful scientist; the competition is tough to get jobs and to publish. There is something about the system that rewards specialization: the focus on one thing because you are trying to compete with other people at that thing. Therefore, you are judged by how well you do that thing, not how broad your intellect spreads over different things. On the other hand, there is a substantially healthy fraction of scientists who do take this broader content more seriously and find it interesting. So, I would like it if it were more important, and those of us who do find it more interesting have their work cut out and that is okay.

PS: Tell us about your latest book.

SC: I wrote a book about "the arrow of time," the difference between the past and the future and how the difference has to do with

entropy and how all that comes from cosmology and the conditions near the Big Bang: the fact you can turn an egg into an omelet but not an omelet into an egg. It is ultimately because the universe is very orderly near the Big Bang. The title is *From Eternity to Here*. I'm sure you recognize the film allusion. I think that you humanities scholars will enjoy it!

Interview with Martin Bojowald, Associate Professor of Physics, Penn State University

PS: In your book, *Once Before Time: A Whole Story of the Universe*, you combine not only science but also mythology and literature and other fields that are related to science, and I'm wondering how you got oriented in that direction. In your education did you study science as well as literature and art?

MB: No. I didn't really like literature in high school in Germany. At some point I got into physics. Initially, actually, I was more interested in biology. I got a microscope. That's how it started. Then I kept reading books, and I found out about all these things and wanted to understand them. And by the time I had to decide where to go to college, it was physics that was my main interest. I also had an interest in mathematics, but it was never really pure mathematics. I always saw it as a tool to understand physics and other things. That was one of the things that fascinated me about physics because it's close to observation; it's about observations, but to a very large degree it uses mathematics to develop it further and to interpret observations to understand what we are seeing. That's an interaction that I found very interesting, so I decided to take physics. I had mathematics as a minor.

PS: Did you take any philosophy classes?

MB: No, but I was always interested in philosophy. I kept reading philosophy. Initially it was science-related philosophy, like positivism, those things that are really influenced by science but then also influenced the developments and some of the understanding in

science. So that's how it started. And somehow, through that connection, I got into Nietzsche. Nietzsche brought me to literature, but there was never any formal class or any formal education.

PS: I know that when I was studying literature, we would read Kant or even Newton, and in the eighteenth century there was such an emphasis on the combining of science and literature. They were almost like twin disciplines. And then, something seemed to happen to education. And I know that when I was talking to Sean Carroll at Caltech about his book called *From Eternity to Here*, which is about entropy, he mentioned C. P. Snow, the British philosopher, who lamented the two cultures, the separation between I guess you call it the humanities culture and science culture. People stopped talking to each other. Or education veered away from science and favored humanities. I think I can see it in my own field. Maybe that's one of the reasons why when I thought about doing a topic on Hitchcock that was science oriented, I realized at least from my reading, that there wasn't much out there that used science and technology. People would talk about the camera and lenses, but the science behind the art was glossed over. That was one of the reasons why, when I saw your book and I saw these other books that attempted to put these things together, I thought to myself that maybe I could do something like that with what I considered to be the most exciting and mind blowing science out there, and that would be physics and cosmology. Do you think that there is a culture gap that exists in American education?

MB: Oh, I think it's everywhere. I think it's even worse in Germany, for instance. Everybody has difficulties of course, with mathematics; that's very common. I think in Germany there's more arrogance among non-scientists toward science and probably also the other way around. In the U.S. my experience shows that it's much more science friendly in general.

PS: Well, there seems to be in American popular culture, anyways, an appreciation for the person who used to be bullied a lot, and that was the nerd and now the geek. And now, it's somehow fashionable and popular to be a geek. Look at the TV sitcom *The Big Bang Theory*, for example. In the Preface to your book, you say that doing a popular book on science would be, "the ideal place to allude to the unity of science, literature and art." So I'm wondering, could you talk about where you see that unity taking place?

MB: Well, I mainly see it taking place in my own experience. When I read literature, I often find places that to me sound just like scientific

statements. They are expressed differently, but in many places you see them. I was reading, recently, Thomas Mann, and he talked about the expansion of the universe. When he wrote the book it was one of his last, unfinished books; it remained a fragment, and cosmology wasn't very widespread at that time. But, everything he says you could still say is correct.

PS: Where would he get that idea?

MB: I have no idea.

PS: In Thomas Mann's *The Magic Mountain*, when Hans Castorp goes up to the mountain and he conveniently contracts this illness so that he can stay up there, he re-educates himself. And all of these most wonderful ideas get discussed in, I think, very fascinating ways. A lot of it is where science, philosophy and art touch each other. And those fields, I find fascinating.

MB: I also found that this kind of literature helps me sometimes. It doesn't really suggest any direct calculation or something that I could do, but, in a long-term perspective, it's really useful, especially in a field in which you don't have the formalism yet. Much of the development is just intuitive. And in this context it helps if you see how other people think about similar questions. I'm enjoying it anyway, but it's also useful for my own thinking.

PS: I remember when I was reading about Einstein, and how he came up with the special theory of relativity and these thought experiments that he would do, I thought they're like little science fiction stories.

MB: Yes, I think, in any case, that's probably how new developments begin in science. In your own mind you think about what could happen. Of course there's all the mathematics floating around, and before you do calculations, you have to think about what the concept should be, what could actually be going on and then you use mathematics to see if that can be true. But the first step is usually trying to do science fiction.

PS: I remember seeing a film by Nicolas Roeg, entitled *Insignificance*. It's based on the idea that Einstein, Marilyn Monroe, Joe McCarthy, and Joe DiMaggio, who was married to Marilyn Monroe at the time, but separated, were all in New York City at the same time. And Einstein was there to appear before the House Un-American Activities Committee. So I guess Nicolas Roeg thought, "What if they met? What would happen?" So there's a scene in which Marilyn ends up going to Einstein's hotel room. She's in New York filming *The Seven Year Itch*, with that famous scene where

she's wearing the white dress that billows over a sidewalk grate, revealing her gorgeous legs. She runs away from the set because her ex-husband, Joe DiMaggio, is after her. She ends up in Einstein's room, and they talk. And then she decides to show him that she understands his theory of relativity, and she uses these little figures that she has and flashlights to illustrate this idea of the speed of light and the relationship to someone moving at the speed of light or slower. So I thought, "What a fascinating idea!" And most people probably didn't know what the hell it was about, really. So thought to myself, when I was contemplating my book, would I like to combine science and film this way? In your book you say in the Preface that you wanted to write a popular book for non-scientists, like me, or for laymen. What prompted you to do it?

MB: Well, the actual prompt was the publisher, who wrote to me and asked if I had thought about it. I had been writing popular articles, so that was already an experience and I liked it—that's what the publisher noticed. I thought about it for a few days, and then I decided to do it. Well, for the same reason I just mentioned:

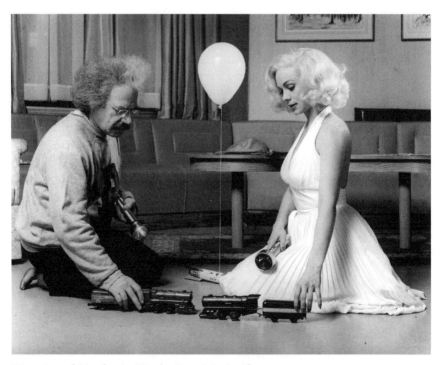

Einstein and Marilyn in Nicolas Roeg's Insignificance

these interactions with non-scientists, by reading literature or just by talking to non-scientists, I always find helpful. Or even email correspondence sometimes. And I see the strong interest that people usually have. There wasn't much available in this area, so I decided it's best to write up what I knew at that time.

PS: Stephen Hawking and Leonard Mlodinow's book, *The Grand Design*, I think, is written for the layman. And then Sean Carroll's book, *From Eternity to Here*, which plays on the title of the famous *From Here to Eternity* film, attempts to tell people about this wonderful stuff that's happening in physics and I don't think people know that it's happening. I think people know about the "Big Bang," but they don't know what it means.

MB: Well, even in science, cosmology has become popular only quite recently. These ideas, the theoretical ideas, are almost 100 years old by now, but as precision science, cosmology's very young, maybe about just 20 years old. The first satellite to observe the whole universe, COBE, was launched twenty years ago and that gave us a lot of information.

PS: Does it make you feel excited to be on this cutting edge? Would you call yourself a cosmologist?

MB: Yes, that would be the closest description.

PS: So, do you feel this is an exciting time to be doing this?

MB: It's very exciting. I remember once when I was just about to graduate, I think, there was a famous cosmologist who came to give a talk and he said "Maybe in ten years we can actually use observations to rule out some of the theories," which was unheard of at this time. And people almost laughed in the audience. But it happened that way. Particle physics also went through this phase, with all these accelerators in the 1980s and 1990s.

PS: So particle physics is the opposite of cosmology? It's the small stuff.

MB: Nowadays, it's the opposite, basically, of cosmology. The universe is very large; particles are very small, but when we go back in time, the whole universe, which is expanding, was probably the same size as particles at one stage. So there's a phase in the universe in which one really has to combine things. It's not just an idea or philosophy of unification. It's necessary, because the whole universe, everything there is, was extremely small, even smaller than an atomic particle.

PS: I mean, talk about mind blowing! There's a wonderful short film called "Cosmic Zoom" that was made by the National Film Board of Canada. It starts off with a kid rowing, and all of a sudden the

camera zooms back slowly, and you see the lake and all of a sudden it's like you're in a rocketship and you pull back from the earth and the solar system, and then we're going way, way back out into the farthest reaches of space. Then the camera stops, and then we zoom in very fast. Then we go down to the kid's hand, and there's a mosquito biting him, and so the camera goes in and zooms into the world in there, and it keeps going and going and there are molecules, first cells and then molecules and then smaller and smaller things until it reaches the very thing that looks just like the thing outside. I know it's not the same thing, but like the biggest place was once the smallest.

MB: Even at the level of physics, there are statements like this, that things that happen at different scales really do repeat each other. So it's not just visually that an atom looks almost like the solar system. There's something orbiting around, but it's also the different theories that describe it. On top of the many phenomena, there is a more general phenomenon, what we call "emergence," that structures arise from more elementary things. It seems to be a very universal concept, something that realizes the smallest and the largest.

PS: I had just written this book on the shower scene in *Psycho*, and part of what I did was to analyze, to do what I guess you could call a close reading of the scene, so I looked at each frame and each shot and tried to figure out what Hitchcock was doing with his camera. When I was done with it, I wasn't quite satisfied because there were things that I couldn't put my finger on that were there but not there, and then I was reading about dark energy, that so much of the universe is made up of this stuff that you can't see but that's exerting this gravitational force that's having an effect on things around it and I thought, "Wait a minute! That's what's going on in these shots, that what looks to be empty space isn't empty: it's loaded with energy." I call it dark energy because of Hitchcock's dark vision of the world. That's why I was thinking of the physics of cinema. Then I thought, "Well what is cinema but the capturing of light onto a medium and then capturing space too and then time," and I thought that sounds like spacetime. Could you explain to me, what spacetime is?

MB: Well, we don't really know what time is. Maybe space is a little easier, but even that is difficult, I think. Usually in physics we use two different understandings of space and time. Time is not just different places; there is some kind of ordering of events, causal relationships where some things can influence others. Then relativity

tells us that space and time are not really separate because when you're moving in what seems to be a spatial direction for one observer, it could be at least to some degree a time separation. Two events that are simultaneous to one observer would not be simultaneous to another person who is moving at high velocity, and that means—we would say there's a transformation—if you just change your velocity you can transform space into time or vice versa. Just as when you're rotating in space, what you see as the different dimensions are rotated into each other. For that reason we talk about spacetime and not space and time separately. But that doesn't really help us understand what time is. That's a question that's usually important at these very fundamental levels, and we're still working on combining quantum physics and gravity. So, I guess the most fundamental viewpoint is that time is not really a separate thing. It's made up of relationships between different kinds of matter, different objects and people, and we experience time because we have our memory. We know there are past events that we remember and can compare with current events, or maybe even extrapolate to the future, but there's not necessarily a notion of time that's realized at a fundamental physical scale. It may not be linear. It may not progress at the same pace at all times, which is also part of relativity. But probably, if you throw in quantum physics it becomes even more extreme. That's one of the questions where physics is becoming more and more philosophy.

PS: Yes, that's what I'm thinking. What you're saying is they're philosophical statements. "What is time?" Is there time do you think on a quantum scale?

MB: We don't know. If you take an elementary particle or an atom, which is a quantum system, you have strong uncertainties and fluctuations—in these systems time certainly exists. Time is even more elementary than an elementary particle. But when we go to quantum gravity, we are talking about quantizing spacetime— quantizing gravity, but gravity is spacetime. These pictures that we usually see from the deflection of light in curved spacetime, that tell us, by general relativity, that gravity is caused by properties of spacetime so spacetime is curved. It's bending around, and that means there are gravitational forces. But then if we try to combine quantum physics with gravity, we have to do quantum physics of spacetime. And then, as always in quantum physics, usually intuitive notions become much more murky. That applies to space and time as well, so we don't know yet whether time would still exist. It's still

there in some mathematical combinations, but it might disappear in others, somewhat changing its properties. There could be quantum jumps in time. That's one of the cinema metaphors that I use in the book because time is becoming discrete, almost like having just individual frames instead of a continuum.

PS: You said that when you put those frames together into a shot, you're really illustrating the physics of spacetime because what you've got in one strip of film is space and time together indistinguishable from one another and you can actually run it backwards. You can go backwards, but you could actually stop the film and call that the present and then run it and you're actually in the future. And I think that a filmmaker like Hitchcock, I don't know if he thought of things like this, but I think he intuited things like this. He called it pure cinema. Montage—that's time, and mise-en-scène is the space—and you combine them together, you've got a perfect illustration of spacetime where you're actually capturing light that existed forty years ago, for example, in some form and then showing it in the present. To me cinema leads to scientific ideas or it might illustrate them.

MB: When I read this one question in your email I also thought about these different notions of time. Because clearly, if you just put all these frames in a line, you order them. It's like the linear notion of time that we usually use in physics. We just have a time parameter in equations, and it runs through its range; but it doesn't change so you wouldn't slow it down or anything. It's just completely separate from anything else. There are certain events, collisions of particles or stars that happen with respect to this time, so it's almost like having a direct film of what's happening: let it run, and you see that the movie is a function of time. But when I thought about it a little more, I noticed that that's not really the notion that we think we are developing in quantum gravity, because time is more relative so it doesn't have this rigid structure. It seems that in physics there's certainly this underlying, rigid notion of time just by taking the frames. When you watch a movie, you don't notice the frames. You notice the interactions between different people or different events, and that's much closer to the notion of time that relativity has told us is more real because there's no absolute time and the way to measure change is by observing changes of some objects with respect to others. That's how we measure time: we think that there's some time going on, but we used to measure time by how the earth was revolving around the sun or its own axis,

or by comparing what we are doing with respect to the hands of the clock. We call it "relational time," so there's no absolute time but rather time as a consequence of relations between different objects. What we still don't understand is why it has to go in just one specific direction, for instance. You can move in all kinds of directions in space but not in time. We can't stop that; it has to keep going. The relational idea doesn't imply that this must be so—if it's relational, it's conceivable that at some point relations or changes just stop; it's not implied that time has to keep changing in one direction just because there are these relationships. There must be something even more elementary that we haven't discovered yet.

PS: Well, I know if you look at montage, or editing, and you take what's called parallel editing, two events happening in different places but at the same time, you can show those by showing the bad guy tying up Pearl Pureheart on the railroad tracks, and you cut to the train and it's coming closer to her and what you're doing is you're cutting up and expanding time. Or you can put it on the screen and split the screen up and have them actually in space happening at the same time. So I'm wondering why physicist don't go to the movies more. I think this is your next article. I think you ought to write about this.

MB: There are certainly different notions of time in movies as well as physics. I think what you just described makes it more relative because as there are more events that are happening, there's more suspense. You use more frames, so time seems to progress at a slower pace. On the other hand, as we experience it, sometimes you would say it's faster because it's more suspenseful; then even the psychological notion of time comes in.

PS: I think the great filmmakers, whether they realize it or not, have to be technicians. They wouldn't necessarily be scientists, although some of them come from technical or science backgrounds. In other words, they started out as cameramen and they study the lenses and light and all that stuff. But some of them come from the theater so they approach film as more a theatrical thing but they're still dealing with space and time; they have to understand those things.

MB: I know that some of my colleagues use movie scenes in their introduction to physics classes.

PS: Speaking of physics and the movies, I remember a fascinating movie called *Sliding Doors*, which presents two intertwined plot lines about two possible relationships involving the main character, played by Gwyneth Paltrow. The movie is on these two parallel

tracks, and it keeps cutting back and forth from one possible universe to another. And I know from reading your book and Hawking's book, that you're talking about different universes that are possible in quantum physics.

MB: Think of it as a pair of pants. At one point, if you take cross sections, it's still connected, but then if you slide down, you have two separate circles as one cross section. It would be two dimensions higher in four dimensions, but something like this could also happen for the universe. It might split off like this. You can have two separate universes, even if there's no quantum physics. There are some models in which our "Big Bang" was actually such a splitting-off point. We had had a much larger universe earlier and then, maybe through a black hole or something, spacetime pinched down and then it split off, down to our universe.

PS: So there could be another universe.

MB: There might be. But we would have no contact. We couldn't even say there's another universe "now" because it wouldn't have the same time, our time. If we have two separate spacetimes, you can't even compare them, and you can't say whether they are happening at the same time or not. The only way to say that would be to go backwards, to look backwards using observations, and then one might possibly see that there was that splitting off. That would be extremely difficult. Mathematically it's possible if one could find solutions that describe a large universe in this way, which then splits off. Quantum physics brings in a new perspective. For elementary particles, it happens usually that you have two different positions even if you have just one particle. A single electron in a hydrogen atom can be in two different states at the same time. It can have two different energy levels. Classical physics would always say at one time there is one specific energy value; we might not be able to measure it precisely, but there is some value that we just don't know and if we go closer and closer with our measurement we would find out what the value is. In quantum physics, it might be so, but in our situations it's not true. It can happen and it happens quite often that the electron has two different energy values at the same time. Or maybe even more than two values, and even if we try to measure the energy more and more precisely, we won't find the precise value, just something between the values that are realized in those things. That's called "quantum fluctuations," which also relate to Heisenberg's uncertainty principle. Now, that's quite established; you can make observations, measurements of

atoms and you see these things. And then if you apply quantum physics to the whole universe, you could have—that's what Hawking describes, I don't really like that idea, it's a little too speculative—but you might even have the universe, like the electron, in several different states at the same time. So in the movie that you describe, it's one universe, but it's in two different states.

PS: You look at one, but you don't see the other one.

MB: And you can't influence the other one even if you would know about it. There's no way to change things.

PS: Do you know there's a connection between Germany and Hitchcock? I like the parallels between Hitchcock's career and the development of cinema and scientific developments starting in 1905. But Hitchcock was born in 1899, and the film industry begins in 1895 and of course the special theory of relativity is in 1905; there are a lot of parallels. Hitchcock went to Germany in 1924 to act as an assistant director for an Anglo-German co-production called *The Blackguard*. He was strongly influenced by German Expressionism and by all the great German directors: Pabst, Murnau, Lang. In fact he even saw a couple of those films in production. He said, "If you want to understand me, go back and look at what the Germans were trying to do with light and images and time and space and so forth." So there's a nice connection between Germany and Hitchcock. He even spoke German. He directed his first film in Germany in 1925, so there are some interesting connections.

MB: He could have met Einstein.

PS: Well, you know, I thought they must have met at some time; after all, they were both pop culture "phenoms." Their personas were interesting to people: Einstein with the wild hair and Hitchcock with the funny profile. Their faces were as popular in the popular imagination as their work was. That would be fascinating: Einstein meets Hitchcock.

MB: About seven years ago, when Einstein's 150th birthday was celebrated, I saw a talk at a conference called Einstein and Picasso. I don't remember much.

PS: I know that Steve Martin wrote a play called *Picasso at the Lapin Agile*, which imagines that Picasso and Einstein met at a crucial time in their careers. And then there's Arthur Miller's book, *Einstein, Picasso*. Well, you know what Picasso does with space and Cubism; they're all related I think in interesting ways. Let me ask you about dark matter and dark energy. Could you talk about those things as concepts?

MB: Dark matter was found much earlier than dark energy. At some point an astronomer noticed if you look a galaxy, the way it's rotating, the outer reaches rotate much faster than they should actually according to the distribution of mass. We know that in the solar system, for instance, the period of the orbit of a planet depends on the mass of the sun and all the matter that's between the orbit and the center. So one can compute how fast a particular region of the galaxy should rotate around the center because we have a good idea of what kind of mass there is, the mass that we see, but then this astronomer noticed that that's not actually the case. The galaxy rotates much faster as we move out from the center than it should, and so there must be some kind of extra matter. That's the only explanation, or our understanding of gravity's not correct. Some people think that might actually be the case, that if you go to these large scales somehow the gravitational force doesn't have exactly the form that we think it should have. But it's difficult to fit all observations with this idea, so the only understanding is there's this extra mass. We don't see it; it doesn't produce any light; it's not hot enough or it's a kind of matter that doesn't emit light. So we don't see it, so that's why we call it dark. Well, another reason I think it's called dark is because we don't really know what it is. We can see its influence on the matter that we know, that we see and can predict correctly. By now it's been seen in many different versions as well, from the rotation curves but also from the deflection of light by large masses. The sun deflects light, and the same is true for dark matter. We don't understand dark matter, but it's better understood than dark energy. Some people think there might be some elementary particles that we don't know yet which are attracted to the center of the galaxy just because particles have mass. But then they don't produce light, so we don't see them. People are building detectors to find this type of elementary particle. Then dark energy. It was found much more recently, a little more than ten years ago. It was also unexpected, and here people looked at distant star explosions, phenomena which can be seen from very far away. The expansion of space is accelerating. There's no ordinary matter that we know which would lead to acceleration. Matter that we know always attracts each other, which would slow down the expansion. Mathematically it's possible to have this kind of acceleration. Physically that means one needs negative pressure. Pressure usually pushes on the walls. If you have more pressure, then the energy that you need, the work that you have to do to

keep it contained, is larger. There's a relationship between pressure and energy. Energy is always positive and pressure in this form is usually positive as well. But if you have negative pressure, then the opposite happens. The matter you have doesn't try to expand; it tries to collapse. A reversal of this is necessary in gravity, but it's difficult to explain intuitively. Even classically, just to see the implications of negative pressure. The only thing I can say is positive pressure is like mass or energy that leads to attraction. Negative pressure is the opposite so it leads to repulsion, and instead of slowing down the expansion it increases the expansion. That means since we see the expansion increasing, by these observations, there must be some kind of matter form which has negative pressure. That's called dark energy but it's even less clear what it is than that we call dark matter.

PS: What I find fascinating is the idea that there are unseen things that we don't understand that are affecting things around them and this is how you detect it. And that's why when I was looking at Hitchcock's images, I saw a lot of empty space, what looks like empty space around the figures and the characters, but the space is actually loaded with something, I decided to call it dark energy. But it's not the same as in physics. It's more metaphorical. Let me give you an example from *Psycho*. After Marion has been killed in the shower, in the famous shower scene, which I wrote the book about, Norman goes in to clean up: I call it the "cleaning up scene," and it's all done without dialogue because Hitchcock said he owed a lot to the Germans and he said they tried to tell the story visually, without resorting to subtitles, or inter-titles, so the whole thing is done without dialogue. But the whole scene is loaded with this, incredible sense of anxiety because of what's just happened, so everything you're seeing on the screen is conditioned by what you've just seen. So it's not just a guy coming into a shower and finding someone dead. It's way more than that. And so that's how I want to at least start talking about dark energy.

MB: Even for us it's really like a matter form when we say dark energy, although it's not like saying there's an electron. With an electron we really know what we mean. We know how to measure it, how to describe it mathematically. But dark energy is not the same kind.

PS: I think it's like the evil empire, Darth Vader!

MB: Some people suggest a candidate which could be responsible for that; they call it the phantom field.

PS: The phantom field, Oh, I love that! Martin, you have to write a screenplay here! There's a movie out there and it would help people to understand the "Big Bang." When I first heard that, I thought, "What a great idea to name it that rather than to give it some scientific sounding name!" Everybody understands the "Big Bang." I know it wasn't meant as a complimentary thing from your book but it's such a great concept that something blew up, but what blew up?

MB: I think even for physicists, names play a large role. Another example is the term "Black Hole."

PS: There's a film called *The Black Hole*. I think it was a Disney film, and one of its stars is Anthony Perkins, who plays Norman Bates. Hitchcock didn't make science fiction movies although I think he was interested in the way things influence the present day. But he never really worked in the field of science fiction, but I think he had a sense that the universe influenced what people did, in certain ways. I talk about Hitchcock having a kind of overarching vision about the nature of human beings; that's why darkness is in his biography, *The Dark Side of Genius*. Would you say science has a moral vision? Is any of this, any of the things that you're working with now or thinking about have any moral dimension at all since you're talking about how the universe began and what it was like and so forth?

MB: I don't think it's the case for the things that we actually work with, but I do think that with science as it's being developed sometimes there's a moral part, at least in the development of certain ideas.

PS: I know that Einstein objected to quantum mechanics. I guess he said God wouldn't play dice with the universe.

MB: That was actually very important because of his criticism. He had many debates, with Bohr the most famous one and others. And this was not political. It was extremely strong criticism because he just wasn't convinced. And I think he was, well maybe not fully right, I mean. In quantum physics by now we have so many observations, there has to be something right about it. But I don't think a lot of physicists are happy with it. Because it tells us how to describe things, how to do calculations, to make predictions which we can then compare with measurements, but it doesn't really give us any understanding of what's going on. And that's what Einstein wanted. His theory of general relativity, it's difficult to grasp but it gives us a very clear understanding of the gravitational force by the way spacetime bends. Quantum physics doesn't provide that. It just tells

us how to correct the classical understanding, which itself doesn't agree with experiments.

PS: So in your attempt to talk about quantum theory of gravity in your book, is that your attempt to maybe bridge the gap there?

MB: Certainly there is a gap that we want to bridge, have to bridge. But it probably doesn't help us to understand quantum physics better because we would need to use it. Some people think it will happen eventually but the motivation I think is rather pragmatic. We know that quantum physics applies very well to many experiments in the lab, and general relativity applies well too many observations in the cosmos. And then there are these situations in which both of them have to apply, when the universe itself is very small, or in black holes when matter collapses. There's a region with a strong gravitational force, but also collapsed to very high density. Whenever that happens, we know the theory is incomplete. People have tried to use just general relativity or just quantum physics and it doesn't work. You get meaningless results, like infinite numbers and these things. It doesn't mean that if we combine the theories that it will be meaningful, but it's at least one hope.

PS: So where do you see the field going, at least in your research? Will physics be able to bridge the gap between quantum mechanics and general relativity?

MB: Yes. It's a very popular part of physics. It's certainly not the only one. The idea of unification is mainly applied in these extremes—very small distances or very high energies rather than the very large distances of the cosmos. So I wouldn't say that's where physics is going.

PS: Do you think that Hawking is right when he says that philosophy is dead, that physicists are the new philosophers? Because philosophers haven't kept up with science.

MB: Well, they don't have to keep up with science. His statement is probably, to some degree, a misunderstanding about what philosophy is supposed to be. It was never about detailed descriptions of physics or other things, biology perhaps. There are certainly many different ways of doing philosophy. But one thing is that it provides a general framework of thinking which also applies to science, but not just to science. What's actually happening in science doesn't really have to reflect back on this general way of thinking. And for that philosophy is still necessary. I think even if Hawking is making such a statement, then he needs philosophy to really see what's faulty about the statement. Also, many of the

things that he describes are rather recent. It hasn't been the first time in the interaction of science and philosophy. The same thing happened with relativity. It had a strong influence on philosophy, the notion of space and time. There were certainly philosophers who noticed it very early, but it took several decades for many of these notions to go into mainstream philosophy or at least some part of it. Even if it would be true, currently, to say that philosophy hasn't been able to keep up with science, it is because it needs some time to process.

PS: There's always a lag, I think.

MB: And, with relativity when one's philosophy develops, ideas improve. It helped physics. It helped our own understanding in physics to describe what it really means for space and time to behave in this way. And we're still trying to understand time; that's why we need philosophy.

PS: Can you talk about light as a physicist might do? As you know, without light there would be no cinema.

MB: Light is a form of electric and magnetic forces that can exist and propagate on their own, without charges or currents. In theoretical physics we often view light as the main example for the idea of unification: Two apparently different forces such as the electric and magnetic ones work together, combined to a new thing, the electromagnetic field, and help us explain phenomena such as light. Light as a general notion has played important roles in physics, for instance, in special relativity where considerations of its velocity revolutionized our understanding of space and time. So light is indeed enlightening, and of course we use it directly also in telescopes and other detectors, often with lasers. What we call light in the strict sense, which is what we actually perceive with our eyes, has a more coincidental origin. The atmosphere just happens to be transparent for a certain frequency range of electromagnetic waves, and so during evolution eyes adapted to see the corresponding range of colors. In physics, we usually think of light in more general terms, as electromagnetic waves. When we say "the speed of light" it is really the speed of all electromagnetic waves, also including ultraviolet and infrared waves, x-rays, radar and radio.

PS: The filming process involves capturing light from a specific time and place, and then the projection process involves using light from the present moment to rekindle the light captured on the film. How would you describe, as a scientist, what is going on in this process?

MB: It's a transfer of information. Light carries information about the objects it is scattered off before it reaches the film. The film transfers the information into binding properties of molecules, and stores it. When the film is shown, information is transformed back into light and then into our eyes and brains. Light is useful because it travels far and straight, so it is a reliable information carrier.

PS: Do we—physicist and laymen alike—really know what light is?

MB: In physics, light is one of the best understood phenomena. We know since Maxwell how to calculate its behavior, and also quantum physics of light is well-established—mainly thanks to Feynman's work on quantum electrodynamics. By comparison, light is rather simple. It does not have mass, so we don't have to wait till we see the elusive Higgs particle to understand it fully. Another question is why is there light? Why do the carriers of the electromagnetic field, the photons, remain massless even though other forces have massive carriers? That's something we don't know.

Epilogue

It was 2010, 34 years after the Bell and Howell projector had burned a hole through Uncle Charlie's head and subsequently destroyed the Newton dining room right before the eyes of my students and me. The arrow of time—irreversible in "real life—as opposed to "reel life"—had inexorably shot forward. Hitchcock had died in 1980. I had retired from full-time teaching in 2007. During that 27 years, the worlds of entertainment had undergone a revolution. The Bell and Howell projectors had been replaced by digital projectors; celluloid had given way to hard drives. The single screen local movie house had been replaced by automated, multiplex theaters. The projectionist had become an endangered species. Science and technology had penetrated almost every aspect of life; social media had transformed society in profound ways. Einstein, who died in 1955, right in the middle of Hitchcock's most creative period, would be amazed at the way that his theories had transformed the world.

I had traveled to Princeton University to interview Uri Hasson from the Department of Psychology and the Neuroscience Institute. Uri and his colleagues at the NYU Center for Neural Science had written an article for *Projections: The Journal of Movies and Mind* about a groundbreaking experiment that they had conducted in 2008. This experiment had introduced a new scientific paradigm to study the effects of films on viewers' brains: The new paradigm is called neurocinematics. This is what the abstract of the article says about this new field: "Brain activity was measured using functional Magnetic Resonance Imaging (fMRI) during free viewing of films, and inter-subject correlation analysis (ISC) was used to assess similarities in the spaciotemporal responses across viewers' brains during movie watching."[1]

I had become interested in neurocinematics because it had a direct connection to Hitchcock and the book I was writing. For the fMRI experiment described in the article, Uri and his colleagues had chosen three films to show their subjects: 1) an episode of Larry David's *Curb Your Enthusiasm* (2000); 2) a scene from Sergio Leone's *The Good, the Bad and the Ugly* (1966); and 3) an episode from *Alfred Hitchcock Presents*, entitled "Bang, You're Dead" (1961). The experiment revealed that the Hitchcock film evoked the highest response

in the cortex of the viewers' brains—65 percent—compared to 45 percent for the Leone clip and 18 percent for the Larry David episode.

What really excited me when I read the article was this statement: "The fact that Hitchcock was able to orchestrate the response of so many different brain regions, turning them on and off at the same time across all viewers, may provide neuroscientific evidence for his notoriously famous ability to master and manipulate viewers' minds. Hitchcock often liked to tell interviewers that for him 'creation is based on an exact science of audience reactions.'"[2]

Finally, here was scientific confirmation of my belief that Hitchcock's camera is indeed absolute.

As I left my interview with Uri, I reminded myself that the MRI technology that had made neurocinematics possible had grown out of experiments in quantum mechanics in 1927, just after Hitchcock had made his second film and had married his most important collaborator, the film editor Alma Reville. Walking through the scenic campus, I recalled that Einstein, who had introduced quantum mechanics in 1905, had visited Princeton in 1921, one year after Hitchcock had entered the film industry in England. When Einstein left Berlin for good in 1933, he came to Princeton, where he became associated with the Institute for Advanced Study. He stayed at Princeton until his death in 1955. I walked into a building that contained pictures of famous Princeton alumni. There, on the wall, next to a stairway, was the picture of Jimmy Stewart, class of 1932, who had gone on to become a movie star and to appear in two of Hitchcock's greatest films, *Rear Window* and *Vertigo*.

Notes

Introduction

1 Thomas McFarland, *Tragic Meanings in Shakespeare* (New York: Random House, 1966), 13.

2 Vittorio Storaro, *Writing with Light*, trans. Susan Ann White and Felicity Lutz (New York: Aperture, 2003), 6.

3 Francois Truffaut, *Hitchcock*, rev. edn. (New York: Simon and Schuster, 1984), 335.

4 *Culture of Light: Cinema and Technology in 1920s Germany* (Minneapolis: University of Minnesota Press, 2005), xiii.

5 Steven Weinberg, *The First Three Minutes: A Modern View of the Origin of the Universe*, updated edition (New York: Basic Books, 1993), 6.

6 Guerin, xiii.

7 *Alfred Hitchcock: A Life in Darkness and Light* (New York: Regan Books, Harper Collins, 2003), 31.

8 Harro Segeberg. "Is Everything Relative?: Cinema and the Revolution of Knowledge Around 1900," in *Film 1900: Technology, Perception, Culture*, ed. Annemone Ligensa and Klaus Kreimeir (Bloomington: Indiana University Press, 2009), 67.

9 McGilligan, *Hitchcock: A Life*, 27.

10 "A Short History of the Magnetic Resonance Imaging," Tesla Memorial Society of New Your, http://www.teslasociety.com/mri.htm (accessed November 1, 2012).

11 http://www.gladwell.com/blink/index.html (accessed November 1, 2012).

12 Philip J. Skerry, *Psycho in the Shower: The History of Cinema's Most Famous Scene* (New York: Continuum, 2009), 21.

13 *The Plain Dealer*, December 17, 2008.

14 Walter Isaacson, *Einstein: His Life and Universe* (New York; Simon & Schuster, 2007), 113.

15 *Subliminal: How Your Unconscious Mind Rules Your Behavior* (New York: Pantheon Books, 2012), 5.

16 Mlodinow, *Subliminal*, 4–5.

17 Isaacson, *Einstein*, 122.

18 *Alfred Hitchcock Interviews*, ed. Sidney Gottlieb (Jackson: University Press Mississippi, 2003), 253.

19 Andrew Robinson, *Einstein: A Hundred Years of Relativity* (New York: Metro Books, in Association with the Albert Einstein Archives, 2005), 29.

20 The Society for Cognitive Studies of the Moving Image, http://www.scsmi-online.org/category/forum (accessed July 10, 2011).

21 "From the Editors: Big News in River City," *Projections* 4:1 (Summer 2010): v–vi. online.

22 David Germain, "Thai Film Takes Top Honor at Close of Festival in Cannes," PDQEA, May 24, 2010.

Chapter 1

1 Robin Clark, ed. *Phenomenal: California Light, Space, Surface* (Berkeley: University California Press, 2011), 20.

2 Zeeya Merali, "Gravity Off the Grid," *Discover*, December 2011, 46.

3 Isaacson, *Einstein*, 119.

4 Isaacson, *Einstein*, 93.

5 (London: Phaidon, 2000), 10.

6 Guerin, *A Culture of Light*, 7.

7 Isaacson, *Einstein*, 120.

8 Isaacson, *Einstein*, 122.

9 McGilligan, *Hitchcock: A Life*, 14.

10 Brian Greene, host, *The Fabric of the Cosmos*, senior producer and director Jonathan Sahula (Boston: WGBH, PBS, 2011), DVD.

11 *The Fabric of the Cosmos*, DVD.

12 *The Fabric of the Cosmos*, DVD.

13 Isaacson, *Einstein*, 131–2.

14 Stephen Hawking, ed. *The Dreams that Stuff Is Made Of: The Most Astounding Papers on Quantum Physics and How They Shook the Scientific World* (London: Running Press, 2011), 16–31.

15 Gottlieb, *Alfred Hitchcock Interviews*, 306.

16 McGilligan, *Hitchcock: A Life*, 198.

17 Gottlieb, *Alfred Hitchcock Interviews*, 251.

18 Ted Haimes, dir. *Dial H for Hitchcock: The Genius Behind the Showman* (Los Angeles, CA: Universal Television Entertainment, 1999), VHS.

19 http://www.cosmology.carnegiescience.edu/timeline/1929 (accessed October 15, 2012).

Chapter 2

1 *Dial H for Hitchcock*

2 Isaacson, *Einstein*, 2.

3 *Moving Image Technology: From Zoetrope to Digital* (New York: Wallflower, 2005), 1.

4 S. V. "Camera."

5 (New York: Continuum, 2009).

6 *The Sixties: 1960–1969. History of the American Cinema*, Vol. 8, general ed. Charles Harpole (New York: Charles Scribner's Sons, 2001), 190.

7 (Boston: Little, Brown and Company, 2002).

8 (New York: Little, Brown and Company, 2000).

9 (New York: W. W. Norton, 2011).

10 Greenblatt, *The Swerve*, 7.

11 Greenblatt, *The Swerve*, 11.

12 (New York: Basic Books, 2001).

13 Miller, *Einstein, Picasso*. 2.

14 "Progression," *The New Yorker*, Nov. 14, 2011, 36.

15 Hawking, *The Dream That Stuff Is Made of*, 1.

16 Hawking, *The Dream That Stuff Is Made of*, 4.

17 Enticknap, *Moving Image*, 25–6.

18 McGilligan, *Hitchcock: A Life*, 25.

19 McGilligan, *Hitchcock: A Life*, 26.

20 "Hitchcock," Special Collections, 41 doc., The Margaret Herrick Library, The Academy of Motion Picture Arts and Sciences.

21 McGilligan, *Hitchcock: A Life*, 27.

22 Truffaut, *Hitchcock*, 26.

23 Truffaut, *Hitchcock*, 26.

24 Truffaut, *Hitchcock*, 27.

25 Truffaut, *Hitchcock*, 18.

26 Truffaut, *Hitchcock*, 334.

27 Truffaut, *Hitchcock*, 123.

28 Truffaut, *Hitchcock*, 182.

29 Feb. 21, 2012.

30 Gottlieb, *Alfred Hitchcock Interviews*, 304.

31 *Interviews with Film Directors* (Indianapolis: Bobbs-Merrill, 1967), 241.

32 April 12, 2012.

33 March 9, 2012.

34 Gottlieb, *Alfred Hitchcock Interviews*, 305.
35 Gottlieb, *Alfred Hitchcock Interviews*, 70.
36 Truffaut, *Hitchcock*, 31.
37 McGilligan, *Hitchcock: A Life*, 63–5.
38 McGilligan, *Hitchcock: A Life*, 75.
39 Truffaut, *Hitchcock*, 103.

Chapter 3

1 Sidney Gottlieb, ed. *Hitchcock on Hitchcock: Selected Writings and Interviews* (Berkeley: University California Press, 1995), 203.
2 Robinson, *Einstein: A Hundred Years*, 30–1.
3 Truffaut, *Hitchcock*, 25.
4 Robinson, *Einstein: A Hundred Years*, 31.
5 Truffaut, *Hitchcock*, 25–6.
6 Truffaut, *Hitchcock*, 319.
7 Isaacson, *Einstein*, 93.
8 Isaacson, *Einstein*, 549.
9 Truffaut, *Hitchcock*, 290.
10 Carlos Calle, *Coffee with Einstein* (London: Duncan Baird, 2008), 23.
11 *Dial H for Hitchcock.*
12 Truffaut, *Hitchcock*, 214.
13 Truffaut, *Hitchcock*, 11.
14 (New York: Columbia University Press, 1989), 152.
15 *The Genius of the System: Hollywood Filmmaking in the Studio Era* (New York: Pantheon Books, 1988), 6.
16 "German Hitchcock," *Framing Hitchcock: Selected Essays from the Hitchcock Annual*, eds. Sidney Gottlieb and Christopher Brookhouse. (Detroit: Wayne State University Press, 2002), 66.
17 Truffaut, *Hitchcock*, 18.
18 (Evanston IL: Mary and Leigh Block Museum of Art, Northwestern University: Northwestern University Press, 2007), xi.
19 4th edn. (Chicago: University Chicago Press, 2012), 27.
20 Robinson, *Einstein: A Hundred Years*, 62–3.
21 *Casting a Shadow*, xi.
22 (Lanham, MD: Scarecrow Press, 2003), 173–7.
23 *Alfred Hitchcock* (Paris: Cahiers du Cinema Sari, 2010), 85.

24 http://www.seeing-stars.com/museums/StudioMuseum.shtml (accessed July 15, 2011).
25 (New York: Crown, 1985), 115.
26 Skerry, *Psycho in the Shower*, 32.
27 Ken Mogg, et al., *The Alfred Hitchcock Story* (London: Titan Books, 1999), 116.
28 McGilligan, *Hitchcock: A Life*, 479.
29 (New York: Grosset and Dunlap, 1950), 3.
30 Truffaut, *Hitchcock*, 218.
31 Gottlieb, *Hitchcock on Hitchcock*, 256.
32 Peter Bogdanovich, *The Cinema of Alfred Hitchcock* (New York: The Museum of Modern Art Film Library, Distributed by Doubleday & Co., Garden City, NY, 1963), 4.
33 Garncarz, "German Hitchcock," 75.
34 Coleman, *The Hollywood I Knew*, 178.
35 (London: Phaidon, 2000), 143.
36 (London: Wallflower, 2002), 5.
37 Truffaut, 180.
38 (New York: Limelight Editions, 1997), 2.
39 (New York: Dutton, 2010), 2.
40 Sharff, *The Art of Looking*, 3.
41 Sharff, *The Art of Looking*, 3.
42 Sharff, *The Art of Looking*, 5.
43 Caroll, *From Eternity to Here*, 2.
44 Laurent Bouzereau, *The Alfred Hitchcock Quote Book* (Secaucus, NJ: Carol Publishing Group, 1993), 3.

Chapter 4

1 Stephen Hawking and Leonard Mlodinow, *The Grand Design* (New York: Bantam Books, 2010), 5.
2 "Is Everything Relative," 68.
3 http://www.smithsonianmag.com/science-nature/Dark-Energy-The-Biggest-Mystery-in-the-Universe (accessed February 1, 2012).
4 (Chantilly, VA: The Teaching Company, 2007), DVD.
5 http://preposterousuniverse.com/writings/metaphor05/ (accessed July 15, 2011).
6 Isaacson, *Einstein*, 78.
7 Isaacson, *Einstein*, 78.

8 Truffaut, *Hitchcock*, 216.

9 Truffaut, *Hitchcock*, 316.

10 Eric Rohmer and Claude Chabrol. *Hitchcock: The First Forty-Four Films.* (New York: Frederick Ungar, 1979), 17.

11 http://whatis.techtarget.com/definition/antimatter (accessed September 10, 2012).

12 Bouzereau, *The Alfred Hitchcock Quote Book*, 164.

13 Gottlieb, *Hitchcock on Hitchcock*, 313.

14 "Boy Meets Girl: Architectonics of a Hitchcockian Shot," *Senses of Cinema*, 62: April 18, 2012, http://sensesofcinema.com/2012/feature-articles/boy-meets-girl-architectonics-of-a-hitchcockian-shot/ (accessed October 10, 2012).

15 Pomerance, "Boy Meets Girl," 1.

16 Pomerance, "Boy Meets Girl," 3.

17 Annette Kuhn, "History of the Cinema," in *The Cinema Book*, ed. Pam Cook (New York: Pantheon Books, 1985), 212.

18 "The 180 Degree Rule," *Words of Art*, http://www.ouc.bc.cal/final/glossary/0_list/180degreerule.html (accessed July 10, 2004).

19 Pomerance, "Boy Meets Girl," 3.

20 Louis Giannetti, *Understanding Movies*, 10th edn. (Upper Saddle River, NJ: Pearson Prentice Hall, 2005), 77–8.

21 http://www.scsmi-online.org/forum/film-style-a-motor-approach (accessed September 15. 2012).

22 http://www.genopro.com/genograms/family-systems-theory/ (accessed October 1, 2012).

23 Carroll, *From Eternity to Here*, 2.

24 Kuhn, "History of the Cinema," 212.

25 Truffaut, *Hitchcock*, 151.

26 http:www.ualberta.ca/~dmial/English121/milton1.htm (accessed October 12, 2012).

27 Bouzereau, *The Alfred Hitchcock Quote Book*, 154.

28 (New York: Alfred A. Knopf, 2011), 24–5.

29 Segeberg, "Is Everything Relative," 68.

30 Krohn, *Hitchcock*, 56.

31 http://www.thefreedictionary.com/kinaesthesis (accessed Oct. 12, 2012).

32 http://www.aip.org/history/einstein/essay-einsteins-time.htm (accessed October 12. 2012).

33 McGilligan, *Hitchcock: A Life*, 441–2.

34 Gottlieb, *Hitchcock on Hitchcock*, 298.

35 Truffaut, *Hitchcock* 266.

36 http://www.writing.upenn.edu/~afilreis/50s/gays-in-govt.html (accessed November 1, 2012).

37 "Illicit," Turner Classic Movies, http://www.tcm.com/this_month/article.html (accessed December 1, 2012).

38 (New York: Viking, 2001), 269–70.

39 sensesofcinema.com/2005/great-directors/Hitchcock/.36:July 22,2005 (accessed July 15, 2006).

40 "Editor's Day," June 9, 2012, http://www.labyrinth.net.au/~muffin/ (accessed September 15, 2012).

41 *The Alfred Hitchcock Story*, 101.

42 Deborah Knight and George McKnight, "Suspense and its Master," in *Alfred Hitchcock: Centenary Essays*, eds. Richard Allen and S. Ishii-Gonzales (London: British Film Institute, 1999), 108–9.

43 Knight and McKnight, "Suspense and its Master," 109.

44 Isaacson, *Einstein*, 138.

45 Isaacson, *Einstein*, 138.

Chapter 5

1 Kuhn, *The Structure of Scientific Revolutions*, 6.

2 Kuhn, *The Structure*, xiii.

3 Kuhn, *The Structure*, 10.

4 Kuhn, *The Structure*, 10.

5 (Chicago: University Chicago Press, 2012), 29.

6 *The Big Picture: The New Logic of Money and Power in Hollywood* (New York: Random House, 2005), 3–4.

7 Kuhn, *The Structure*, x.

8 Kuhn, *The Structure*, 11.

9 Schatz, *The Genius of the System*, 6.

10 Truffaut, *Hitchcock*, 133.

11 Thomas Doherty, *Pre-Code Hollywood* (New York: Columbia University Press, 1999), 379.

12 *Movie Made America: A Cultural History of American Movies* (New York: Vintage Books, 1976), 174.

13 Kuhn, *The Structure*, 6.

14 Monaco, *The Sixties: 1960–1969*, 190.

15 McGilligan *Hitchcock: A Life*, 205.

16 Jonathan Romney, "A Hitch in Time," *New Statesman*, July 19, 1999:35–6.

17 "Don DeLillo, A Writer by Accident Whose Course is Deliberate," *The New York Times*, Feb. 4, 2010, C1. Online. October 4, 2012.

18 Don DeLillo, *Point Omega: A Novel* (New York: Scribner, 2010), 5.

19 *The Fabric of the Cosmos*, DVD.

20 Isaacson, *Einstein*, 250.

21 Robinson, *Einstein: A Hundred Years*, 10.

22 *Soul in Suspense: Hitchcock's Fright and Delight* (Metuchen, NJ: The Scarecrow Press, 1993), 10.

23 "Tomorrow Show," hosted by Tom Snyder. Interview with Alfred Hitchcock, May 29, 1973. *YouTube*. May 17, 2012.

24 McGilligan, *Hitchcock: A Life*, 355.

25 "Phobias," http://www.freud.org.UK/education/topic/10575/subtopic/40020/ (accessed October 12, 2012).

26 "Tomorrow Show."

27 *The Dancing Wu Li Masters: An Overview of the New Physics* (New York: Perennial Classics, 2001), 206.

28 *The Hidden Reality: Parallel Universes and the Deep Laws of the Cosmos* (New York: Alfred A. Knopf, 2011), 241.

29 en.wikipedia.org/wiki/polymorphous-perversity (accessed October 12, 2012).

30 Skerry, *Psycho in the Shower*, 71.

Chapter 6

1 Robinson, *Einstein: A Hundred Years*, 52.

2 (New York: A. S. Barnes, 1965), 10.

3 McGilligan, *Hitchcock: A Life*, 514.

4 (Chicago: U Press, 1992), 2.

5 *Hitchcock's Films Revisited*, 152.

6 Kuhn, *The Structure*, 82.

7 http://newyorksocialdiary.com/node/225401 (accessed November 24, 2012).

8 trans. Robert W. Lawson (New York: Peter Smith, 1920), 23–5.

9 "Henri Poincare: The Unlikely Link Between Einstein and Picasso," http://www.guardian.co.uk/science/blog/2012/jul/17/henri-poincare-einstein-picasso (accessed November 17, 2012).

10 *Picasso at the Lapin Agile and Other Plays* (New York: Grove Press, 1996).

11 Hanway Films, Ltd. and Zenith Productions. The Criterion Collection, 2011. DVD.

12 http://physicscentral.com/explore/pictures/relativity-tram.cfm (accessed October 12, 2012).

13 (New York: St. Martin's Press, 1998), 175.

14 Isaacson, *Einstein*, 374.

15 (New York: Riverhead Books, 2003), 6.

16 *The Plain Dealer*, September 26, 2012, E3.

17 "*Vertigo*: Alfred Hitchcock," September 2012, 55.

18 (Hackensack, NJ: World Scientific, 2010), 1.

19 "Fearless Symmetries," http:www.timehighereducation.co.uk/story.asp?secti oncode=26&storycode=421555&c=1 (accessed November 7, 2012).

20 *The Fabric of the Cosmos*, DVD.

21 http://www.artofthetitle.com/title/vertigo/ (accessed November 17, 2012).

22 Auiler, *Hitchcock and the Making of Vertigo*, 55.

23 *The Beginning of Infinity: Explanations that Transform the World* (New York: Viking, 2011), 3.

24 "Physics and Feynman's Diagrams," *American Scientist*, 93:156–65. http://www.web.mit.edu/dikaiser/www/FdsAmsci.pdf.157 (accessed November 15, 2012).

25 Kaiser, "Physics and Feynman's Diagrams," 156.

26 Kaiser, "Physics and Feynman's Diagrams, 157.

27 Guillermo del Toro, "The Genius of Hitchcock," 38.

Epilogue

1 Uri Hasson, et al., "Neurocinematics: The Neuroscience of Film," in *Projections*, vol. 2:1 (summer 2008), 1.

2 Hasson, 16.

Bibliography

"Antimatter." http://whatis.techtarget.com/definition/antimatter (accessed September 10, 2012).

Art of the title, http://www.artofthetitle.com/title/vertigo/ (accessed November 7, 2012).

Auiler, Dan. *Vertigo: The Making of a Hitchcock Classic.* New York: St. Martin's Press 1998.

Bloom, Harold. *Hamlet: Poem Unlimited.* New York: Riverhead Books, 2003.

Bogdanovich, Peter. *The Cinema of Alfred Hitchcock.* New York: The Museum of Modern Art Film Library, by Doubleday & Co., Garden City, NY, 1963.

Bojowald, Martin. *Once Before Time: A Whole Story of the Universe.* New York: Alfred A. Knopf, 2010.

Bordwell, David. The Society for Cognitive Studies of the Moving Image. http://www.scsmi-online.org/category/forum (accessed July 11, 2011).

Bouzereau, Laurent. *The Alfred Hitchcock Quote Book.* New York: Citadel Press, 1993.

Calle, Carlos. *Coffee with Einstein.* London: Duncan Baird, 2008.

Carnegie Institute for Science, http//:www.cosmology.carnegiescience.edu/timeline/1929 (accessed October 15, 2012).

Carroll, Sean. *Dark Energy, Dark Matter: The Dark Side of the Universe.* Chantilly, VA: The Teaching Company, 2007. DVD.

—*From Eternity to Here: The Quest for the Ultimate Theory of Time.* New York: Dutton, 2010.

—"From Experience to Metaphor, by Way of Imagination." www.preposterous universe.com/writings/metaphor05/ (accessed July 15, 2011).

Clark, Robin, ed. *Phenomenal: California, Light, Space, Surface.* Berkeley: University California Press, 2011.

Coleman, Herbert. *The Hollywood I Knew: A Memoir: 1916–1988.* Lanham, MD: Scarecrow Press, 2003.

Daiches, David. http://www.ualberta.ca/~dmial/English_121/milton1.htm (accessed July 15, 2012).

DeLillo, Don. *Point Omega: A Novel.* New York: Scribner, 2010.

Del Toro, Guillermo. "The Genius of Hitchcock." *Sight and Sound.* August 2012.

Deutsch, David. *The Beginning of Infinity: Explanations that Transform the World.* New York: Viking, 2011.

Doherty, Thomas. *Pre-Code Hollywood.* New York: Columbia University Press, 1999.

Eames, John Douglas. *The Paramount Story.* New York: Crown, 1985.

"Edwin Hubble Discovers the Universe is Expanding." *Everyday Cosmology.* http://www.carnegiescience.edu/timeline/1929 (accessed October 15, 2012).

Einstein, Albert. *Relativity: The Special and General Theory.* Trans. Robert W. Lawson. New York: Peter Smith, 1920.

Elliott, Deborah. "The 180 Degree Rule." *Words of Art.* http//:www.ouc.bc.cal/final/glossary/0_list/180degreerule.html (accessed July 10, 2004).

Enticknap, Leo. *Moving Image: From Zoetrope to Digital.* New York: Wallflower, 2005.

Epstein, Edward Jay. *The Big Picture: The New Logic of Money and Power in Hollywood.* New York: Random House, 2005.

Feinstein, John. *The Punch: One Night, Two Lives, and the Fight that Changed Basketball Forever.* Boston: Little, Brown and Company, 2002.

"From the Editors: Big News in River City." *Projections* 4:1. Summer 2010.

Galison, Peter. American Institute of Physics, http://www.aip.org/history/einstein/essay-einsteins-time.htm (accessed October 12, 2012.

Garncarz, Joseph. "German Hitchcock." *Framing Hitchcock: Selected Essays from the Hitchcock Annual* Ed. Sidney Gottlieb and Christopher Brookhouse, 59–81. Detroit: Wayne State University Press, 2002.

GenoPro. http://www.genopro.com/genograms/family-systems-theory (accessed October 1, 2012).

Giannetti, Louis. *Understanding Movies.* 10th edn. Upper Saddle River, NJ: Pearson Prentice Hall, 2005.

Gibbs, John. *Mise-en- Scène: Film Style and Interpretation.* London: Wallflower, 2002.

Gladwell, Malcolm. *The Tipping Point: How Little Things Can Make a Big Difference.* New York: Little, Brown and Company, 2000.

—*Blink.* http://gladwell.com/blink/index.html (accessed November 1, 2012).

Gottlieb, Sidney, ed. *Hitchcock on Hitchcock: Selected Writings and Interviews.* Berkeley: University of California Press, 1995.

—ed. *Alfred Hitchcock Interviews.* Jackson: University Press of Mississippi, 2003.

Grace, Michael L. http://www.newyorksocialdiary.com/node/225401 (accessed November 24, 2012).

Greenblatt, Stephen. *The Swerve: How the World Became Modern.* New York: W. W. Norton, 2011.

Greene, Brian. *The Fabric of the Cosmos.* Nova PBS, 2011. DVD.

—*The Hidden Reality: Parallel Universes and the Deep Laws of the Cosmos.* New York: Alfred A. Knopf, 2011.

Guerin, Frances. *A Culture of Light: Cinema and Technology in 1920s Germany.* Minneapolis: University Minnesota Press, 2005.

Guerra, Michelle and Vittorio Gallese. "Film Style: A Motion Approach." The Society for Cognitive Studies of the Moving Image. http://www.scsmi-online.org/forum/film-style-a-motor-approach (accessed September 15, 2012).

Hacking, Ian. Introduction to *The Structure of Scientific Revolutions*, 4th edn., by Thomas Kuhn. Chicago: University Chicago Press, 2012.

Haimes, Ted. Director. *Dial H for Hitchcock: The Genius Behind the Showman.* Los Angeles, CA: Universal Television Entertainment, 1999. VHS.

Hasson, Uri, et al. "Neurocinematics: The Neuroscience of Film." In Projections: The Journal of Movies and Mind. Vol. 2:1 (Summer 2008). 1–26.

Hawking, Stephen, ed. Introduction to *The Dreams that Stuff Is Made Of: The*

Most Astounding Papers on Quantum Physics and How They Shook the Scientific World. London: Running Press, 2011.

Hawking, Stephen and Leonard Mlodinow. *The Grand Design.* New York: Bantam Books, 2010.

Hitchcock, Alfred. Special Collections: Alfred Hitchcock. The Margaret Herrick Library. The Academy of Motion Picture Arts and Sciences. Los Angeles, CA (accessed April 15, 2010).

Hurley, Neil. P. *Soul in Suspense: Hitchcock's Fright and Delight.* Metuchen, NJ: The Scarecrow Press, 1993.

"Illicit." Turner Classic Movies. http://www.TCM.com/this_month/article.html (accessed November 2, 2012).

Isaacson, Walter. *Einstein: His Life and Universe.* New York: Simon & Schuster, 2007.

Kaiser, David. "Physics and Feynman's Diagrams." *American Scientist*, 93: 156–65. http://www.web.mit.edu/dikaiser/FdSAmsci.pdf (accessed November 15, 2012.

Kapsis, Robert. *Hitchcock: The Making of a Reputation.* Chicago: University Chicago Press, 1992.

"Kinaesthesia." The Free Dictionary. http://www.thefreedictionary.com/kinaesthesis (accessed October 12, 2012).

Knight, Deborah and George McKnight "Suspense and Its Master." In *Alfred Hitchcock: Centenary Essays.* Edited by Richard Allen and S. Ishii-Gonzalos, 107–121. London: British Film Institute. 1999.

Krohn, Bill. *Hitchcock at Work.* London: Phaidon, 2000.

—*Alfred Hitchcock.* Paris: Cahiers du Cinema Sari, 2010.

Kuhn, Annette. "History of the Cinema." In *The Cinema Book,* ed. Pam Cook. New York: Pantheon Books, 1985.

Kuhn, Thomas. *The Structure of Scientific Revolutions.* 3rd edn. Chicago: University Chicago Press, 1996.

Logan, Robert K. *The Poetry of Physics and the Physics of Poetry.* Hackensack, NJ: World Scientific, 2010.

Mann, William J. *Behind the Screen: How Gays and Lesbians Shaped Hollywood, 1910–1969.* New York: Penguin Books, 2001.

Martin, Steve. *Picasso at the Lapin Agile and Other Plays.* New York: Grove Press, 1996.

Matthews, Peter. "*Vertigo*: Alfred Hitchcock." *Sight and Sound.* September 2012.

McFarland, Thomas. *Tragic Meanings in Shakespeare.* New York: Random House, 1966.

McGilligan, Patrick. *Alfred Hitchcock: A Life in Darkness and Light.* New York: Regan Books, Harper Collins, 2003.

McPhee, John. *The New Yorker*, Nov. 14, 2011.

Merali, Zeeya. "Gravity Off the Grid." *Discover*, December 2011.

Miller, Arthur I. *Einstein, Picasso: Space, Time, and the Beauty that Causes Havoc.* New York: Basic Books, 2001.

—"Fearless Symmetries." http://www.timeshighereducation.10.uk/story.asp?sectioncode=26_&_storybook=421555_&_c=1 (accessed November 7, 2012).

—"Henri Poincaré: The Unlikely Link Between Einstein and Picasso." http://www.guardian.co.uk/science/blog/2012/jul/17/henri-poincare-einstein-picasso (accessed November 26, 2012).

Mlodinow, Leonard. *Subliminal: How Your Unconscious Mind Rules Your Behavior*. New York: Pantheon Books, 2012.

Mogg, Ken, et al. *The Alfred Hitchcock Story*. London: Titan, 1999.

—"Alfred Hitchcock." *Senses of Cinema*. http://www.sensesofcinema.com/2005/great-directors/Hitchcock/36 (accessed July 22, 2006).

—"Editor's Day," June 9, 2012. *The MacGuffin*. http://www.labyrinth.net.au/~muffin/ (accessed September 15, 2012).

Monaco, Paul. *The Sixties: 1960–1969*. History of the American Cinema. Vol. 8. General Editor: Charles Harpole. New York: Charles Scribner's Sons, 1990–2004.

Panek, Richard. "Dark Energy: The Biggest Mystery in the Universe." http://www.smithsonianmag.org/science_nature/Dark_Energy_The_Biggest_Mystery_in_the_Universe (accessed February 1, 2012).

"Polymorphous Perversity." Enwikipedia. http://www.en.wikipedia.org/wiki/polymorphous_perversity (accessed October 12, 2012).

Pomerance, Murray. "Boy Meets Girl: Architectonics of a Hitchcockian Shot." *Senses of Cinema*, 62, April 18, 2012. http://sensesofcinema.com/2012/feature_articles/boy_meets_girl_architectonics_of_a_Hitchcockian/shot/ (accessed October 10, 2012).

Pratley, Harold. "Alfred Hitchcock's Working Credo." *Alfred Hitchcock Interviews*. Ed. Sidney Gottlieb. Jackson: University Press of Mississippi, 2003.

"Relativity Train." http://www.physicscentral.com/explore/pictures/relativitytrain.cfm (accessed October 12, 2012).

Robinson, Andrew. *Einstein: A Hundred Years of Relativity*. New York: Metro Books, in Association with the Albert Einstein Archives, 2005.

Roeg, Nicolas, dir. *Insignificance*. Hanway Films, Ltd. and Zenith Productions 1985. Re-issued by The Criterion Collection, 2011. DVD.

Rohmer, Eric and Claude Chabrol. *Hitchcock: The First Forty-Four Films*. New York: Frederick Unger, 1979.

Romney, Jonathan, "A Hitch in Time." *New Statesman*, July 19, 1999. 35–6.

Sarris, Andrew. *Interviews With Film Directors*. Indianapolis: Bobbs-Merrill 1967.

Schatz, Thomas. *The Genius of the System: Hollywood Filmmaking in the Studio Era*. New York: Pantheon Books, 1988.

Schmenner, Will and Corrine Granof, (eds) *Casting a Shadow: Creating the Alfred Hitchcock Film*. Evanston, IL: Mary and Leigh Block Museum of Art, Northwestern University: Northwestern University Press, 2007.

Segeberg, Harro. "Is Everything Relative?: Cinema and the Revolution of Knowledge Around 1900." In *Film 1900: Technology, Perception, Culture*. Edited by Annemone Ligensa and Klaus Kreimeir. Bloomington: Indiana University Press, 2009.

Sharff, Stefan. *The Art of Looking in Hitchcock's Rear Window*. New York: Limelight Editions, 1997.

Skerry, Philip J. *Psycho in the Shower: The History of Cinema's Most Famous Scene*. New York: Continuum, 2009.

"A Short History of the Magnetic Resonance Imaging." Tesla Memorial Society of New York. http://www.teslasociety.com/mri.htm (accessed November 1, 2012).

Sklar, Robert. *Movie-Made America: A Cultural History of American Movies*. New York: Vintage Books, 1976.

Storaro, Vittorio. *Writing With Light.* Trans. Susan Ann White and Felicity Lutz. New York: Aperture, 2003.

"Studio Museum." http://www.seeing-stars.com/museums/StudioMuseum. shtml (accessed July 15, 2011).

"Tomorrow Show." Hosted by Tom Snyder. Interview with Alfred Hitchcock, May 29, 1973. *YouTube.* Online (accessed May 17, 2012).

Truffaut, Francois. *Hitchcock.* Revised Edition. New York: Simon & Schuster, 1984.

Wagner, Kristen Anderson. S. V. "Camera." *Schirmer Encyclopedia of Film.* General Editor: Barry Keith Grant. Detroit, MI: Schirmer Reference, 2007.

Ward, Ivan. "Phobias." Freud Museum. http://www.freud.org.uk/education/ topic/10575/subtopic/40020 (accessed October 12, 2012).

Weinberg, Steven. *The First Three Minutes: A Modern View of the Universe.* Updated edition. New York: Basic Books, 1993.

Wood, Robin. *Hitchcock's Films.* New York: Castle Books, 1965.

—*Hitchcock's Films Revisited.* New York: Columbia University Press, 1989.

Zukav, Gary. *The Dancing Wu Li Masters: An Overview of the New Physics.* New York: Perennial Classics, 2001.

Index

Photographs and diagrams are indexed in bold